To Lauren

Hope this is useful

Merry X-mas '84

love

Robin & Jenny

ANIMAL
DRAWING & PAINTING

REVISED EDITION

Walter J. Wilwerding

FELLOW OF THE AMERICAN GEOGRAPHICAL SOCIETY

Author and Illustrator of

Tembo, The Forest Giant
Animals in Advertising Art
Jangwa: The Story of a Jungle Prince
Keema of the Monkey People
Punda, The Tiger Horse

DOVER PUBLICATIONS, INC., NEW YORK

Published in Canada by General Publishing Com-
pany, Ltd., 30 Lesmill Road, Don Mills, Toronto,
Ontario.
Published in the United Kingdom by Constable
and Company, Ltd., 10 Orange Street, London WC 2.

This Dover edition, first published in 1966, is an
unabridged and unaltered republication of the re-
vised edition of *Animal Drawing and Painting* first
published by Watson-Guptill Publications in 1956.

Standard Book Number: 486-21716-7
Library of Congress Catalog Card Number: 66-28272

Manufactured in the United States of America
Dover Publications, Inc.
180 Varick Street
New York, N.Y. 10014

CONTENTS

This Dover edition
is dedicated to the memory of
WALTER J. WILWERDING
February 13, 1891———September 19, 1966

INTRODUCTION

THE ART OF delineating animals is an ancient one. Even the cavemen did exceedingly well with it, as is demonstrated by the excellent portraits of animals still existent in the Altamira Cave of Spain. These prehistoric artists apparently made no imaginative animals, but, rather, only realistic representations. They had seen the animals and they drew them as accurately as their abilities permitted. Obviously all their animal drawings were not equally good, as these artists, like those of today, varied in their powers of observation and delineation.

The ancient Egyptians also drew animals with great care — they modeled them, too. Their work, like that of the cavemen, derived its inspiration from nature; the species they represented may readily be identified.

This is not true of much of the so-called animal art of medieval times, for in this period imagination ran riot, no doubt stirred by tales of travelers who had sailed to foreign lands and brought back inaccurate descriptions of creatures that they had seen. This attempt to depict animals without knowing their true appearance resulted in drawings of distorted forms having no duplicates in nature.

In the fifteenth and sixteenth centuries, European artists gradually began to make more recognizable pictures of animals, both domestic and wild, and, as foreign animals made their appearance in zoos and private collections, the artists of the seventeenth century portrayed them accurately.

For example, Paul Potter (1625-1654) did remarkably well with horses and cattle, though he lived only twenty-nine years. (Whereas other artists of his time utilized well-drawn animals as secondary motifs in pictures primarily emphasizing humans, Potter seems to have been one of the first since ancient days — perhaps the very first — to give his attention to animal pictures alone, and so to deserve the name of animal artist.)

It was considerably later — not until the nineteenth century — that animal painting truly came into its own. This century produced some of the outstanding animal painters of the world: Troyon, Van Marcke, Mauve, Landseer, and Bonheur, to name a few. This was the era of Friedrich Specht, whose engravings illustrated many of the natural history books published in the last half of the nineteenth century; of Meyerheim, painter and illustrator; of Richard Friese, whose painting of lions watching a caravan is familiar to many, and who worked painstakingly from living models and animals obtained in the hunt; and of Wilhelm Kuhnert, who painted birds and animals and illustrated some outstanding works of natural history.

Among the English animal painters who were born in the nineteenth century and carried the tradition into the twentieth, I might name Archibald Thorburn, who has produced birds that live in pictures; G. E. Lodge, also a celebrated painter of birds; John Swan, who, despite his bird-like name, preferred lions, tigers and leopards for models; and Arthur Wardle, who similarly has chosen to portray the big carnivorous beasts. Their younger contemporary, Peter Scott, is noted for his outstanding paintings of wild fowl.

The Slav, Alfred Kowalski, was a painter of hunting scenes in which dogs, horses and other animals were shown in conjunction with hunters. Sometimes, though, he made

animals his leading motif — who has not seen his "Lone Wolf" standing in the snow on a hillside above a village?

Bruno Liljefors, the Swedish animal artist, painted the wild life that he found near his home. His work abounds with admirably depicted foxes, hares, birds of prey and wild fowl.

In our own time and country, though many were born in the nineteenth century, we have Carl Rungius, painter of American big game animals; F. L. Jaques, painter of American birds and mammals, and a master painter of museum habitat backgrounds; Lynn Bogue Hunt, painter of game birds, animals, and fish; Paul Bransom, whose animal illustrations for books and magazine are well known to all; the Dennis brothers, Morgan and Wesley, who paint horses and dogs; and Dorothy Lathrop, who makes the little animals, such as squirrels, chipmunks, and rabbits, come to life in her illustrations. Jessie Arms Botke paints decorative bird pictures.

The late L. A. Fuertes and R. Bruce Horsfall were master painters of birds. The late Charles Robert Knight painted mammals and made a specialty of prehistoric animals. Charles Livingston Bull, who died in 1932, was, for over twenty years, America's foremost animal illustrator.

A number of American artists, such as Pearson, Peterson, Eckelberry, and Bishop, have specialized in painting birds. Webber does both birds and mammals. Others, like Morris, have specialized in painting horses, while McGargee paints chiefly hunting dogs. Dogs have also been the specialty of Diana Thorne, although she also paints other animals. Percival Rosseau painted only hunting dogs during his lifetime, chiefly setters and pointers.

Many newcomers in this field are now drawing and painting animals for the numerous magazines for men.

One thing is obvious in the work of all these animal artists — they have constantly turned to nature for their inspiration and knowledge. Not only have successful animal artists, past and present, based their work on direct study from nature, but some of them, like Rosa Bonheur, kept live animals for models. Dorothy Lathrop keeps the little animals around her studio when she is working on illustrations for a book. Dog artists usually have dogs about the studio.

No animal artist, worthy of the name, has ever accomplished his results by copying what others have done. It is not the purpose of this book to offer copy material nor to make the illustrations take the place of live models; were this the aim, a hundred volumes crammed with pictures would not suffice. A child can copy a picture of an animal — this in itself means very little. It is my chief aim to start the reader off on a far sounder basis, by directing him to the best of all schools for the animal artist — nature. There, when he has found his models, I hope through the grace of my own past experience to help him capture his beast or bird with pencil or brush.

Some of my readers may be experienced and I hope they will bear with me while I appear to stress the obvious to assist the beginner. As a young art student, over forty years ago, I sorely needed such assistance. An instructor who drew animals gave me valuable advice, "Go to the zoo and draw animals from life." I went, standing before the animal dens and sketching, year after year, when I was not in Africa or some other wild place of the earth in search of models.

So, I hope you won't mind, if I look over your shoulder as you sketch and offer a bit of advice. It is given with the best of intentions and a lifetime of experience in sketching animals — an experience that smells of the menagerie and jungle. An experience, incidentally, that I would not trade for all the Spanish caravels laden with gold that ever roamed the high seas. I hope, in giving you my advice, that I can help you avoid the many mistakes that I made.

Animals are difficult models. Yet, in all their infinite forms, they present an interest and a challenge that can rarely be found in other subjects for painting. There is also adventure in an animal artist's work and a rare feeling of exultation in its accomplish-

ment. Having bagged your game with brush or pencil, you have preserved it forever for posterity.

I have tried to describe the ways of working that I have found best. Some of these you may choose as your own, others you will discard as you find other ways that will suit your methods and talents best. I trust you may find the help you need to continue the tradition of the great animal artists of the past and present.

Two things you must do, if you would attain this goal. First, you must thoroughly master the business of being an artist. This means that, at the outset, you must learn how to draw and paint. You can acquire this knowledge from any capable artist who knows how to teach. He need not be a painter of animals. You can learn how to paint by painting a cabbage or a pair of old shoes. There is no problem in painting textures that cannot be mastered by painting still life subjects day after day. You can learn how to paint animals by painting the human figure from life. That's animal painting. So, I repeat, learn to draw and paint well, and develop the persistence to study everlastingly the animals you intend to paint. With that combination, you have the key to success in animal art. Remember that Paul Potter lived only twenty-nine years, but he made a name for himself. In the longer lifetime which is your normal expectancy, you have a reasonable chance not only to attain his mastery, but to surpass it.

The drawings and paintings of mine that are shown in these pages were done from domestic animals, at zoological gardens and circus menageries, and from animals obtained in the hunting field, here and in Africa. They reveal something of the history of my methods of working, since I have selected examples from a large number done in the past forty years. Rough sketches have been included along with more finished studies in which I literally painted every hair, so that I could use them in future work where they would take the place of live models.

While I have attempted to supply enough drawings and paintings of my own to illustrate the leading points brought out in the text, a volume, such as this, is greatly enriched when the author's work is supplemented by that of other artists who specialize in the same field. Therefore, I have included examples by a group of such artists, each outstanding in his particular specialty. I only regret that limits of space prevent the inclusion of work by the many other notable animal artists whom I have mentioned in the foregoing. I am grateful to those who generously lent their work for inclusion here.

Thanks are also due to the Metropolitan Museum of Art, New York; the Pennsylvania Academy of the Fine Arts, Philadelphia; and the New York Zoological Society for permission to reproduce paintings in their collections. I am personally indebted to the McCall Company, the Curtis Publishing Company and the publisher of *Esquire* magazine for the right to reprint certain illustrations that first appeared in their publications. The Zoological Society of Philadelphia very kindly furnished the plates used on pages 55, 91, 112. These subjects were originally reproduced in *Fauna,* the magazine of that society.

W. J. Wilwerding

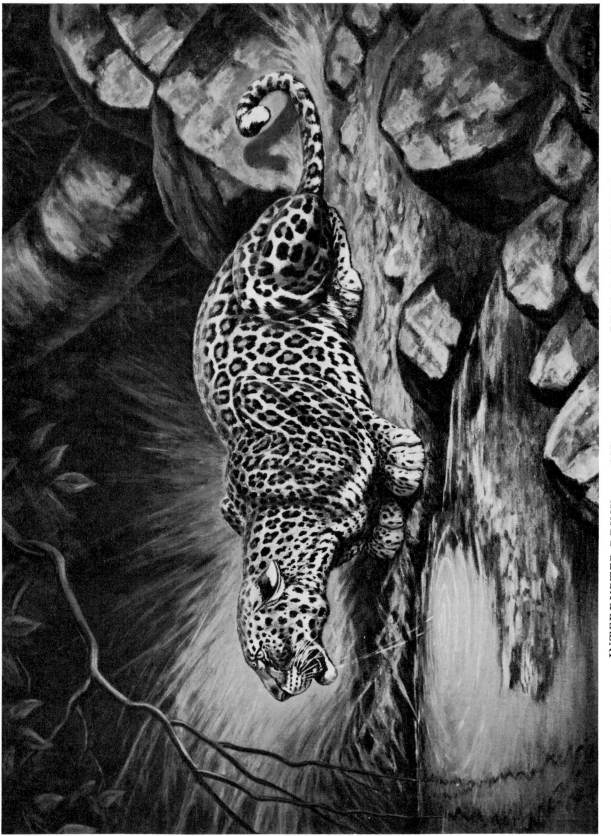

INTERRUPTED DRINK OIL 22 x 30 BY W. J. WILWERDING

In the collection of Mr. Raymond Lapham, Benson Animal Farm, Hudson, New Hampshire

Chapter I

GETTING UNDER WAY

I THINK we might assume that the reader is interested in either animal drawing and painting as his ultimate goal in art, or that he is interested in animal drawing as an accessory to other artwork he is engaged in. We will take it for granted that he can draw. So let us clarify one thing at the beginning — if you can draw, you can draw animals. There is no more mystery about drawing animals than there is about drawing other things. However, there are many thousands of different kinds of animals. It is a good idea to select your subjects, as you could not hope to draw every living creature on earth.

CHOOSING YOUR SUBJECT

Animal drawing covers a vast field. The animal kingdom includes every creature that crawls, walks, runs, swims or flies. We are accustomed to calling dogs, cats and other four-footed creatures by the name of *animal,* but birds, fish, snakes, and even mosquitoes are animals, too. It can be seen from this that animals vary greatly in appearance; even the four-footed ones vary much in this respect and we need only consider the giraffe, kangaroo, and elephant, to realize how much they vary in appearance.

Whether you go to the zoo, to the farm, or to field and forest for your subjects really makes little difference. What counts most is that you should choose subjects that interest you most, as you naturally will do best with these. You can't draw and paint the whole animal kingdom, so choose the animals you like best. Make up your mind at the beginning whether you will draw wild or domestic animals. It might be that you will want to specialize and paint only horses, dogs, or cats.

ON SPECIALIZING

Remember that, while animal drawing is a specialized field of art, there are specialists within this field. The dog artist is an animal artist, and there have been dog artists who specialized in drawing and painting only hunting dogs. Some artists are horse painters. A very famous one, Carl Rungius, has spent most of his life in painting only the big-game animals of America. There are cat artists and artists who paint only birds.

So, at the beginning, it is well to make up one's mind about this animal drawing business. It will save your time and you will direct your efforts where they will do the most good.

THE PRACTICAL ANGLE

It also is wise to employ a bit of common sense in choosing one's animal models. If you live on the farm, draw the farm animals and don't waste time yearning for lion and tiger models. You'll do better with those farm animals because you know them. If you live in the city where there is a zoo, then that is the best place to go for your models. Lacking other models, anyone living in a city, town or village can always draw dogs and cats.

AVAILABILITY OF SUBJECT

What we have been trying to tell you is that, if you want to get the most out of this animal drawing business, you should have the good sense to choose animal subjects that are available as models. So, if you live on the farm, draw farm animals, and, if you live in a big city, draw animals at the zoo. Also, consider yourself fortunate, for each day you can have a new model. Don't pass over this last sentence lightly, keep it in mind — *each day you can have a new model.*

DON'T BE SUPERFICIAL

When you go to the zoo, do not emulate the sketchers who hurry from cage to cage and paddock to paddock, sketching the whole zoo in one afternoon. You are going to the zoo to sketch animals so you will learn how they look and you can't learn by hurrying from animal to animal. Take one subject at a time and draw it carefully. You need not hurry; you have your whole life before you. Draw one animal and decide that you are going to keep on drawing it until you learn all about it.

ANIMALS IN REPOSE

At the beginning, it is a good idea to draw animals that are resting. Animals running restlessly about are not good models. If you choose to draw a dog, draw it at first while it is resting. Dogs really do a great deal of sleeping and are then good models. You can learn much about a dog by drawing it while it is sleeping and this will help you later when you want to draw it standing or jumping about. Cows, when reclining, make excellent subjects. You could do worse than practice animal drawings on cows. Learn what the cow looks like and it will be easy for you to draw a buffalo — yes, even antelope and deer. At the zoo, an animal at rest would be a logical first choice.

MATERIALS

At the beginning, all you need for your work are a few pencils, a sketchpad and an eraser. Do your drawing only on one side of the sheet, to avoid transferring sketches that are on the other side. The HB, B, 2B and 3B pencils are good for sketching, using the softer ones for the darker shadows. Keep a pocketful of sharpened pencils; your model may move while you stop to sharpen them.

TECHNICAL METHODS

We are assuming that the reader is familiar with the elements of freehand drawing, and that he knows how to represent reasonably well the forms of his subjects in correct proportions and light and shadow. However, if sketching from nature is something new to you, spend a bit of time drawing things like an apple or pear, a flower, or perhaps some leaves that you can pluck from

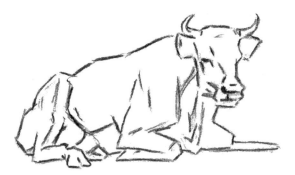

Beginning sketch of Cow, showing main lines of contours

trees or shrubs. A bit of this practice will get you into the mettle of drawing from nature and then you will find animal drawing easier. There are numbers of books on freehand drawing and I would suggest for reference such books as *Freehand Drawing Self Taught,* by Guptill (Harper); *I Wish I Could Draw,* by Bradshaw (Studio); or *Pencil Drawing,* by Watson (Watson-Guptill). *Freehand Drawing Self Taught* offers considerable help on the pencil technique, and *Pencil Drawing* is devoted wholly to this subject.

Draw naturally and proceed without too much conscious thought as to method. As is often the case, your first drawings from life may not satisfy you, but, with practice, you should show rapid improvement.

OVERCOMING PRECONCEIVED IDEAS

One of your greatest handicaps may be that you think you know more about the appearance of the animals than is actually true. Perhaps you think that you know exactly what a dog looks like, but take a pencil and see how well you can draw one from memory. If you are new at sketching dogs, your memory will be lacking in many details and you may find yourself handicapped, because of erroneous impressions you are carrying in your mind.

You can only draw an animal *as well as you can remember its form.* The best way to impress its form on your mind is to go directly to the animal for your information. Many of us are wrong when we think that we know exactly how a certain animal looks. Look at the animal and draw what you see.

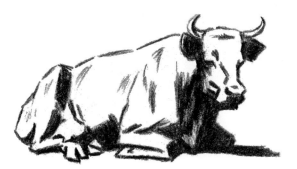

*Sketch of Cow; principal shadows
added in simple tone*

ANALYSIS OF SUBJECT

So get rid, I say, of previous notions as to appearances, and, in order to acquaint yourself fully with your selected subject, study it painstakingly before beginning your sketch. Even if your subject changes position before you have completely studied it, that won't rob you of your newly acquired facts; in that event, merely proceed to draw it in its changed position.

It isn't enough to concentrate on its larger masses; you must analyze it a detail at a time. Look at its head; note whether it is long, round, angular, broad or narrow. Study the ears; see how they are set on the head. You will find that many animals have their ears at the sides of the head and not perched on top, even though the points stick up that way. See whether the ears are pointed or round at the tips; whether they are broad or narrow.

Study the eyes. Note how far apart they are set. The character of the animal may be determined by this. Observe whether the eyes are large or small, set straight or slantwise in the face. Compare in size the eyes with the nose. Study other aspects of the nose, too. It varies vastly on animals of different kinds.

Now note the length of the neck, the proportions of the body, the length of the legs as compared to the length of the body, even the length of the tail. Study the legs and feet in the same way.

In all the foregoing study of form and proportions, pay no attention to the animal's color, or to the pattern of spots or stripes that may mark it. At present you are out merely to record on paper (and in your mind) the animal's form and pose.

ACTION: LIGHT AND SHADE

Two things you will doubtless wish to delineate in order to get a good sketch: first, the action, and, second, the basic light and shadow separation—the main divisions of tone. Of course you will also want to stress the character of the animal you are drawing, though at the start you will be less concerned with the character of the individual specimen than with class or family character—with the way your kind of animal differs from an animal of another kind.

The pose—or action, as it is commonly called—will in itself do much to express character, since animals of a certain kind have a distinctive way of posing. A cow lying down does not look like a cat lying down, and if you catch in your sketch an expression of the particular way in which a cow lies down, you will have captured some of its character. Add to this the characteristic shape of the cow's head, body and legs and you will have a drawing that expresses quite fully the true character of a cow.

As this action can often be caught through line work alone, *i.e.*, without any shading, the beginner frequently works for a time in line. Without some expression of light and shade, however, one's animals, as sketched, may fail to be entirely convincing. In the case of a cow in sunlight, for example, if you wish to give it roundness or depth of form—a third-dimensional quality—a certain amount of shading, enough at least to differentiate its main areas of light and shadow, is almost essential. More about this in a minute.

YOU START TO DRAW

But don't think *too* much just now about either your line work or your shading. Beginners sometimes become altogether too interested in all such matters of technique—don't you worry about them at first. After studying your model's form carefully, as

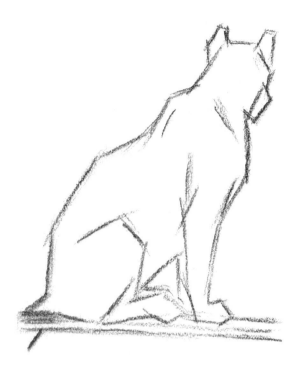

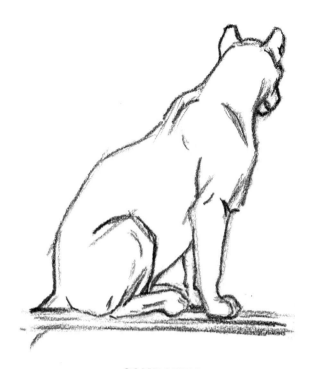

PROPORTIONS

*Draw the main proportions first in a
very simple manner, establishing the
general pose or action*

CONTOURS

*Gradually correct the contours, and
add the larger subdivisions of form.
Keep the whole coming!*

suggested above, look for the main lines that depict the pose or action. Put these down, and, at the same time, check with your eye the proportions, so the lines you draw will enclose the proper proportions of the animal before you. If you have been wise, you have followed our earlier advice by choosing an animal that is at rest; for best results neither he nor you should be surrounded by curious sight-seers. Under such favorable conditions, your model is quite likely to hold its pose long enough for at least a quick sketch—you may even be fortunate enough to make a rather finished job of it.

CORRECTING THE CONTOURS

Once you have the action and proportions worked out—that is, the way the beast lies and the proper relation in size between head, neck, body and legs—you can begin to correct and refine the contours that have so far been sketched-in roughly.

You will find that each animal is usually made up of many curves and a few straight lines. Compare one of these with another,

as you proceed, giving a bit more curve here, a little less there, working lightly at first and then strengthening the lines as you are sure they are right. *Work on all parts of the sketch and do not linger over any particular detail.*

SHADING THE TONE AREAS

If time permits, lightly outline the deepest shadows and fill these in. Half-shadows can now be added, and, if the beast still poses, you can carry to a more detailed finish the drawing of the head, feet or any other portion of particular interest. Should your model move while you are drawing, start another sketch and push that as far as you can.

Sometimes you may find that you have a dozen or more unfinished sketches at the end of the day, but in each you will have learned something about the animal drawn. With a bit of ingenuity, you can often construct one whole animal out of several sketches. The main thing, though, is to stick to the same model until you have learned what it really looks like.

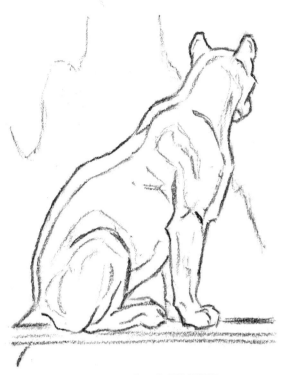

SHADOWS OUTLINED

*If time permits, outline the deepest
shadows and fill these in, later adding
half-shadows*

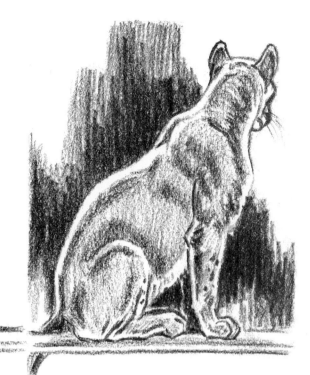

FINISHED

*Eventually you can refine the tones,
utilizing background, if you wish, to
round out the whole*

MEMORIZING APPEARANCES

It is remarkable how much your mind will retain of the animal's form after you have sketched it for several hours. It's a good wager that if you faced the cage of an animal for two hours without sketching, and then went away and tried to draw what you remembered, you would not be able to recall one fourth as much as if you had spent the same time in conscientious sketching.

MEMORY SKETCHES

The necessity of retaining each form in mind during the brief time it takes to transfer it to the paper, gives you a more-or-less permanent mental image. After sketching an animal, I have frequently tried on the next day to duplicate the sketch from memory—an excellent practice. After many years of sketching from life, I now find it possible to make memory sketches of great numbers of animals, some of them not sketched from the model since long ago.

If you would make your own collection of these permanent mental images, try fre-quent memory sketches.

We can even go so far as to say that ability to draw is based largely upon the ability to retain a picture of form in the mind. The hand has nothing to do with this; it is just the tool of the mind, and all talk about the artistic hand is so much drivel. If it isn't in your head, it cannot be in your hand.

As an example of what the mind will retain, let me give you an experience I once had in East Africa. I had spent the late afternoon sketching impalla, which are deer-like antelope. There were many of them and, since there had been little hunting in their country, I found it easy to follow them about with sketch-pad in hand. When they stopped to graze or browse, I sat down, studied them carefully with field glasses, and made sketches. Near the end of the day, I had many sketches, all of grazing, browsing and standing attitudes of impalla. I had even added other animals that had chanced into view.

Now, it happened that at evening an Afri-

can wild dog—a hyena-like animal—ran among the impalla and sent them away on the jump. I returned to camp shortly, sat down at the table, and sketched what I remembered of their jumping and running. Those memory sketches were more convincing than the ones done in the field. The action was better, there was more freedom in the work, and I had even recorded the character of the animals with more fidelity. All that time in the field, my mind had been gathering impressions. When I wanted to put these on paper, they came forth readily.

These two lots of sketches are reproduced below. Which would you choose if you wanted sketches of impalla?

PATIENCE AND DETERMINATION

At times, in attempting to make sketches or studies of a certain animal, your patience will be tried almost to the breaking point. Much drawing of animals, however, will teach you patience. Dogged determination to get your animal at any cost will then take the place of impatience—you will make a sort of game of it.

Once when sketching in the Jardin des Plantes in Paris I had an experience which will serve to illustrate this point. I had stopped there on my way home from East Africa, and was delighted to find in the collection a pair of bushbucks, male and female. This little animal had evaded me in Africa and here was an unexpected chance to record it for my sketch collection.

Taking my place at one end of the long paddock, I began by sketching the male. That little fellow was as nervous as a cat-bird at nest-building time. He would race down the length of the run and then back, stand looking at me for a time, and then continue his antics. Sometimes he stood quietly at the other end and then I would make a quick sketch. When he returned to where I stood, I continued to draw. All this work was done in full color in crayon, so besides waiting to catch glimpses of him in certain attitudes that I had started, I was constantly forced to switch crayons from one color to another. Betweentimes, when he

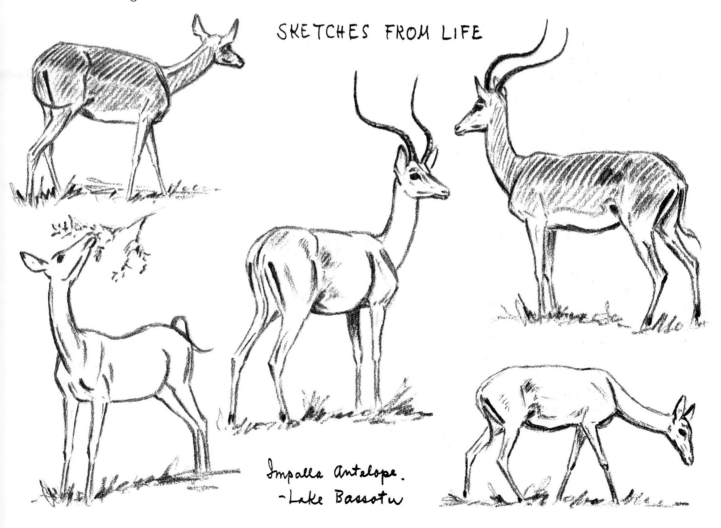

SKETCHES FROM LIFE

Impalla Antelope.
—Lake Bassotu

was too restless for my work, I sketched the female, who was lying down.

I spent all of one morning at the sketching of that bushbuck, but when the work was finished, I had him securely in the bag. The sketches are shown on page 8; I do not offer them as something a beginner might attempt, but to show what can be done with a nervous animal, if you have the will and the patience to stick to the job until finished.

MAKING SEVERAL SKETCHES SIMULTANEOUSLY

As I have already implied, it is often helpful, in sketching animals that are nervous or moving about, to start one sketch and leave room on the paper for several others. If the animal moves, you start a second sketch. If it moves again, you begin a third, and so on, until you have a number under way. Now, as the animal changes from one position to another, you shift from sketch to sketch. Stick it out, and you can generally finish all of them. That is the way the bushbuck was done, as well as the accompanying

sketches of the gemsbok, made in a circus menagerie. In the latter case, I was after attitudes and the strange markings of this animal, which accounts for the absence of more than a minimum of light and shadow. The movements of this antelope were limited, since it was confined to a cage, but it nevertheless moved to quite a degree, as can be seen on page 9.

QUICK ACTION SKETCHES

Obviously you must work fast in making an action sketch of an animal that is moving about or shifting position. It is simply impossible in such cases to begin one place and end another, as is often attempted by the tyro. Forget the detail of head, neck, body and legs, merely indicating these roughly by drawing an oval shape for the body and hastily sketched lines to locate the position of the legs, bending these lines to suggest the joints where the legs are bent, but employing only straight lines where a leg is held straight. Quickly draw the position and curve of the neck, and an oval for the posi-

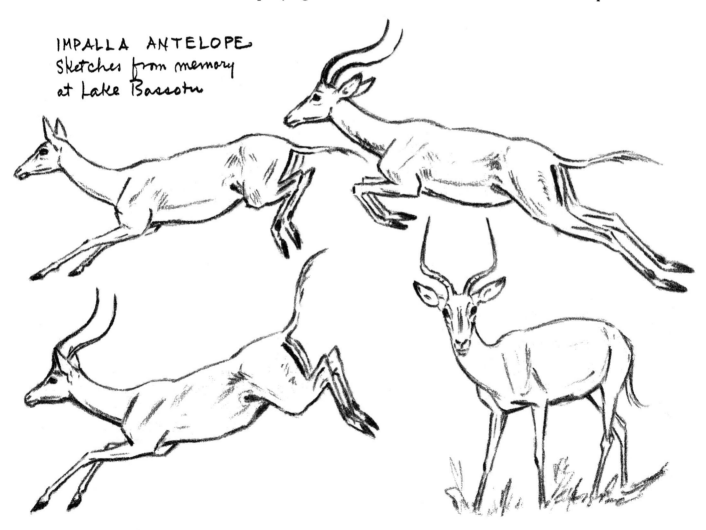

IMPALLA ANTELOPE
Sketches from memory
at Lake Bassotu

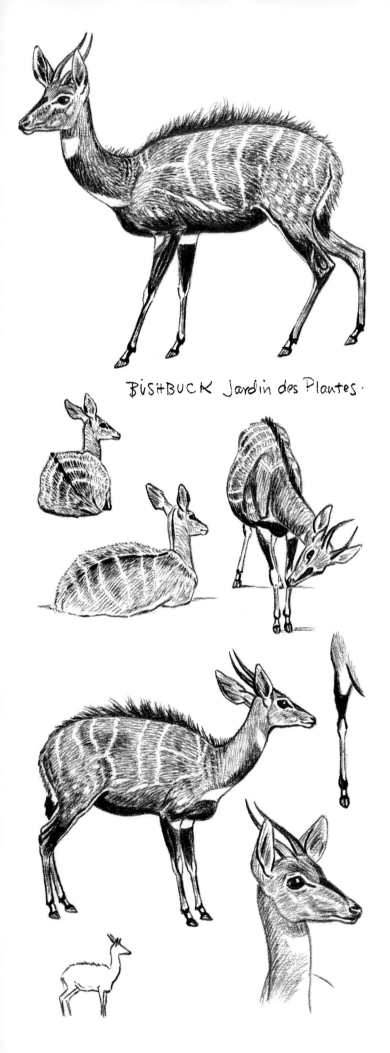

BUSHBUCK Jardin des Plantes.

tion of the head. If the tail is swinging, note its curve and add that.

Make these action sketches small, perhaps but a few inches high, and do one after the other on the same sheet, as the animal changes position or pose. After the sheet is filled, you can finish each sketch in turn. It is possible in this manner to complete the drawing of legs, proper curves of the body and neck, and even the essential character of the head, though it is not necessary to go into great detail in these action sketches. Separate studies of the various parts of the animal can be made later to help with the drawing of the entire animal in any of the various positions that you have sketched.

SKETCHING AT THE CIRCUS

I have mentioned the circus as a sketching ground, and for certain purposes it is ideal. Not only are circuses often to be seen in places where there are no zoos, but the fact that circus animals are in smaller quarters than are the creatures in a zoo, helps, too, since their movements are so confined that it is possible to make careful close-up studies.

The hour is important; I suggest you choose the afternoon, after the performance has started. When the crowd goes into the menagerie tent no work is possible; as soon as the crowd disappears into the big tent you can begin. You will have all afternoon and the whole menagerie tent to yourself, for there are none about but the attendants. They won't disturb you and are, in fact, pleased to help you. You have paid your way in, and if you choose to spend the time in the menagerie that is your own business.

SKETCHING AT THE ZOO

The zoo has its advantages and its disadvantages. For instance, one's model may be on the far side of a large paddock and refuse to come near. On the other hand, once at a zoo I had to contend with the opposite condition. I was trying to draw a kudu bull at the Bronx Zoo in New York. Petted by keepers and the public, he insisted on sticking his nose through the bars to lick my hand. The best animal model is one which

8

goes about its own business and ignores you.

One thing with which you will have to contend in drawing monkeys, baboons and apes is the fact that, like humans, they are self-conscious. Frequently, when sketching these, I have had them turn their heads away. They don't mind the visitor who looks and goes away, but they know when they are being stared at, and the sketcher must stare. When I have overstayed my welcome, I have even had them turn their backs to me, looking furtively over the shoulder now and then to see if I were still there.

A friend of mine had considerable success with drawing animals in the zoo by attaching a small paper pin-wheel to the retaining bar that keeps the public from the cages. The animals were fascinated by the whirling pin-wheel and sat quietly watching it while he sketched.

Just before feeding time is a bad time for sketching, since the animals, especially the meat-eaters, are then very restless. They are usually quiet enough while eating, and can then be sketched with little difficulty. After eating, many of the meat-eating animals stretch out flat on the floor of the cage; and, while this is a good time for making sketches of feet, it is otherwise of little value, since the attitudes are rarely those that you could utilize in a finished picture.

Early morning, right after the zoo opens, is the best time for sketching. After the public arrives, it is difficult to sketch without being disturbed. Some zoos will not allow sketchers before cages once the public has been admitted, and artists must come at certain other hours. This is true at the Jardin des Plantes in Paris, where the artists are allowed only from eight until ten, before the doors are opened to the public. This is an ideal arrangement, and I spent many happy hours there with the animal painters and sculptors of Paris. At such a time the animals are relaxed after a good night's rest from the public gaze; there is no one to look over the sketcher's shoulder and ask foolish questions, and he can work in peace.

DOMESTIC ANIMALS
The procedure for sketching domestic

9

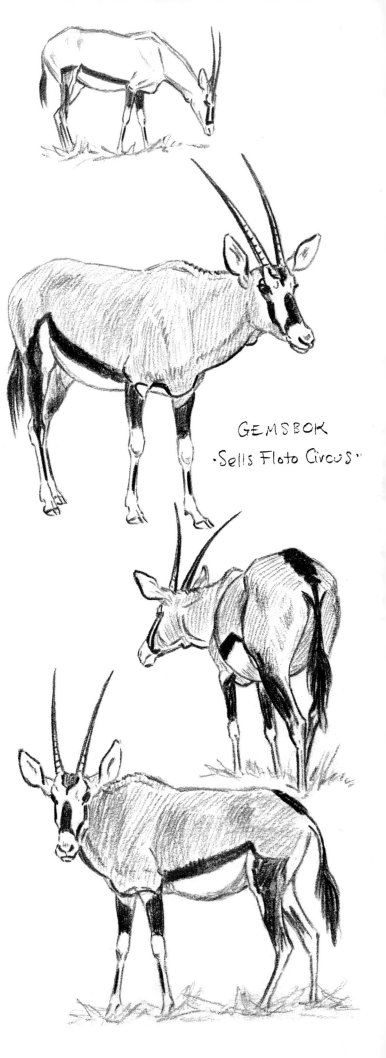

GEMSBOK
"Sells Floto Circus"

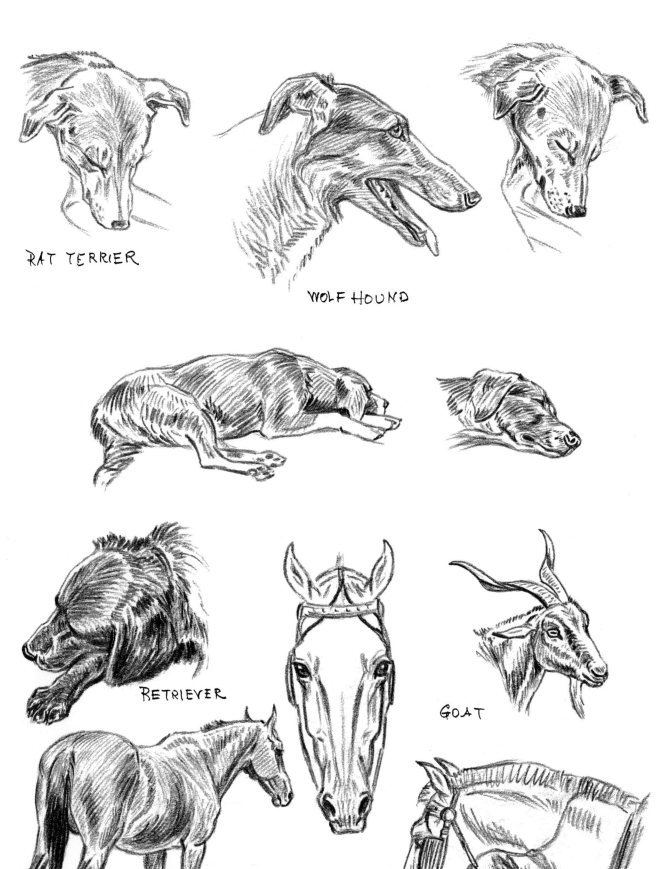

RAT TERRIER

WOLF HOUND

RETRIEVER

GOAT

WORK HORSES

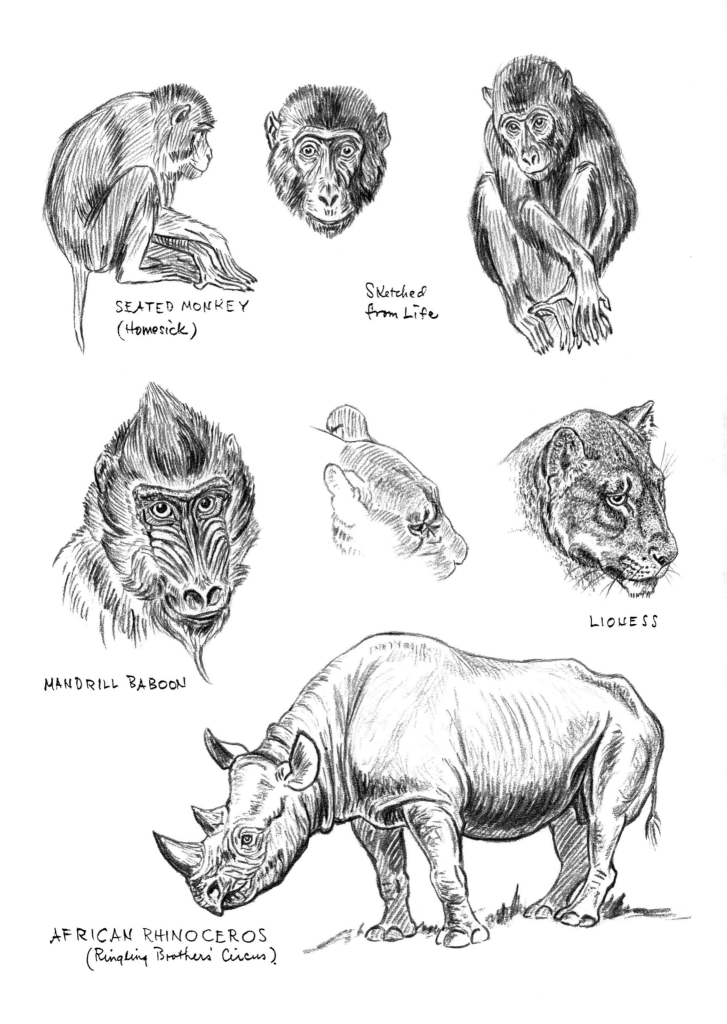

SEATED MONKEY
(Homesick)

Sketched
from Life

MANDRILL BABOON

LIONESS

AFRICAN RHINOCEROS
(Ringling Brothers' Circus)

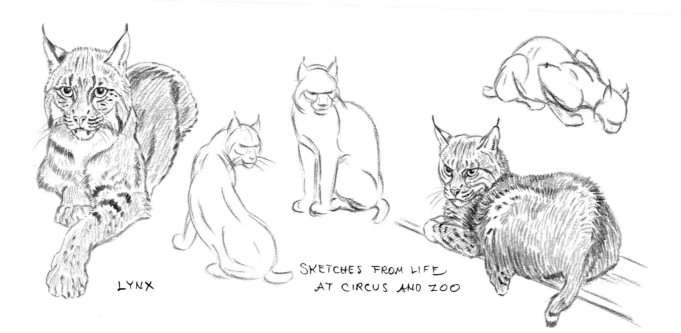

LYNX

SKETCHES FROM LIFE
AT CIRCUS AND ZOO

animals is exactly the same as for animals confined at the circus or zoo, though you can work more at ease, since you have no curious public with which to contend; also you are not bothered with view-restricting bars or wires.

We have already spoken of the dog as a valuable model. Remember that, as in the case of circus or zoo animals, you are sketching the dog to familiarize yourself with its construction. By sketching him as he lies about, you learn the construction of head, body and legs. By making larger separate studies of the head and feet, you are acquiring additional information that will help when you want to draw the same animal in other attitudes.

Once you have learned what the different parts of an animal look like, it is easy enough to draw that same animal whether at rest or in motion. I recall how I was once making a sketch of a lion that was pacing back and forth in its cage. A young man, no doubt an art student, watched me for some time and then remarked, "You know what that lion looks like, don't you?" I answered that I did, and he walked away with an injured air, as if I had been cheating on the job. The fact was that I had sketched that lion many times before, so I knew every line of his construction. It was easy enough to draw him as he paced his cage, for I needed only to watch his action to draw him from what I had learned previously, and to compare what

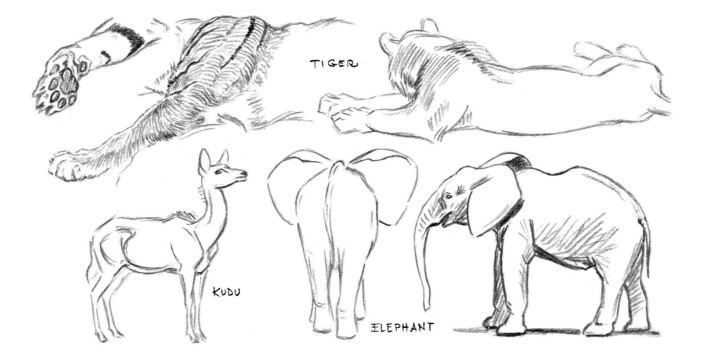

TIGER

KUDU

ELEPHANT

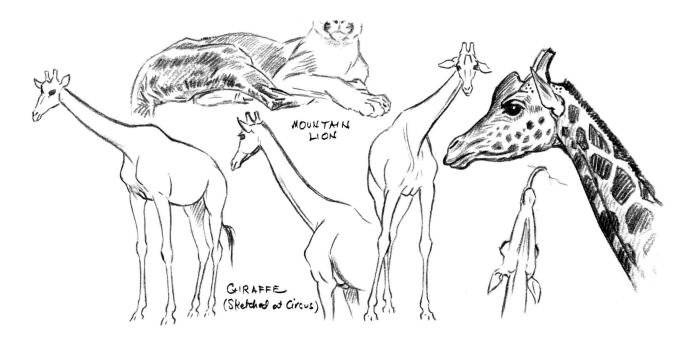

MOUNTAIN LION

GIRAFFE
(Sketched at Circus)

I drew with the animal before me. This would be true of dogs and every other animal.

THE ACCOMPANYING ILLUSTRATIONS

The sketches here shown were drawn at various places, in fact, anywhere that animals were found. The dogs were drawn at kennels and around home. Some were my dogs. The horses were drawn a long time ago at an express company stable, before the time of motor trucks. The wild animals were drawn at various zoos and at the circus. We call them wild animals, but many of them were not really wild at all.

Notice that there are sketches of parts of animals. I draw paws of tigers and lions to have a note of the details, which are very handy when I paint a lion or tiger. This also is the reason why I draw detailed heads of animals. Some sketches were made to record standing and resting attitudes. Sketches of animal attitudes, together with more detailed studies of heads, feet, etc., are highly useful in providing the information you need when you paint pictures of animals. Portrait artists can pose people while they paint, but you can't do that with an animal. You do most of your work from sketches and studies of animals that you have accumulated. This, however, is mainly true of the wild animal painter. Dogs and cats can be taken into the studio while you paint. You can paint a horse as it is tied outside the stable.

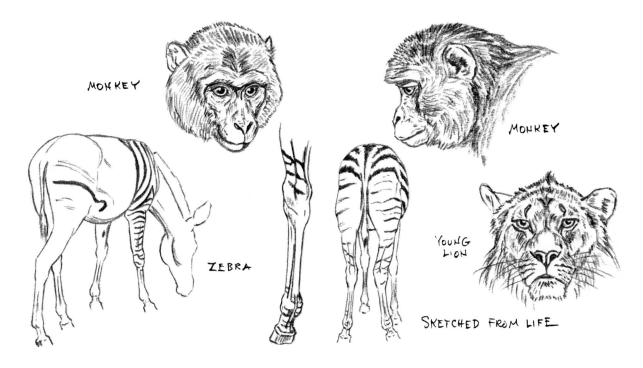

MONKEY

MONKEY

ZEBRA

YOUNG LION

SKETCHED FROM LIFE

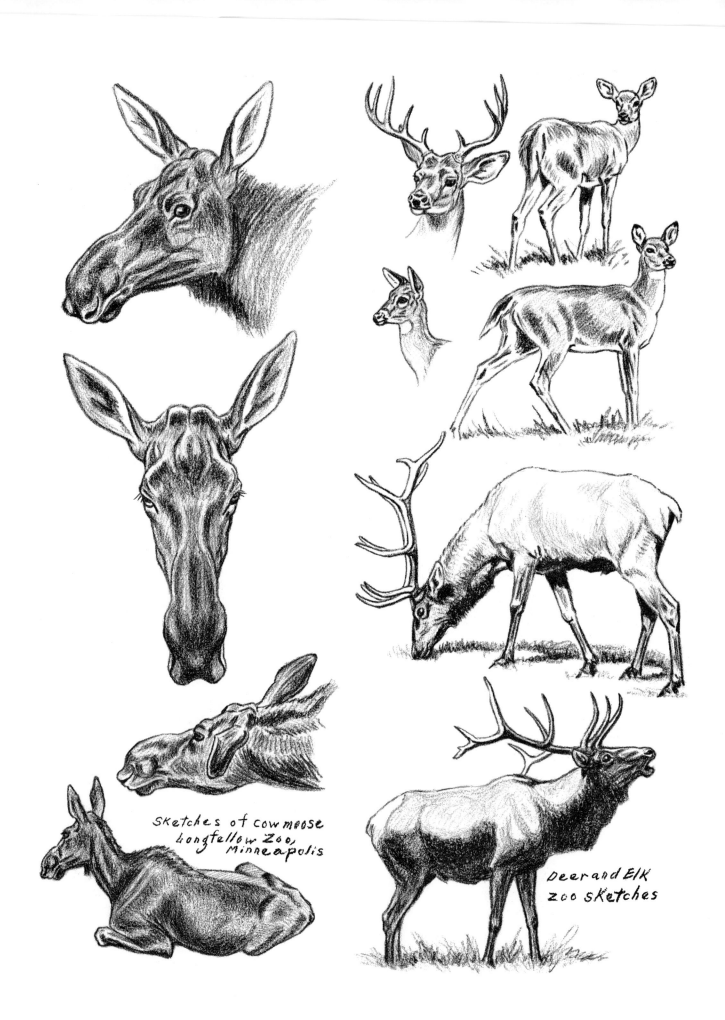

sketches of cow moose
Longfellow Zoo,
Minneapolis

Deer and Elk
zoo sketches

Chapter II

ANIMAL CHARACTER

IN THE FOREGOING chapter, your attention was called to certain differences in character between various kinds of animals. Familiarity with these differences is as essential in the drawing of animals as in the drawing of anything else from nature. If we refer to landscape painting, by way of comparison, every kind of tree in nature—the elm, the oak, the birch or the maple, for instance—has its own characteristics as compared to other trees. Any capable landscape painter is fully familiar with all such characteristics, and he portrays them in his work. And just as each species of tree has its own characteristics, individual specimens vary, too, since nature does not duplicate. In fact, much of the design interest in a good landscape painting often results from sympathetic representation of the individual characteristics of all the trees in a group, even though they be of the same kind.

The identical principle also holds true in figure drawing. A picture showing a group of people, in which each person looked exactly like the others, would certainly be lacking in character.

So, too, would a picture of animals in which all looked alike, for individual animals of any given species vary as much in appearance as do humans. This may not be apparent at first glance, but a careful study of individuals in a group will show that it is true.

A case to demonstrate this point came to my attention one day after watching some caged lions perform. There were four large, heavily-maned lions in the group and, as they went through their routine, the trainer called each by name. As he stepped from the cage, a lady asked him how he could tell which was which since, as she said, "one looked exactly like another." "They really don't look any more alike than people do," was the trainer's rejoinder, "and I know them by their faces." I, too, knew those lions by their faces, since I had sketched them frequently. Incidentally, that same trainer, in looking through my sketches, could name the animals, as you might name people on seeing their portraits.

KINDS OF CHARACTER

There are, therefore, two kinds of character to look for: the character of a type or species of animal, as it differs from other species, and the character of an individual animal that sets it apart from others of its own kind.

A timber wolf, for instance, differs considerably from a fox, though both belong to the wild dogs. The wolf has a heavier head and jaws; his ears are shorter in proportion to the size of his head, and the pupils of his eyes are round instead of elliptical. In comparison, the fox, with its elliptical pupils, has a more cat-like expression; its muzzle is slender and pointed, its ears large, its tail (or brush) much heavier and longer in proportion to its body. It is more daintily built than the wolf, for its prey is small, so it needs speed rather than brute strength. These are differences in construction between one kind and another within a general class. There are, of course, also the differences in color and markings. But, if you drew all your wolves to look alike and did this too with foxes, then a group of these in a picture would still be lacking in character.

INDIVIDUAL CHARACTER

To get character into a picture that shows a pack of wolves, each wolf must have its in-

dividual look. One will be heavier in the face than another. A second will have jaws that are more powerful. There will be variation in the slant of the eyes. Some will even look more savage than others, just as people vary in expression. When you painstakingly record such differences in your picture of a pack of wolves, you will obtain character. The same principle holds true whether you are painting dogs, cattle, horses, deer, or any other animals.

Once when I was sketching hunting dogs at a field trial, I asked one of the judges to tell me about the good qualities, from a show standpoint, of a dog that I had drawn. Looking at the sketch he remarked, "I see that you draw them as they are and do not fix up their bad points." He then explained that the flat forehead which I had recorded was a fault of that particular dog. If you sketch dogs for a time, you will soon realize that no two look alike, even though of the same breed and color.

Individual character can often be expressed by painstakingly portraying the contours of the head. Some animals have rounded heads, others angular. Often an animal will differ from its mates by having a rounded ridge to its muzzle as seen in profile, a more definite stop above the eyes, where forehead meets muzzle, or a deeper or more slender muzzle. Animals also vary in length of muzzle, size of nose and eyes, and even in length of ears. As with humans, they are heavy or slender in body, depending upon the individual, and they also vary in length of legs and tail.

Look for these things and don't try to correct them when you make your drawing— perhaps to conform to some ideal or some preconceived notion that you have in mind —but put down what you see. Later, as I have just implied, you will learn that among each kind there are what we might call good-looking individuals and ugly ones. Of course, you will choose the handsome ones when you want to show that kind of animal at its best. Opinions vary as to what constitutes good looks. As an old zoo-keeper once said to me, "Any animal is good-looking if

it is a perfect specimen of its kind, and that is true even of the crocodile and the hippopotamus."

In East Africa I once made a careful sketch of a kudu that I had obtained while hunting. Months later, when I showed my work to the director of the American Museum of Natural History, he remarked that there was too much curve on the head from the eyes to the nose. Now it happened that this kudu actually possessed a curved profile and I had succeeded in getting the character of that individual. The sketch is shown herewith—you will note the strong curve on the head. Another may have had a straight head-line in profile. To find out what the rule is among animals of one kind, it is necessary to draw many of them, or at least to observe in a comparative manner how individual specimens vary. Once you find out what the rule is, it is easy enough to recog-

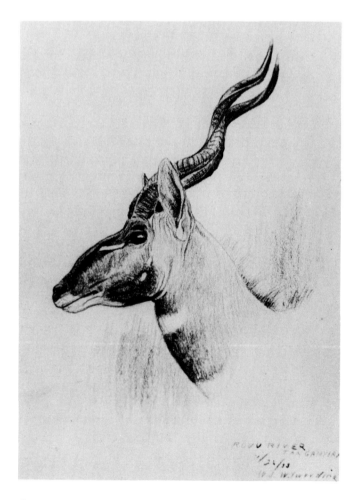

Lesser Kudu — Study from animal, Ruvu River, E. Africa

16

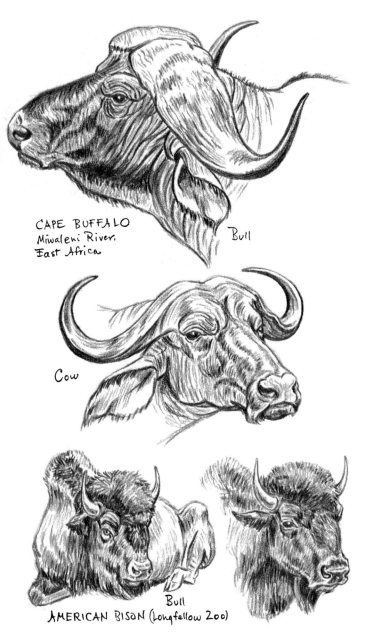

CAPE BUFFALO
Miwaleni River,
East Africa

Bull

Cow

Bull
AMERICAN BISON (Longfellow Zoo)

nize the individuals that are exceptions.

At another time I was sketching a bull elk in a zoo—the big, powerful leader of the herd—when an older artist who was accustomed to sketching these animals happened along. "That's a fine bull," he remarked, "but you must draw his legs a bit longer if you want to make him perfect, because his legs are abnormally short." I compared the bull with others that stood near and saw that my friend was right. In a case of this kind you must decide for yourself whether you wish to make the animal appear a perfect specimen or whether you just want to draw him as he is, preserving his individual

characteristics. Before you try to change him, be sure you know what a normal specimen should look like, or you may give him characteristics that he should not have.

At times you will find animals that are so ugly in appearance, compared to others of their kind, that you will not want to sketch them. This is often true of older animals that have long passed their prime. I recall a lion that once lived in the Bronx Zoo. He was very old and, though he had an exceptionally fine head and mane, his body was thin almost to the point of emaciation. It would not have been possible to make him look well without using considerable imagination. So it is usually best to pick for models only animals that are in their prime.

AGE AND SEX

As can be seen from the foregoing, the character of your model can also express its age. It can, in fact, express its sex. A tomcat does not look like a female, for its head is much fuller and usually its expression is more surly. The same is true of tigers, leopards, jaguars and pumas. Once you have learned how such animals appear, you can tell by a glance at their heads alone which are males and which are females, just as you can in the case of people. Keep all this in mind when you are after a sketch of an animal that will show whether it is male or female; young, half grown, fully grown; in the prime of life or in old age.

The two sketches of African buffaloes demonstrate this difference in character and sex between two animals of a kind. Above we have a study of the head of a bull, while the lower drawing is of a cow buffalo. Note the rounding of the muzzle of the bull, the wrinkled cheeks, dewlap, heavy neck and broad horns. In contrast, the cow is less wrinkled on the cheeks, has a muzzle without extensive curvature, and narrower horns set higher above the eyes. (These were drawn, incidentally, from specimens obtained in the hunting field in East Africa.)

Here, too, is a study of a bison bull, reclining, and the head of a cow bison; these are commonly called American buffalo. Note that the bull has a heavier head than the

17

cow, and thicker and longer hair on the forehead.

The accompanying sketch of a baboon, and the study of its head, not only depict the character of that particular species, but also demonstrate distinctly that this specimen is a female. Compared with other baboons shown in the sketches and studies in this book, you will note that this female has a more refined muzzle than have the old males—in fact, it displays none of their heaviness of head and jaw. Observe, too, how close together the eyes are set.

Very young meat-eating animals—lions, hyenas, wolves, etc.—have the fluffy rounded appearance common to all cubs. Later they get leggy. Still later they take on their more familiar, mature proportions. In their prime they are likely to be rather heavy of body, but, in old age, very thin, usually due to failing health or to lack of teeth, which prevents proper mastication. In nature, this thinness may result from scarcity of food, since they are not strong and quick enough to catch it. The reason is not our concern here; we are interested, however, in the fact that old animals are often thin and emaciated. Surely you would not want that kind of model if you were to picture the beast at its best. For the same reason, you would not choose a half-grown or immature beast. In short, when you wish to show animals to advantage, you will not only select models in their prime, but you will pick the big, heavy, powerful-appearing ones.

The accompanying study of a brindled gnu delineates the heavy appearance of the bull gnu in his prime. The separate sketch of the head is of the same animal, face view. Note how the ears come forward in front of the horns; the way the long hair grows on the face; the glands at the end of the tear pits, and the oddly shaped nose. (This, by the way, was drawn in the menagerie of Ringling Brothers Circus.)

Much of the above is, of course, rather obvious, as is the fact that a bull, whether it is a moose, elk, or one of our domestic cattle, could not be shown at its best unless it were drawn heavy of body, with a thick

neck. Draw him with slender, graceful appearance and his true character would be lost. The thick head and neck, long dewlap and heavy body of the domestic bull are the leading things that give him his characteristic appearance—that make him look like a bull. This, too, is true of the bulls of wild cattle, bison and buffaloes.

SEASONAL CHANGES

It is less obvious, perhaps, that the time of year has much to do with the characteristic appearance of an animal. A buck deer does not look the same in summer as in late fall. He looks thinner in the summer, for he *is* thinner—especially in the neck. Then,

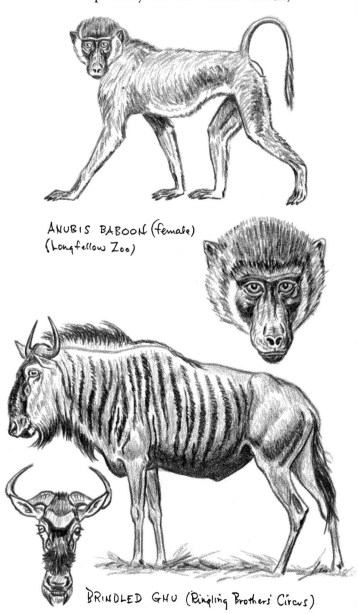

ANUBIS BABOON (female)
(Longfellow Zoo)

BRINDLED GNU (Ringling Brothers' Circus)

18

too, his coat is not as heavy as in the fall. In the late fall, male members of the deer family have heavy bullnecks, since the neck glands swell during the rutting season; their coats, too, are heavier. A sketch made of a buck in the spring or summer would therefore not do as a guide if you wished to represent this animal in a fall or winter setting. Even if you were to add fully-grown antlers to your sketch, the deer would still look wrong. It would be necessary to have every detail as it actually appears at the exact time of year in which you wish to show him.

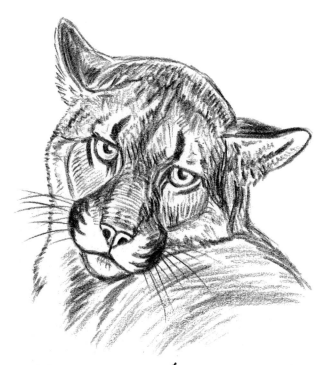

YOUNG PUMA (Mountain Lion)

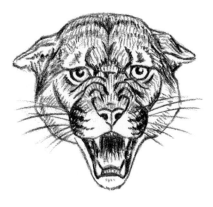

SNARLING PUMA

Remember, too, that young animals, such as fawns and calves of deer and the various kinds of antelope—as well as the young of zebras and other members of the horse family—have legs that are longer than their elders in proportion to the body. They are immature only in the size of the body, which is small in proportion to length of leg. This is because from the day they are born they must run with, and keep up with, the rest of the herd. Look for this characteristic in your young models and show it in your drawings. In sketching from life it is easy to compare leg length of young and older animals, as the young usually stand close to the mother.

Spring is a bad time for sketching northern animals, for once they have begun to shed their winter coats they look miserable and ragged. Who, as we have said, would want to picture animals at their worst?

VARIATIONS IN NATURE

So far, we have considered animal character only from the standpoint of appearance. Let me now remind you that each class of animals, as well as each individual animal within a class, also has a nature of its own; in this, animals vary as much as humans. Meat-eating animals, for example, are bold or fierce, for they live by killing other creatures. Some other species are more or less placid in nature; others actually timid—one thinks of a tiger as being fierce and of a gazelle as being timid. You must always try in a sketch to bring out this true nature of an animal. Look at the gazelle and attempt to discover for yourself just what it is that makes it look timid. And why does the tiger look fierce? Emphasize in every sketch what you learn by such investigation.

My three sketches of the heads of mountain lions were drawn to record the individual character of the animals, as well as their nature. The pair of pencil sketches depicting the same animal in two moods demonstrates that this beast is not a mild pet. I confess that I wanted a snarling picture for future reference, but I don't care to disclose how I made the animal snarl, lest

19

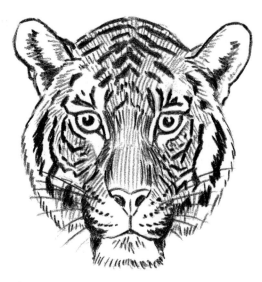

MALAY TIGER

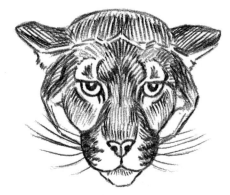

PUMA (Longfellow Zoo)

sharp below the upper eyelid, and have a crisp, white highlight, not too large, in the eye, just below that dark shadow, and your tiger will look fierce.

My sketch of a tiger's head (done, incidentally, from a tiger at a zoo) shows you how the light eyes, with dark pupils and the markings above the eyes, add to the fierce appearance of the tiger, even when its face is not wrinkled in a snarl.

As to the deer and gazelle, it is their large, dark eyes which give them their timid appearance. Here you must avoid sharp, scowling lines above the eyes. On the contrary, if you would make a bull look sufficiently untamed, you should show those sharp scowling lines, and also reveal a bit of the white of the eye. Here, too, a distended nostril would add to the wild appearance.

VARIATIONS IN MOOD

Aside from the inherent nature of the beast, there is likewise his mood of the moment to consider. A sleepy tiger might be sketched to look fierce and sleepy at the same time. Also, a mother tiger playing with her young should have none of the fierce expression that she might exhibit in attacking her prey, or in standing alert over her young to defend them from danger. Always study the mood of the beast you are drawing and try for it in your sketch. If you try hard enough, it will eventually be sure to show in your work.

My sketches herewith of heads of sleeping tigers reveal the sleepy mood of the beasts, and yet retain some of their fierce nature. Note how, in one of these, the tiger has opened its eyes momentarily and this was caught in the sketch.

CHARACTERISTIC POSE

In our previous chapter we touched upon characteristic pose, and this is something that you cannot neglect if you would have your animals look right. We pointed out that animals stand, walk about and lie down in a way that is characteristic of their kind and condition. Notice a horse in a pasture and you will see that when full-fed he stands with his neck almost in line with his back; no doubt he is sleeping in an erect position.

others try it and get into trouble. My model for the sketch which shows the ears laid back and mouth closed was growling in a surly manner, but not snarling. The top sketch, page 19, is of another and much younger animal; there is still some of the cub lingering in that expression.

Answering a question of a moment ago, you will find that much of the tiger's fierce appearance is brought out by his pale yellow eyes, with their round black pupils, and by the stripes above his eyes. In drawing the tiger, keep the shadow dark and rather

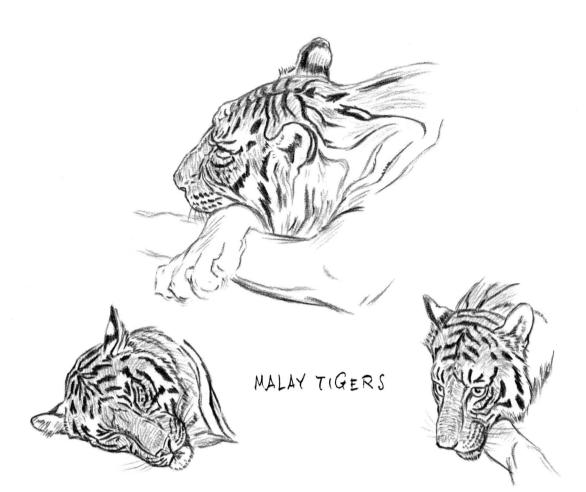

MALAY TIGERS

Awakened and on the alert he lifts his head, and his neck then forms an angle with his back. Did you ever see a cow lift its head in that same fashion? Cows can raise the head a bit, but no cow swings its neck up at a sharp angle with its shoulders, nor do wild cattle such as buffaloes and bison; their neck muscles are not made for this. Don't picture animals in positions that they cannot assume, but study the pose of each animal before you put it on paper.

Deer often hold the head high. So do antelope, if on the alert, but when walking along they usually carry the head much lower. This, too, is true of sheep, whether wild or domestic.

So, to repeat, keep your eyes and mind open and observe these things for yourself, remembering that the pose can express both character and mood. If further illustration is needed, think of the domestic cat as it slinks after some bird or squirrel, crouched low, with head down and ears forward, the tail held close to the ground and with the end just twitching a bit. That is its characteristic pose when stalking. When just loafing around, the same cat holds its tail upright.

This brings us to the point that you can often determine an animal's mood by the way it manages its tail. A lion, furious, and ready to charge, will lash its tail wildly from side to side. In hunting, it keeps the tail low like other cats. When walking, lions, tigers and leopards hold the tail down instead of aloft like the domestic cat. Similarly, domestic dogs usually carry the tail high, while the wild ones, like wolves and foxes, hold the tail low. The rhinoceros has its tail up when running, and so does the wart-hog of Africa. The tail of a buffalo bull will go up when danger is scented. The white-tail deer usually leaves its tail down when walking along unworried; surprised

21

and on the jump, it jauntily bears it aloft. Frequently, when suddenly surprised, a deer will instantaneously erect its tail before it starts jumping.

When you draw an animal reclining, make it look relaxed and at rest. By the same token, when you stand an animal on its feet, be sure to have it look as if its legs were supporting its weight. A big bull should have its legs planted solidly on the ground to support its body. Draw it to appear as if it weighed almost a ton and you will have gone a long way toward correctly depicting it.

The accompanying sketches of attitudes of an African buffalo bull were drawn (in the Bronx Park Zoo, New York) to show characteristic appearance and poses. Note the cattle-like attitudes and general construction. Buffaloes, being wild cattle, have much in common with domestic cattle in both appearance and pose.

It would take volumes to describe the characteristic poses and appearances of all animals, and I have only pointed the way for you. Keep your eyes open, as I have repeatedly said, and your powers of observation will sharpen as you proceed with your sketching. Sketch what you see, and write down notes on what you have observed. Sometimes my sketches are entirely surrounded with scribbled notes. Good as a trained memory can become, don't place too much confidence in it. It may fail you!

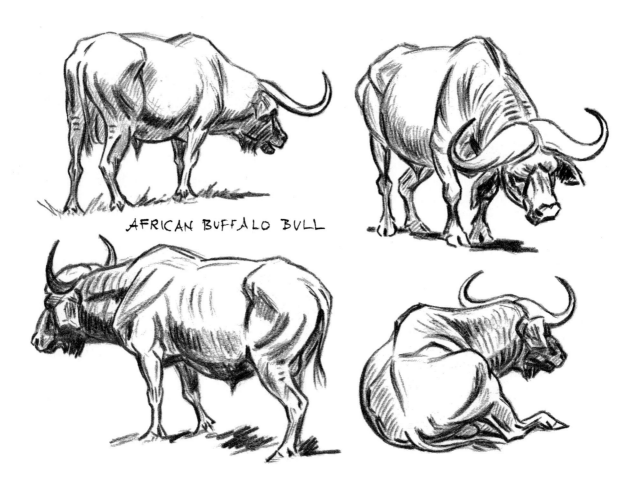

AFRICAN BUFFALO BULL

Chapter III

FEATURES AND OTHER DETAILS

JUST AS IT IS IMPOSSIBLE to draw the faces of people correctly without an adequate knowledge of the construction of the human features, or a good figure of a person without an understanding of the forms of hands and feet, so the correct construction of features and various other details is necessary in the drawing of animals.

Obviously a dog picture with badly drawn eyes, nose and ears deserves no praise, nor can it look right if the feet have been incapably delineated. I have frequently criticized students' drawings of horses showing bodies correct in general proportion and with good heads, but exhibiting badly drawn legs and feet. There is little excuse for this, as the legs and feet of an animal are no more

difficult to draw than any other part; it is just a matter of learning *how* they look and of taking the pains to draw them *as* they look. If you have difficulty picturing legs and feet—or any other such details for that matter—concentrate on them for a while. It will save you time in the end.

When I first began sketching animals from life, I found that it was not hard to indicate quickly the action of the animal, and even the curves of the body. I could also suggest the general head construction without trouble. However, I discovered that, if I kept my mind on the small details of nose, eyes, ears and feet, my model might move before I had these completed; so I soon learned that it was better to catch the

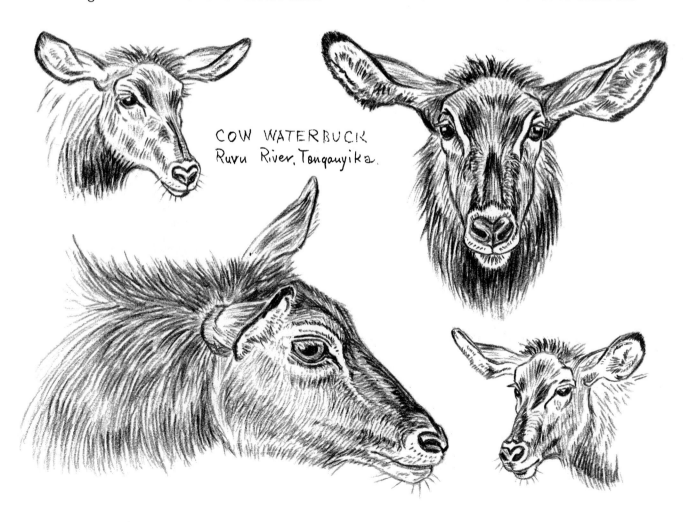

COW WATERBUCK
Ruvu River, Tanganyika.

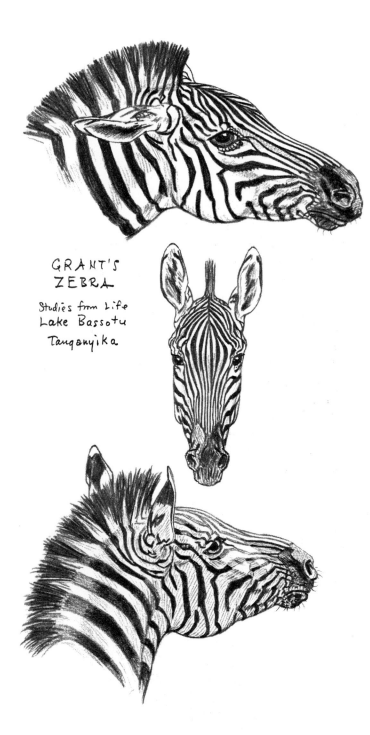

GRANT'S
ZEBRA

Studies from Life
Lake Bassotu
Tanganyika

drew these as the beasts lay resting or sleeping, sketching them again and again in many positions, until I really knew their construction. Similarly, I drew the feet of horses, deer and other animals from life, until I could almost draw them blindfolded. Such practice is excellent preparation for one's later sketching, because he can then look quickly at any animal, see in what position it holds its feet, and draw them without continually looking from sketch to animal for reference.

FEATURES OF THE HEAD

This same thing is true of the head. Once you have faithfully and repeatedly copied the features of the head from life until you know their construction, it becomes much easier forever after to draw that animal's head.

In portraying the features of animals, you must remember that when you turn from one species to another you have something entirely different to interpret.

EARS

Don't make the mistake of thinking that all animals have pointed ears. Many students fall into this error, and I have seen animals drawn with their ears pointed when they should have been rounded. There are just as many animals with rounded ears as with pointed ones. Even if ears are pointed, they should not be drawn like two spear points, but should have the correct form, according to their species.

The pointed ear of the horse, for instance, has a rounded base, somewhat like a cylinder that has been opened at the top and sharpened. The ear folds together in a rounded form at the base and then becomes flat near the tip, though the back is rounded. When the horse stands facing you with ears forward, the tips do not point straight up, but inward a bit, and the outer contours of the ears are curved inward. To get character in the drawing of the horse, these must be drawn correctly.

Also, if you will look at the ears of the cow, you will see that they are not pointed at all, and, instead of being set high on the head, as is the case with the horse, they are

leading elements of any animal hastily, whatever its pose, and then, if it moved, and I wanted more information for a more complete picture, I could sketch the features separately regardless of the position in which the animal happened to be.

FEET

To learn how the feet of lions looked, I

set low on each side of the head, showing beneath the horns (if the cow is horned). Cows' ears are broad and thickly covered with hair.

Many dogs have ears that are broad and rounded at the ends. The ears of shepherd dogs come more nearly to a point, though the point is not sharp, but rounded at the very tip. In this respect they look more like the ears of wolves and foxes, all of which have pointed ears; but, again, the points are not sharp like a pencil point.

The ears of the cat are rounded at the tip. In studying the large cat animals, such as the tiger, lion and leopard, you will note that their ears, in front view, are rounded in appearance. These same ears seen in side view sometimes appear a bit pointed, because you are looking at the edge. Observe and draw ears exactly as they appear in the animal before you.

I have often seen drawings picturing deer with their ears pointed, although deer really have broad, rather oval-shaped ears that are rounded at the tip. This is true of most members of the deer family, which includes moose and caribou. In this connection, it might be well to remind the sketcher that size must also be taken into consideration. The moose, for instance, has large ears, and the ears of the deer are of good size, while those of the caribou are small. The caribou would not look right if drawn with large ears.

The greatest variation in ears may be found among the different members of the antelope family. The African kudu has large, broad ears, rounded at the tip, while the big, cow-like eland possesses pointed ears. Gazelles have pointed ears, too, as do the gnu and the various kinds of hartebeest, but the impalla has ears like our deer. The ears of some species of oryx are pointed, while those of the waterbucks are rather large, and rounded at the tip. Our American pronghorn antelope has pointed ears, in which it differs from every other antlered and horned animal on our continent, with the sole exception of the mountain goat.

Now, here is something to remember: If

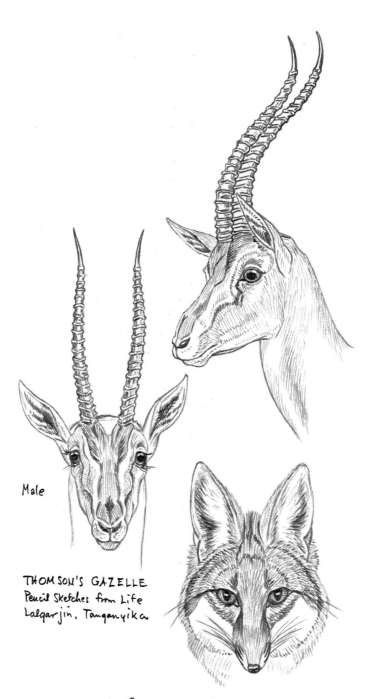

Male

THOMSON'S GAZELLE
Pencil Sketches from Life
Lalgarjin, Tanganyika

GRAY FOX - Crayon Sketch
-Longfellow Gardens, Minneapolis

you learn how to draw the ears of a gazelle correctly, you can be pretty sure that you will have little trouble drawing ears of other horned animals so long as these ears are slender and pointed in construction, since all such ears follow similar construction. Also, if you can draw the ears of our deer, you will have little trouble with the ears of the

25

moose, since the construction is the same. You will find, too, that other horned animals with similarly-shaped ears have like ear construction. For instance, there is no vast difference between the construction of the ear of our deer and that of the African waterbuck, and if you can draw the ears of one species of hartebeest, you will have no trouble with the ears of other members of this family. The same is true of the various waterbucks and kudus.

But you may run into difficulty in the horse family. Though the wild horses of Asia, like our own domestic horses, have pointed ears, the striped wild horses of Africa exhibit broad ears that are rounded at the tip. Zebras do not possess pointed ears, though they may appear so in some views, as shown in my sketch. This is especially evident in the case of the Grevy's or Abyssinian zebra, which has large, oval-shaped ears, very furry.

Most wild members of the dog family, which includes the wolves, coyotes, jackals and foxes, have pointed ears, but some have bat-like ones, and it may be that our hunting dogs, with their large, rounded ears, that would look bat-like if they stood erect, may have descended from some wild hunting dog with ears just like that. There is such a dog in Africa, called the wild dog, hunting dog, or hyena-dog, and it has large, rounded, bat ears.

Besides noting the correct form of the ear, observe how it is set on the head. On some animals it is high and on others low. Most horned animals have ears low enough to permit their free movement below the horns. On no animal are they set right on top of the head, though in the case of dogs, cats, and their wild relatives, the inner edge is on top of the head and has its fastening there. The base of the ear is on the side, however.

Note, too, that many ears have a definite base—usually a rounded projection from the head, formed by a stiff cartilage lining—which is most noticeable on deer, antelope and other horned animals. One does not see it on the elephant. On dogs, and numerous other animals, this rounded base becomes a part of the general ear construction and does not have the appearance of a short handle, as on deer and some antelope.

If I seem to overemphasize the matter of ears, it is because these features can add much to the appearance of an animal, just as well-drawn ears can play an important part in human portraiture. Give your animals good ears and they will be better-looking for it.

The accompanying studies picture the varied ear construction of different animals. Note the big, rounded ears on the cow waterbuck. The ears of most waterbuck are large, but those seen in the Ruvu River country in northern Tanganyika are actually huge. Their inner surfaces are covered rather thickly with hair. My two biggest drawings were done as careful studies to show the construction of ears, eyes and nose. The smaller sketches, in pencil, illustrate the ears in different views. See page 23.

Compare the ears and nose of the waterbuck with those of the male gazelle. Note that the gazelle has pointed ears that are less hairy on the inside. The black, shaded areas within the gazelle's ears are bare.

Again, compare the ears of the waterbuck and the gazelle with those of the zebra. Two of these studies picture the zebra in profile and three-quarter profile, where the ears appear pointed, because viewed from the side. In the sketch of the face view, the ears look broad and not nearly as pointed at the tip. Also, in these various sketches, compare the nose of the zebra with the nose of the gazelle and waterbuck.

All these studies of the waterbuck, gazelle and zebra were made directly from the animals in East Africa, while that of the head of a gray fox was done in a zoo. Since the fox was apparently interested in watching me draw, it posed perfectly. Note in this drawing the large ears and eyes, and the small nose. While the ears of the fox are pointed, they are not sharp at the tip, but rounded.

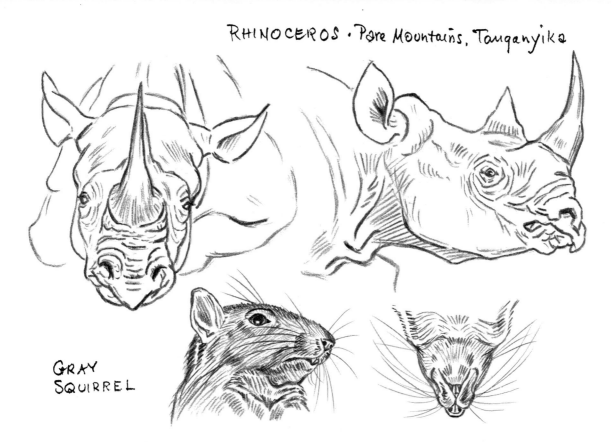

GRAY SQUIRREL

NOSES

Noses of animals vary greatly, perhaps more than ears. By the nose, I do not mean that long forward projection of the head that is called the muzzle, but the end of the muzzle, where the nostrils are. You will find in sketching animals that there is considerable variation even among animals that otherwise look alike. The deer, for instance, has a nose somewhat like a cow's, though not as broad. There is a naked patch at the end of the muzzle, and the nostrils are set at each side of this patch, near the top. Some antelope exhibit this naked patch; others reveal a narrow naked strip between the nostrils. Still others have just a line at that point, like a parting of the hair. Gnus possess broad nostrils, with a sort of rounded lid over each. This peculiar formation adds much to the gnu's odd appearance.

The nose of the cat varies considerably from that of the dog. The nose of the bear is more hog-like. The lion, though a cat animal, has a large nose compared to the domestic cat. The nostrils are also relatively larger. The noses of goats and sheep possess marked similarity, and gazelles, though classed with antelope, have noses much like those of goats. The nose of the horse is quite different from that of the cow. The moose is a deer, yet its nose does not resemble those of other deer.

Rodents, such as squirrels, mice and rabbits, have small noses with similar construction. Noses of monkeys and apes vary— some have a broad and others a narrow septum. They also differ in size of nostrils. The noses of baboons are rather hog-like.

Note in my pencil drawings of the heads of gray squirrels the construction of ears, nose and mouth. These sketches were made directly from the squirrels. The careful drawing of the features adds character.

The two pencil sketches of the rhinoceros were also drawn directly from the animal, in East Africa. Observe the oddly-shaped ears and how they are fastened to the rear top of the head. Study especially the construction of the nose, and how the eye is very small for the size of the head, and set below the rear horn. Also note the construction of the mouth, and the manner in which the tip of the upper lip overlaps the lower.

The sketch of the baboon shows the long muzzle with the nostrils at the end. The eyes are set close together. See page 28.

The two wart-hog drawings serve to express the snout construction of this beast.

27

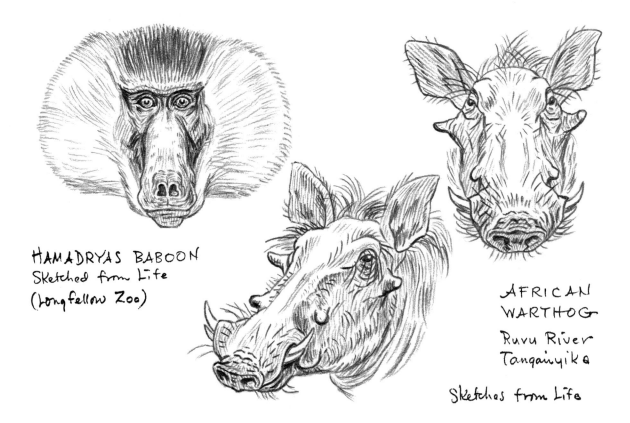

HAMADRYAS BABOON
Sketched from Life
(Longfellow Zoo)

AFRICAN
WARTHOG

Ruvu River
Tanganyika

Sketches from Life

EYES

Eyes also play an important part in the drawing of animals, and the way you draw them may make the beast look alive or not, depending upon how truly you handle them. There is really no variation in the shape of eyes, since all are globular, but they do vary greatly in size and color, as well as in their setting in the heads of different species.

The eyes of many an animal are set on the sides of the head, but turning inward toward the front, so the animal can see straight ahead, as well as at each side. This is particularly true of animals that are preyed upon by others, including such species as deer, antelope, sheep and goats. It is also the case with horses. The meat-eaters as a rule have their eyes placed to look forward, as do the monkeys and apes. The eyes of small animals, like squirrels, rabbits, etc., are on the sides of the head near the top of the skull; no doubt these creatures can see sideways, forward, backward, and upward without difficulty, since their enemies might come from any of these directions.

Some animals have a prominent tear-pit at the inside corner of the eye, and others have none. If you see this, draw it correctly.

Returning to the matter of the shape of eyes, study how the pupils vary in form in different animals. Deer and antelope, for instance, have long, oval pupils, set horizontally in the eye. Dogs have round pupils, as have wolves; but the pupils of foxes are of the elliptical type usually known as "slit" pupils. Among the cat animals, the larger ones, such as lions, leopards and tigers, have round pupils, while many of the smaller ones, including our domestic cat, have slit pupils which open up to appear round at night. The slit pupil adds character to these smaller cats, just as the round pupil must be employed to make the yellow eyes of lions, tigers and leopards look correct.

In large sketches of the heads of animals, particular attention should be paid to the correct curve, and other characteristics, of the lower eyelid. This lid has thickness, it is moist, and it has a definite highlight; it is not, in short, just a black line under the eye. Remember also that the eyeball is rounded, and draw it to appear round, with shading, as on a globe, and with a definite highlight, which should be small and sharply indicated. Large white highlights in eyes take away life and make the eyes look blinded. Small sharp highlights add life. See that they are

placed in proper relation to the source of light.

Remember, too, that whereas live eyes reflect light, glass eyes on mounted animals reflect objects, such as windows, or anything else near by. Which reminds me of a story told me by the cartoonist Frank Wing. A friend of his was exhibiting his small daughter, who had recently had a blinded eye replaced with a glass one. Frank was asked to notice how natural the glass eye appeared. He looked, and what he saw in the glass eye was the reflection of a brick house and a windmill! So don't make the eyes of your animals look like glass eyes, and don't use the glass eyes of mounted animals as models for your work. If you draw eyes from life just as you see them, watching the lights and shadows, and giving these their proper place and size, the eyes will seem natural.

Some eyes will look small and beady; others big and liquid. The light yellow eyes of the large cat animals, with their rounded, black pupils, have a tendency to stare, but that is a natural characteristic and it is proper to draw them that way. Note how the eyes of antelope, deer and cattle seem to bulge forth from their eyelids.

MOUTHS

In drawing the mouths of animals, observe that in most species the upper lips have a good thickness, and overlap the lower jaw. Also notice how far back the mouth opening extends. On some animals with long jaws, like foxes, coyotes and jackals, this opening extends beyond the eyes; but this is not the case with deer, antelope and other ruminants. In the case of drawings of dogs showing the mouth open, the serrated edge of the lower lip should be indicated.

Also, when drawing dog or cat animals with open mouths, strive for the correct placement of the teeth, and especially for the proper relationship (in both placement and size) of the canine teeth to the cutting teeth. In front view, it is a good idea to count the teeth that show, and draw the correct number. In most meat-eaters there are two canines in each jaw, set at either side of six small cutting teeth.

Returning to the matter of highlights, these appear not only on the eyes and eyelids, as just discussed, but also on the nose and any lip that shows. The correct indication of these will do much to add life and give character to your drawing. Such areas, being moist, reflect light readily.

MORE ABOUT FEET

The feet of animals vary according to their intended use — something to keep in mind when drawing them. Cat animals catch their prey with their forepaws, which are therefore broad and well equipped with sharp claws; all five toes are arranged to present a good batting arrangement. In contrast, the hind feet are smaller, and, with rare exceptions, have only four toes. Once in a while some freak among domestic cats

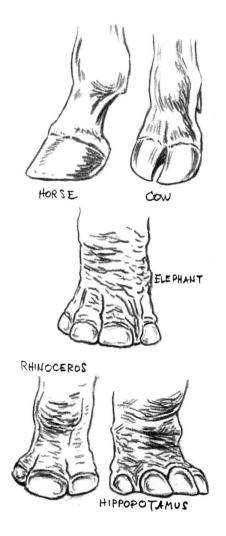

HORSE COW

ELEPHANT

RHINOCEROS

HIPPOPOTAMUS

29

may have more, but you should not draw freaks. Remember, too, that the claws show only when cats actually distend them to scratch, or to catch something. You do not see the claws when the cat is at rest, and obviously they should not be drawn when they do not show. A lion lying down should not be pictured with feet studded with long, curved claws.

Most dogs have five toes on the forefeet, the fifth toe being set high on the inside. The normal number of toes for the hindfeet is four, though a fifth toe, set high, is sometimes seen. All toes are clawed, and the claws are constantly exposed. On the wild dogs, wolves, jackals and foxes, this same arrangement is customary, so if you learn the foot construction of one dog you will have a good foundation for drawing the feet of other dogs, domestic and wild.

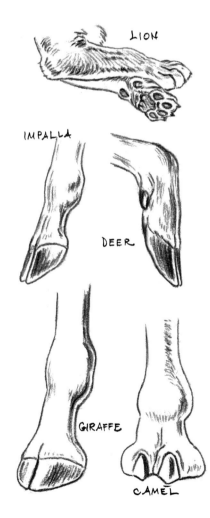

Most split-hoofed animals, such as deer, antelope, goats, sheep, pigs and cattle, have feet which are much alike. Cattle, both domestic and wild, have broader and more rounded hoofs than do deer and antelope. Most of these split-hoofed animals have two smaller hoofs set a bit higher on the back of the foot at each side, but all do not. Among the exceptions are the impalla of Africa and the pronghorn antelope of America, which have but two hoofs on each foot and not four, the side hoofs being missing. Don't draw side hoofs on an animal just because you think they should be there, but look at the animal and see for yourself whether or not they are present.

The giraffe is a split-hoofed animal without side hoofs. Camels, and their American cousins, the alpacas and llamas (not to mention their wild relatives), have no side hoofs, and the hoofs themselves are rather small, looking more like heavy nails set in front of the two toes.

The rhinoceros has but three toes on each foot, while the hippopotamus has four. On elephants there are usually five toes in front and four behind, but this is not a fixed law, so draw the number you see. As a rule, since the elephant will be pictured in side and three-quarter views, as well as in front view, the toes will not all show in any one drawing. Draw only those that do.

Horses, donkeys and zebras have similar feet with a single hoof, not split. Take pains to draw the proper shape of the hoof, as this will do much toward expressing the appearance of these animals. Usually, horses have shorter and broader hoofs than donkeys and zebras.

It will pay you to draw the feet of many kinds of animals, so you will get to know their construction. If birds interest you, then do the same with them, since feet, bills and wings vary greatly in birds, and a knowledge of their construction is necessary to correct depiction. With the details of construction well in mind, your sketching of the whole animal or bird will be much easier and faster.

Chapter IV

THE MAKING OF A STUDY

So FAR, we have dealt primarily with the *sketching* of animals. Once you have had broad experience in sketching not only attitudes, but also such details as features and feet, you should be well prepared to try *studying* any chosen animal. A sketch differs from a study in that it is a quickly drawn note, a study being exactly what its name implies — a carefully worked-out drawing done in greater detail.

Artists make sketches as notes. Usually they make studies so they can employ them as preliminaries in the painting of finished pictures. Often a sketch has only a limited use in this connection, for although it will serve to show the natural attitude of an animal, there is not enough information in the average sketch to be of much help. Therefore studies are necessary.

This is particularly true in the field of animal painting. Whereas the landscape artist can go outdoors and paint his picture from nature without the aid of studies, and the figure artist can likewise paint directly from living models, the animal artist, on the contrary, cannot take an elephant into his studio to use as a living model, so he must get his information at the zoo, or in the field or forest, where he will make many sketches and careful studies, together with color notes, in order to record all the information he will later require.

Let the beginner bear in mind that although the painter of animals and birds can do wonders in developing his memory, he is no superman who can trot out at will from his store of mental impressions any animal or bird and put it down on paper or canvas in correct form and detail. If his work has merit, he has learned how to handle the tools of his profession, but he must have adequate models for his serious work. It is of course possible that, if he has worked long enough at sketching from life, he may have accumulated a collection of sketches and studies of many animals to which he can refer when preparing his paintings, but any subject that he has not sketched before will require a search for that particular bird or beast, so that sketches and studies may be obtained.

By way of exemplification, I was once called upon by an editor for a painting of a certain species of bird of paradise. He wanted it for the cover of a magazine, and it was to be accurate and in full color. Now, though I had painted many birds, the bird of paradise was not among these, and I cannot trot birds of paradise out of my head any more than the next man. I had to learn what that bird looked like before I could paint it. Fortunately I lived near New York and there was a good collection of these birds at the Bronx Zoo. After some hours of sketching in color and of making notes, I knew the bird, and went back to my studio and painted it.

Let me reiterate that you can draw or paint a thing well only if you know it well. You can come to know it well only by seeking it out and studying it. If I seem to overemphasize this truth, it is merely because it is so important to the artist. Yet many beginners apparently believe that, in some magical way, their hands will put down the correct forms for them, even though their eyes have not beheld those forms before!

Even if you could take a dog or cat into the studio when you are painting—and this is the thing to do when you are painting a

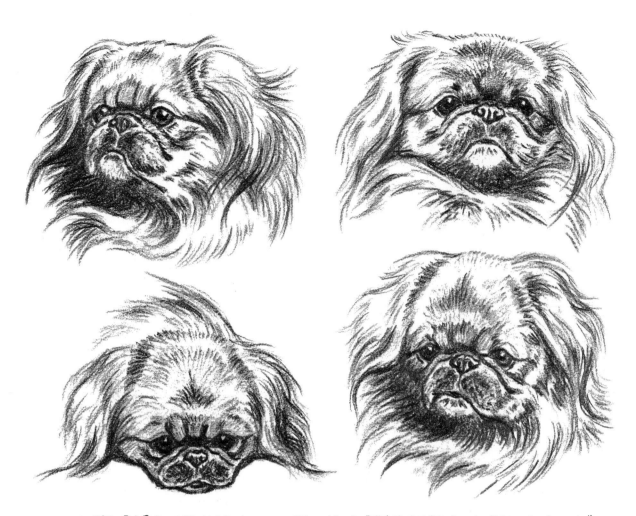

STUDIES OF MRS. WILWERDING'S PEKINESE DOG, "CHIN-CHIN."

dog or a cat—you would still have trouble in making a satisfying representation of your animal if you had not previously made careful sketches of attitudes and painstaking studies of features and other characteristics. This is because no animal will pose for you in the position you want—you have to get most of your information in advance, and simply have the animal on hand for reference as to color, light and shadow, textures, and the like.

The making of a study is therefore in the nature of a necessity for the painter of animals. It takes patience, but, without patience, the artist had better turn his attention to the painting of fruit on a plate. I cannot stress too often that anyone who deals with animals *must* have patience as a primary attribute.

In the making of studies, it is well to bear in mind the advice offered in the first chapter. Know what you want to paint and stick to your plan. If your desire is to paint dogs, then make sketches and studies of dogs. Since dogs may be found almost anywhere, this should be easy. It entails none of the complications that might arise should you wish to paint birds or wild animals.

STUDIES OF DOGS

Suppose we consider the making of dog studies; this is a good starting point for you, if a typical student. First of all, you will have made sketches of dogs of all kinds in numerous attitudes. You will also have made sketches of features, legs, and feet. If these have been done with care, they will be somewhat in the nature of studies.

Let us imagine that you have now de-

cided to attempt a painstaking study of the head of a certain dog. With your model before you, and a large sketching block at hand on which to work, you begin the head in the position in which the dog is holding it. As he moves, you start a second drawing next to the first. If he again shifts his head, still another drawing is commenced. Each of these should be of good size, so the features can be drawn in detail. It is evident that this is practically a repetition of the advice earlier given you on sketching animals in various positions, excepting for the fact that you are now going to make finished studies rather than sketches. Therefore, don't go at your task with the expectation of finishing it in just a few minutes, but plan to take hours. Work from one drawing to another as the dog shifts its head, and keep at it until every one of those heads is finished in detail, with the light and shadow, and textures— in short, every characteristic of the subject —correctly and adequately recorded.

In making such studies as these, you must not resort to guessing. What is meant by this is that, if you are working on one pose and the dog happens to swing his head, you must not continue with the thing you are drawing at the moment, if you cannot see it plainly and in proper position, but you must turn to another study until the dog has again shifted to his former position.

With patience, working thus from one study to another as opportunity affords, you should be able to finish such a series of studies in a few hours. You will then have recorded definite facts that you can use for reference whenever you choose. You will also *know* how that dog's head really looks. If you do the same thing with the feet and like details and then carry forward a similar series of drawings of the whole dog, you can turn to your easel at any time and paint that dog, for there will be little left to your imagination. And, better still, much of what you have put on paper will remain in your mind.

Should you have trouble with some particular feature of an animal, then make a series of studies of just that one feature. We will say that you want to master the nose construction better. Very well; begin your investigation as before, by commencing a drawing of the nose in the position in which you first see it. As the animal turns, start another drawing and still another until you have a series of them all over the paper, recording the nose in various positions. These studies you will finish in detail, one by one. I venture to predict that if you do this faithfully, you will not even have to refer to the studies when later making your painting, for the forms will be indelibly impressed in your memory.

THE USE OF PHOTOGRAPHS

You might ask, why waste all this time, when a camera can record these various ap-

BLESBOK — Studies from Life

pearances more quickly? Some artists do use the camera, but the camera cannot impress the form on one's mind; it only impresses it on the film. Such artists are therefore tied to their photographs forever. Should they lose them, they, too, would be lost.

This reminds me of the manufacturer who wanted to employ a superintendent to run his factory. He conducted an applicant through the plant, showing him many things and asking him questions about this process and that, to find out what the man knew. Constantly, in answering these questions, the applicant referred to a notebook. When the tour of the factory was over, the manufacturer decided not to hire this prospective employee. "If that man ever lost his notebook," he remarked, "he would be useless to me."

You won't be too much handicapped if you do lose your notebook if you have repeatedly made sketches and studies of animals until you know how they look, for the essence of the information will remain in your head.

Photographs, in other words, may be useful—extremely so—in obtaining *extra* information about animals for attitudes and detail, and we offer no argument against such reference, but if you develop the habit of relying on photographs entirely, you will always be tied to the attitudes shown in them, and so cannot place your subjects in any position at will as good animal painters must be able to do. In this connection, I recall the remarks of a famous painter of animals who said that when he wanted to draw an animal in a certain position he first sketched it from memory in that position, and then, with the animal before him, he finished this drawing by looking at the animal, to be sure everything was correct in his picture. It wouldn't have been possible for him to draw the animal in the desired position had he not, through previous experience in sketching, learned how.

To exemplify this thought still further, let us assume that you want a picture of a lion walking. If you obtain it with the camera, you will quite possibly have to include the bars of the cage in front of the lion, and these will photograph much larger than they appear to the eye as you glance through them. In other words, your two eyes will see much more of that lion between the bars than will the one eye of the camera. But, if you have drawn that animal again and again until you know its every detail, you can draw him from memory in walking attitude and simply refer to the living lion for correct construction.

Another trick that the camera can play on you has to do with perspective. The camera, having but one eye, will see the animal in much more acute perspective than will you with your two eyes. You can readily prove

STUDIES OF BLESBOK
(From Life - Ringling Brothers' Circus)

this. Make a photograph of a dog, face view, with nose pointed right at you. After you have the print, hold it before you and look at the dog in the same position. You will find that your print will show a dog with a much larger nose in proportion to its head than you see with your two eyes, as your eyes are able to look *around* that nose and see more of the head, while the camera's one eye looks *at* the nose and sees less of the head.

I once took a photographic close-up of an elephant, head on. It came out in excellent detail, portraying that animal with every wrinkle on his trunk and hide, but the head was enormous and the hind legs much too small for the forelegs, for the camera had seen these in too sharp perspective, with resulting distortion. A sketch made of the same animal, of course, showed it as the eyes saw it, without the disproportion of head and body, fore and rear legs.

Many excellent photographs have been taken of animals by expert photographers—photographs which *do* show the animals truly—but be sure you are an expert if you want either to take or use photographs as models.

Despite these distortions and other faults, photography's virtues are many. You may be sure that if the old masters had lived in an age when there were cameras they would have utilized them to the fullest advantage. If you are to do so, you should not only familiarize yourself with the handling of a camera, but it will pay you to learn to take really good pictures. In order to take successful animal photographs, you must use a camera with a superior lens and a fast shutter. (The shutter, in order to stop motion, should not be slower than 1/200 of a second.) You should also employ fast film.

If your photographs are to be of maximum advantage, you will want to have many of them enlarged. In photos where the animals appear small, with too much background around them, have the animals alone enlarged.

Once you have mastered the manipulation of your camera, you can put it to many important uses. For instance, you will find it a time-saver in getting action pictures of animals. Also, after you have made a color sketch of a landscape, it would be a waste of time to draw pictures of trees for their detailed characteristics, to help you with the final painting. A camera will snap many trees for you very quickly, and you will then have your color sketch and the contours of the trees you need for your picture. Likewise, the camera is convenient in taking direct side-view pictures of animals, which will give you their correct proportions. Remember, when photographing an animal in direct front view or three-quarter view, not to get too close or there will be distortion such as we mentioned above, the head appearing too large for the forequarters, and the forequarters too large for the hindquarters. Obviously, if you attempted to use a photo of that kind for your work, your entire result would be out of proportion.

In short, yours is the dual task of learning to manipulate your camera equipment and of coming to understand both the virtues and faults of photography as it relates to your work as an animal artist, and how to take advantage of the former while avoiding or overcoming the latter. It is especially unfortunate that beginners — and sometimes others — so often hold the erroneous impression that the camera cannot lie. I hope I have made plain that it can lie, especially in that its single lens sees things quite differently from the two eyes of the normal human.

It is also regrettable that some people seem to think that it is quite an art merely to be able to copy faithfully the photograph of an animal. Actually there is little merit to this; often children of twelve can do it but this ability doesn't make animal artists of them.

FILING YOUR REFERENCE MATERIAL

I cannot overstress the importance of filing all reference material properly. A portfolio filled with hundreds of mixed-up sketches and studies is a nuisance. A bit of system in the studio is as useful as system in a business office. For facility in working, I

file all my own sketches and studies carefully, so they may be found with ease. I keep those of a kind in one envelope, a note on the flap indicating its contents. These envelopes are filed alphabetically; squirrels under S, tigers under T, etc. Photographic prints and negatives I file with equal care.

You, too, would be wise to start a file immediately. Again and again in the middle of a painting you may want a study or a photograph that will help you with something on which you are working, and then a carefully filed collection may prove most helpful.

AT THE MENAGERIE AND ZOO

Many of the studies shown in this book were done from living animals in zoological gardens and circus menageries. Since such animals are confined, and their movements therefore restricted, it is easy enough for one to make finished studies of any desired animal by sketching it first in some pose it assumes, next amplifying this sketch into a study by carefully noting in the subject the details of head, legs and other parts and then drawing these fully and precisely. The drawings of the blesbok shown herewith were made in this manner, not only in various poses, but also in full color. When I had finished them, I had that blesbok in various positions for a picture, and I also knew exactly how its colors and markings appeared in these positions. I combined them in one painting as a group of blesbok, and simply had to refer to my studies as I proceeded.

Sometimes, in working at the zoo, you may find it impossible to finish your sketches and studies before you leave. In such a case, save your unfinished ones, and take them back to the zoo another day. If you are lucky, you may then discover the animals in the positions you want, and you can finish your interrupted work.

MUSCLES

In your observation of living creatures at the zoo, don't overlook the muscles, for, as I shall stress in Chapter VI, dealing with anatomy, nothing can take the place of this detailed observation of all such things as affect external appearances. Watch the play of muscles under the skins of short-haired animals, especially on the shoulders and hindquarters. Then in your studies and sketches show the principal ones by employing the light and shadow as you see it on the animal before you. Also note the long muscles, ending in tendons, on the forelegs, and indicate these. Carefully observe the construction of the hock of the hind leg—the way the heavy tendon is fastened on the back—and put this into your study. Notice, when the weight shifts from one foot to the other, that the muscles change, and the shoulders move up or down. When an animal takes the weight off a front foot, that shoulder is lowered, while the one with the weight on it has the shoulder higher. As the weight is shifted on the hind feet, the hips raise and lower from side to side, too. The hip drops when the weight is off and raises on the side that at the moment supports the weight.

The studies of Mourning Dove on this and opposite page were made directly from specimen with colored crayon in pencil form

THE KNEE

On animals like the rhinoceros and elephant, note the low position of the knee on the foreleg, which corresponds to the wrist on humans. Get this knee in the proper place. If you draw it too high it will look too much like the knee on a horse.

WORKING IN THE WILDS

When I was familiarizing myself with animals in the wilds of East Africa, I made my sketches of attitudes directly from life as the animals walked about on the veldt. I could not make studies that way, so I was forced to shoot the animals that I wanted for studies. Posing these in typical positions which I knew would prove useful later, I drew or painted them with great care. Mostly I wanted careful studies of the heads, so I did these from many positions. When finished, I had drawings from full face, three-quarter view, side view, and often, top view. I also photographed the animals in all these positions. My studies looked like pictures of live animals. The photographs looked dead, because of the reason mentioned above, and often there was some distortion, particularly in front view where the noses looked too big.

STUDYING DEAD SPECIMENS

This working from dead models is something that should have your consideration, if you are really intent on becoming an animal artist. Animal artists, for centuries, have gained much of their knowledge of animal construction by carefully drawing dead animals. I know that I could never have obtained the information that I gathered in East Africa without having the dead animals before me so I could make studies of detail to my heart's content.

Should your interest be in birds, then studies of this kind, made from dead specimens, will be invaluable to you. Every year birds are killed by accident. You find them lying on the lawn after they have tried to fly through a window or screen. They fly against wires and are often struck by automobiles. Take them home when you find them. Have your friends bring those that they find. Here is valuable material that you should not miss.

Lay the bird on the table and draw it breast up. Lay it breast down and draw its back. Make careful studies of the feet. Draw the head in numerous positions. Spread the wings and draw these. Make studies in color, either with colored crayon or water color. Measure the bird, the length of its tail and wings, the length of its bill, anything that will help later in setting it on a branch and giving it a semblance of life. If it is fresh, make a careful note of the color of its eyes, its bill, and its feet, for these colors may change later.

Referring now to our illustrations, the two studies of a large male mourning dove are of a specimen that was found dead. The originals were actual size and in full color, being done with polychrome crayons — these come in sixty hues. The colors were rubbed into the paper, and strengthened with more crayon drawn over this rubbed work. A sharp knife removed the crayon for the light edges of feathers, as shown in back view.

A BIRDSKIN COLLECTION

Should your interest be in birds, you will

perhaps want your own reference collection of birdskins, unless such a collection is available in a nearby museum. In the latter case, forget about making a collection of your own, as the museum will doubtless have a much better one than you could ever hope to accumulate, regardless of your effort, which would of necessity be considerable. You would have to obtain permits from the game department, for instance, and even the Department of the Interior. You could spend your time better in drawing and painting. However, if you *do* ever make a collection, some of the good books on taxidermy will give you all the information you need on preparing skins. An excellent book is *Taxidermy and Museum Exhibition,* by John Rowley (D. Appleton & Co.). The work, although a bit messy, is really not very difficult. A taxidermist will, of course, prepare them for you and the cost is not great. Label your specimens carefully as to the time of year they were obtained, since birds' plumage often changes with the seasons. Keep them in cabinets where they will be available. Don't pile them on top of one another

Audubon's bird pictures were all drawn from birds that fell to his gun. Fuertes worked that way. So do the living bird artists of today.

Fish artists likewise make careful studies of fish in this manner, often going out to catch their models, then producing careful studies in color while the fish are fresh and before the colors fade. It is of course possible to make studies of living fish by placing them in a glass tank in the studio. By slipping a glass partition into the tank to confine a fish to a narrow area, it will obviously be obliged to remain in one position while studies are in the making.

Undressed poultry, freshly killed, affords good subjects. Chickens, ducks, geese and turkeys can be obtained in this form. Carefully drawn studies of a domestic turkey will prove valuable in painting wild turkeys. Drawings of chickens will show you foot and head construction helpful in depicting birds like grouse, partridge and pheasants. (The domestic chicken, incidentally, be-

longs to the pheasant or grouse family.)

Pheasants, wild ducks and other game birds that a hunter friend might present to you are golden gifts when you have your heart set on painting wild fowl, for you can do them in black and white and in color until you know every detail. You can eat them later! We have seen that one's own hunting can afford a means of obtaining the specimens that he wants for his work; he can even carry his drawing material into the field so he can make studies while the game is fresh.

MUSEUM RESEARCH

With proper permission from the museum authorities, you can learn much about animals and birds by working in natural history museums. A trouble you may run into is that the light is not usually very good in front of habitat groups, since these are lighted on the inside and you must do your work in the dark hall. You can, however, make black and white drawings, and notes about colors.

I hope I have made clear by now that you should never neglect the opportunity of making studies of any animal, living or dead, that falls into your hands. If you find a new animal at the zoo, draw it at once. It may not be alive tomorrow, but your drawing will live for you. I recall how I once went to a small zoo and found a fisher-cat there. The zoo was privately owned, and the owner frequently bought animals from trappers, only to sell them later at a profit to some larger zoo. I carefully drew that fisher-cat, for it was the first one I had ever seen alive. Shortly afterward, the owner sold it and I have never seen a live one since, so I am especially glad to have my studies. In the same manner I once made careful sketches and studies of Canadian lynx that later were sold. So, I repeat, take advantage of all such opportunities.

If there is a taxidermist in your town (and few places are without them), acquaint him with your interest in drawing animals. He may let you draw the specimens that are brought to him for mounting, before he removes their skins.

ANTLERS AND HORNS

Anyone interested in painting big game, such as deer, elk, moose, etc., will do well to obtain a collection of antlers and horns. These can often be picked up at small cost from a taxidermist. It is much easier to draw an animal in different views than to draw its antlers in various foreshortened positions. The animal may not stand long enough to permit drawing them in detail and correct foreshortening. With the antlers at hand, you can place them in any desired position while drawing or painting.

OUR ILLUSTRATIONS

The accompanying study of a red, yellow and blue macaw was carefully made from the living bird. Confined to a cage, it sat quietly for its portrait. The original sketch was done in colored crayon, using red, yellow, blue and black. Black was selected to strengthen the shading at the bend of the wing and along the flight feathers. The yellow middle feathers of the wing were tipped with green, and blue was drawn over yellow for these. The red quills of the yellow feathers were drawn right over the yellow.

On page 40 is a study, originally done in colored crayon, of a king vulture. All the colors were carefully noted and drawn on this study for future reference. In this manner I have made studies of gray, red and fox squirrels, rabbits and other small animals; to these studies I frequently refer when I have drawings or paintings to make.

The pencil studies of a field mouse, here reproduced, were made directly from the mouse, which died from a too rich diet of nuts and dates on which I had fed it. After its death, I did the studies of the head in four positions.

The studies of the head of a house mouse were done life-size in pencil. Special attention was given to the correct drawing of the ears, and to the position of the long hairs over the eyes and on the upper lips.

The top and bottom views of the head of a squirrel were made from a dead fox squirrel. Note how, on the bottom view of the head, the pencil lines show the hair direction, and the position of lips and teeth.

39

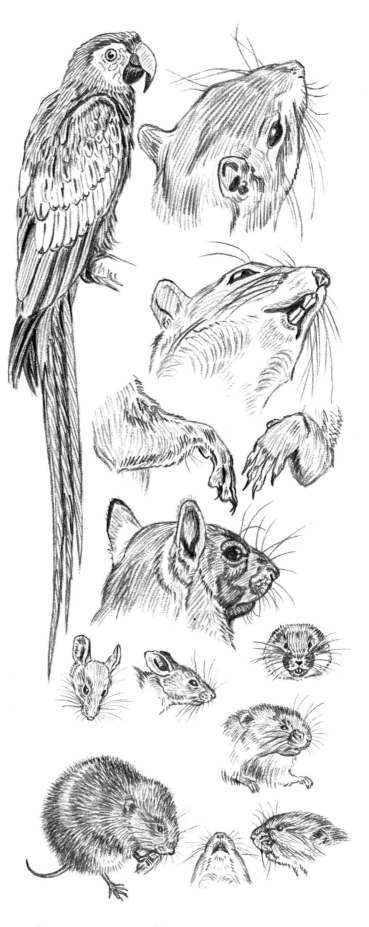

Top left: Macaw. Top right: two studies of Fox Squirrel heads. Center: head and feet of Gray Squirrel. Left center: head studies of House Mouse. Bottom: studies of Field Mouse

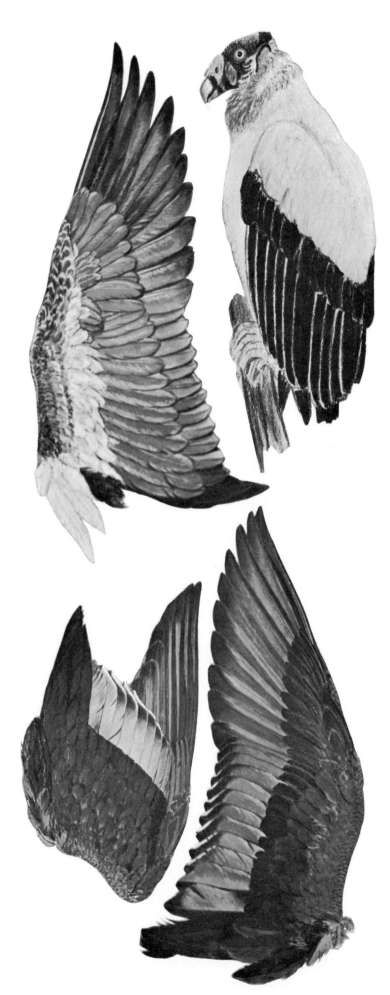

In the three-quarter back view of the gray squirrel's head, observe the folds of the ear and the shading about the eyes. The forelegs and feet are of the same animal. Observe how short the legs are, but with heavy muscles for climbing and clinging to bark and branches. There are only four toes, as shown in front view, and a little nub or warty growth that takes the place of the thumb. Incidentally, the forefeet of squirrels have four toes and the hind feet five.

In drawing squirrels, measure the length of the tail and the length of head and body. This will give you the correct relative proportions for drawing these things. Note, likewise, how the ear is folded at the back edge. Draw all such details — the feet, too — as you see them in various positions. In the case of heads, be sure to sketch them in side, front, three-quarter, top and bottom views, as all will help in later work.

In drawing wings of game birds, use pins to hold them open on the drawing board, placing these pins in the joints of the wing and not in the feathers. Draw both the upper and lower view of the wing, as the feathering arrangement is different. Also count the flight feathers and the tail feathers—the latter often number six to a side. Also count the joints of the toes to get the correct drawing of feet. As most birds have four toes, you will find that the toes have one, two, three and four joints, counting from the inner, short toe.

The accompanying studies are of the wing of the ring-necked duck, the upper side being fully extended and partly closed, and the lower side fully extended as in flight. The feathers were carefully counted and painted individually. These wings were first painstakingly drawn in pencil and then finished in tempera paint in natural color. Studies of this kind can be filed away for future use, and, if truthfully copied from nature, will take the place of the actual specimens when you later need information.

The studies of birds shown herewith were all of dead specimens, posed in natural positions. That of the blue-roller was drawn from a specimen in East Africa. I posed the

Top right: study (from life) of King Vulture. Left and below: studies of wing of Ring-necked Duck, inside and outside views

bird as if it were perching, even fastening its feet around a branch. In like manner, I drew the bar-tailed trogon, the purple wood pigeon and touraco. How else could one paint such specimens in detail and full color in the jungle? If one could always catch his models alive and confine them while he made his studies, he would have ideal conditions, and dead models would not be necessary, but, since this is not always possible, he must work as he can. After all, these dead specimens can best serve art, for the artist is able at will to make them live again for posterity.

My studies of the head of a female sharp-shinned hawk were done directly after the bird was shot, while the eyes still retained their color. Three of these studies were finished in actual colors. The other two were not in color, being drawn for attitudes only.

Remember what has been said about saving your studies, keeping those of certain animals together in an alphabetical cabinet where they will be instantly available. Being your notes, made directly at the source, they are the most valuable material that you can gather. They are to you what the dictionary and thesaurus are to the writer.

DRAWING MATERIALS

Here, a bit of additional advice on materials for making studies might prove helpful. I use every medium, but prefer pencil for black and white studies, and colored crayons, water colors and oil paints for more finished studies. Some artists like pastel crayons, but I have found these too perishable. Pastels cannot be preserved with fixatif without loss of color and quality, and unfixed studies are as fragile as butterfly wings.

Polychrome crayons — pencil-like in form

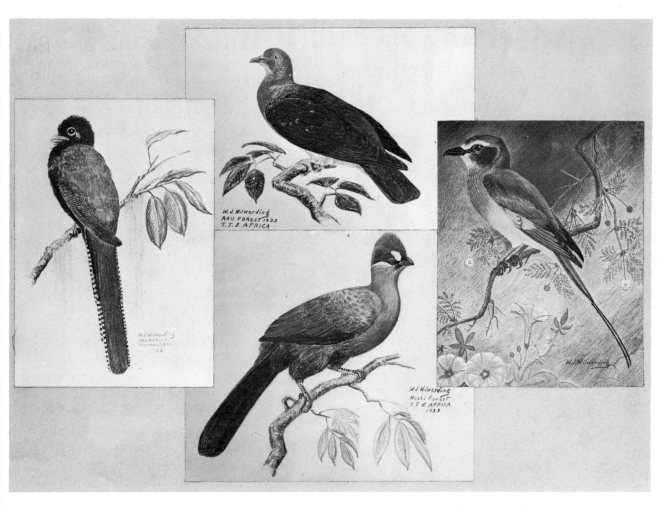

Color crayon studies from Tanganyika. Top: Purple Wood Pigeon, Rau Forest.
Left: Bar-tailed Trogon, Lalgarjin Forest. Right: Blue Roller, Ruvu River.
Bottom: Hartlaub's Touraco, Ruvu River

— are very useful for colored studies, and many of the reproductions shown herewith are from such studies. The crayons come in sixty colors, as aforementioned, many of these being browns, ochres, grays, etc., that are ideal for drawing animals. You can rub one color into the paper and put another over this, thus obtaining any desired hue. When sharpened, the polychromes are good for detail, but the work must not be too small.

Many of my colored crayon studies are on paper about 10 x 14 inches, and they cover most of the surface. However, I have successfully grouped many smaller studies on a single sheet of this paper. I prefer a paper of good thickness and not too soft in texture. I start the crayon drawing lightly and gradually work it up into full color, employing a sharp knife for picking out detail, highlights on eyelids, hair direction, and lights on horns or along the edges of birds' wings.

For water color studies I use a water color pad, not too rough. My procedure is similar to that which I employ with pencil. I use the tip of my brush and light lines for action and proportions, drawing outlines with brush strokes approximating the color of the animal. Next I brush in tones with a full brush to indicate colors. When working at a zoo, I take a bottle of water with a wire attached, and bend the top of the wire into a hook which I hang over the railing used to keep people away from cages. A board with a crosspiece to accommodate the water color box, and a place for the sketch pad below, is useful; I rest this on the railing while working. The animal may move after the first sketch lines have been drawn, but colors may be noted as I work.

For oil sketches, I prefer the same size canvas boards as for crayon sketches, about 10 or 11 by 14 inches. The contours are first painted lightly in outline in a color suggesting the general color of the animal. I then work this up into a color study as with water color, except that the method of building values is reversed. In water color, you work from light to dark. In oil, the shadows are put in, in full strength, next the halftones and finally the highlights.

For pencil or crayon work I use much white paper, though toned paper — either gray, brown or tan — may also be employed. Such paper can serve for the general tone of the animal, the outlines and shadows being drawn. Highlights can then be painted with opaque white water color. I have employed white crayon, but it is usually of little use as it does not give the proper snap. Chalk can be employed, but will rub off. A tube of good water color white and a small sable brush will prove more valuable.

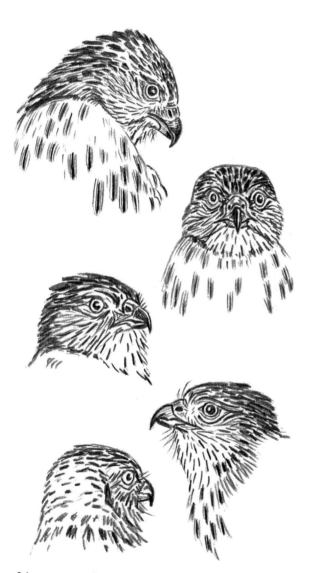

Studies of head of SHARP-SHINNED HAWK
Askov, Minnesota

Chapter V

COMPARATIVE CONSTRUCTION

ANY ART STUDENT who wishes to make animal drawing and painting a specialty should learn something about the anatomy of animals. However, I believe, after many years of painstaking study of animal bones and muscles — what we might call "internal" anatomy — that it is a moot question whether the artist gains much by delving *too* deeply into this particular phase of his subject. For whatever his field of specialization, the artist, after all, is concerned chiefly with external appearances — with those effects which meet the eye.

If we turn to landscape, for example, a great deal of drivel has been written by so-called art critics on how the spectator can see or feel the great rock-ribbed structure underneath the painted earth or grass in this landscape painting or that; yet the fact remains that the artist painted earth and grass. Maybe there *were* rocks underneath the things he painted, but it is a fairly safe wager that he was studying the values, colors and contours which he could see, and gave little if any thought to what was hidden below. When an artist paints the rugged bark of an oak, do you think he has in mind the oak wood under the bark, and the growth rings and the grain of that wood? No; artists who paint trees seldom know or care what kind of wood is beneath the bark.

This being the case, why should an artist concern himself too seriously about what lies under the skin of an animal? And this question is asked by one who for years was an almost incurable anatomist. I not only studied the bones of animals — I counted them, knew their names and exactly where every one fitted into the skeleton of this animal or that. I did the same with muscles.

I still find that I must indicate muscles on short-haired animals, but I also find that I do not have to indicate them any more clearly than they show on the living animal. Why, then, if the muscles of my dog must be painted as they appear on the living beast, should I skin the dog to find out how they look when he has no skin?

It has been said of the sculptor Barye's lions and tigers that a surgeon could pick out all the muscles and explain them to you. I have no quarrel with Barye's sculptured animals; they are unique and monumental. However, if an artist were to use Barye's lions and tigers for models, his drawings or paintings would not look at all like those beasts as seen in nature with their skins securely around them. Barye's works are not, in other words, naturalistic representations; they are sculptured anatomical studies. For me, they lose interest otherwise.

After my many years of studying animal anatomy, I was rudely shocked to find that some artists, without even a slight knowledge of that subject, could beat me at painting animals by the simple expedient of painting them in correct color and light and shade, and indicating the texture of hair or fur. I was painting what I had learned of anatomy — what I knew existed — while these others were painting what they saw with their eyes. Needless to say, I have since modified my approach.

Not that I am against a reasonable degree of anatomical investigation; surely it is well to know how an animal's machinery works — what makes his legs go and his head turn. If one does not understand something of this, then he might try to make an animal do impossible things with neck and legs. For

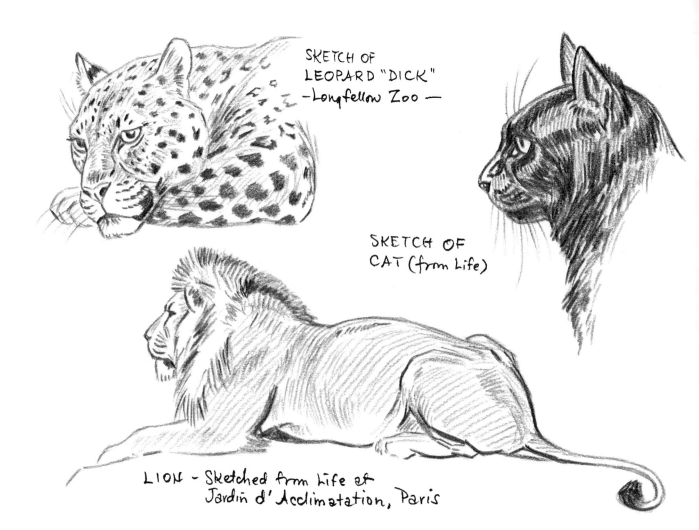

SKETCH OF LEOPARD "DICK" —Longfellow Zoo —

SKETCH OF CAT (from Life)

LION – Sketched from Life at Jardin d' Acclimatation, Paris

there are normal limitations to the movements of necks and legs, though some animals of course have greater flexibility than others. A cat, for instance, comes pretty close to proving itself a contortionist when enjoying a tongue-bath. Cows, deer and antelope, though lacking the spine flexibility of the cat animals, can reach back and lick at a spot on their flanks. While cat animals have considerable side motion in their front legs, the legs of such other animals as horses, deer, and cattle are quite muscle-bound, and the action is chiefly forward and backward.

The giraffe, despite the length of its neck, has very little flexibility in that neck. If you paint or draw the giraffe and show its neck bent into too sharply curved arches, then you do not show it correctly. While it can swing its neck up or down and sideways, arching it within certain limitations, it cannot twist it into sharp curves at will.

Also, an elephant, having a very short neck, cannot swing its head around to look back, the way deer, cattle and many other animals can. Try turning your own head from left to right and you will find that it will go only so far and no farther. Some animals are better equipped than you in this respect, while others are even more restricted. Watch each species and observe what it can and cannot do and you will learn how to draw it in correct action.

RELATED TYPES

Related kinds of animals are similar in shape of head, neck, body and legs, so however much they may vary in size, color and markings, this shape similarity, if studied carefully, will aid in their representation.

THE CAT ANIMALS

Study the domestic cat, for instance, noting the shape of the head and the construction of ears, nose and mouth, and you will have a good basis for the drawing of other cat animals. Some of these may have longer

44

noses, shorter ears in proportion to the head, or may deviate slightly in other respects, but the general head construction will be the same. You will also find this true of the construction of the legs, feet and other details of the cat — learn how to draw them well and you will have little trouble in drawing the same parts of a puma or leopard. Discover how the cat walks and skulks, and you can draw a leopard or tiger walking or skulking.

As a typical example of minor variations in general construction, the head of the lion is larger in comparison with its body than is that of the cat. The lion is also relatively more powerful in its front legs, for whereas the four legs of a cat do not vary greatly in size, the front legs of a lion are much larger than his rear legs. The jaguar possesses a heavy head, small eyes and comparatively short legs. The lynx, compared with the domestic cat, has very long, heavy legs and a short tail. The leopard is quite like the domestic cat in proportions, though its muzzle is longer. The puma comes still closer to being an enlarged cat.

Compare related animals in this manner, using in each case the most familiar type as your standard, as I have just used the domestic cat to compare with all cat animals, and it will be easy to see how individual species digress from this standard, though all have similar basic construction.

THE COW FAMILY

For construction of cattle, for instance, you could do no better than make a careful study of the Jersey cow, for I believe the Jersey to be a refined type of the various cattle forms — a suitable standard for comparison. You will see in studying cattle that they are heavy in body, short of legs, and, therefore, longer than high. Their necks are heavy and held horizontally. Their heads are deep, compared with deer and most antelope. Most domestic cattle are built more coarsely than the Jerseys; this is es-

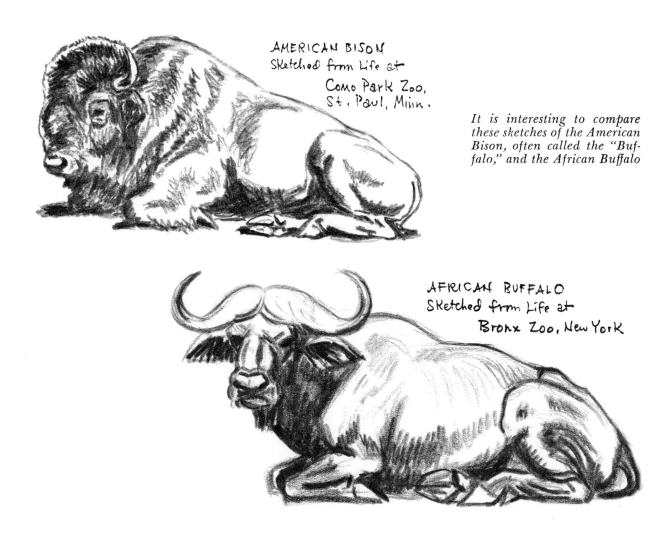

AMERICAN BISON
Sketched from Life at
Como Park Zoo,
St. Paul, Minn.

It is interesting to compare these sketches of the American Bison, often called the "Buffalo," and the African Buffalo

AFRICAN BUFFALO
Sketched from Life at
Bronx Zoo, New York

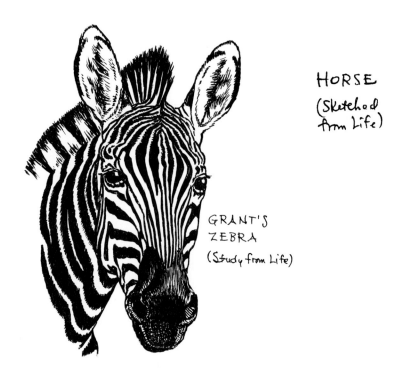

GRANT'S
ZEBRA
(Study from Life)

HORSE
(Sketched
from Life)

pecially true of the beef-type cattle. Zebus vary chiefly from our standard in having a hump over the shoulders, though they are also more rounded at the hips, without such a pronounced showing of the pelvic construction which is so noticeable in many domestic cattle. In this respect, the zebus are more like wild cattle, for bison have humps over the shoulders, with smaller and more rounded hips.

Because of the high humps on bison, the head has the appearance of being carried low. Bison usually hold the head in a more vertical position than domestic cattle. This is perhaps due to the way in which the neck bones are fastened to the back of the skull. The bison, although called buffalo, is not a true buffalo. Buffaloes — which include the African buffalo and the Asiatic water buffalo — do not have the pronounced hump, and in general construction look like heavy cattle. Their heads are not unlike those of heavy beef-cattle in form. Principally, buffaloes differ from bison and domestic cattle in both the shape and position of their horns, which sweep outward from the crown of the head and are broad and much flattened at the base. This flat-

tened formation is particularly noticeable on the horns of the water buffalo.

Other variations from the domestic cow will be found in wild cattle such as the gaur, banteng and anoa.

THE HORSE

In the horse family, you will find animals of all sizes from the pony to the heaviest draft horse, but the general construction remains constant. So study one horse carefully and you will have an excellent basis for the drawing of all members of this family, whether domestic or wild. There are no major variations, such as humps on some and none on others, nor can there be a difference in horns, since all horses are hornless. The greatest divergencies will be in weight; heavy draft types are heavier throughout, having heavy heads, necks and bodies. Race horses are not only much lighter, but longer in the legs. Zebras vary chiefly in having broader ears; also their tails are not long-haired to the base. In these respects, zebras more closely resemble the wild asses. In markings, they of course differ greatly from other horses, but this has nothing to do with construction. (Compare the two drawings above.)

46

THE DOG

In studying the dog — which family includes all domestic dogs, as well as wolves, coyotes, jackals and foxes — it would be well to take as your standard of construction the shepherd type, or so-called police dog. This is a well-balanced animal with a body about as long as it is high at the shoulders. Careful studies of this dog will prove valuable in representing all wild types, and all domestic types with the exception of those which have been bred with abnormally short legs or muzzles. For instance, the head of a police dog offers little that would help you in drawing the head of the English bulldog. Also, the bent and shortened legs of the dachshund have little resemblance to the trim legs of the shepherd, pointer and many other types. Yet, if you put erect and pointed ears on a dachshund, its head would not be unlike that of a shepherd. The flop ears of hounds, setters, pointers and spaniels are no doubt the result of domestication. No wild types have flop ears, yet all domestic dogs have gradually developed from the wild. If you raise the flop ear of a dog, you will find that it has much the same construction as the erect type.

Spaniels, setters, pointers and hounds have many details of construction in common. Muzzles are deep and ears long. Such types vary greatly, however, in length of leg, and, of course, in length of hair. Similar variations will be found in other types. Make drawings of a shepherd or a collie, a hunting dog, a terrier and one of the toy types and you will learn much about dogs that will help you in drawing all kinds.

THE BEAR

Bears have shapes like sacks of flour, but this does not make them easier to draw, for they have their definite construction which differs from that of other large meat-eaters. A bear's head is rounded back of the muzzle and its muzzle is heavy, terminating in a large nose. The eyes are small for the size of the head. Ears are short and rounded. Legs are heavy, and feet large and plantigrade. The bears have no hock joints, and,

47

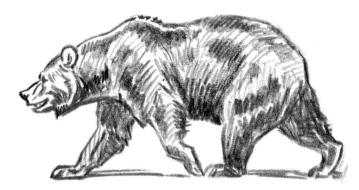

ALASKAN BROWN BEAR

Sketches from Life, Bronx Zoo, New York

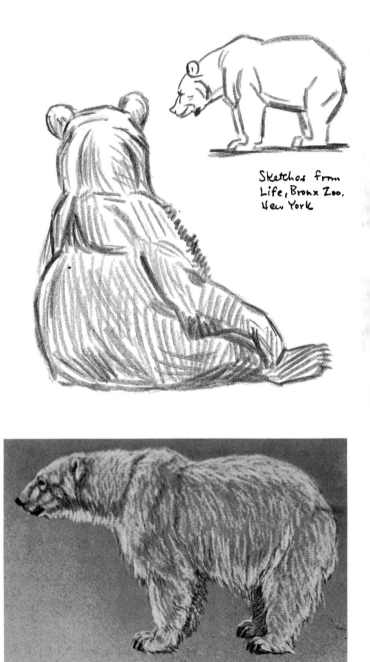

Polar Bear, "Zero," sketched from life

in this respect, their hind feet resemble the feet of humans.

Draw one bear and you will know them all pretty well. The polar bear differs chiefly in having a longer neck and shorter ears than either the black, grizzly or brown bear. Its ears are set rather low as compared to these several types. There is not much difference between the others — chiefly they vary in size and color. All have five toes on all four feet, heavily clawed. Note, too, that the tail is so short as to be almost no tail at all.

I have found bears difficult to sketch. When in repose, they are shapeless lumps. When moving about, they are restless, swinging their heads and shuffling this way and that, in a manner trying to one's patience. Quick action sketches are best; these can be amplified by studying the bear carefully and making additions later.

DEER AND ANTELOPE

Deer and antelope are much alike in construction and general appearance, having similar legs, bodies, necks and heads, etc. Therefore, if you make careful studies of the deer, you will have little trouble with the antelope. Also, if you draw one kind of deer, it should not be hard for you to draw another kind. The chief difference in deer is in the formation of the antlers, but, since the does, or females, of most deer have no antlers, they are quite alike in appearance. While deer vary in size, they all have similar necks, and their legs are of about the same relative length when compared to length of body. Antelope differ in size, too. Certain species are no bigger than rabbits; others are as large as cattle.

The chief difference among the antelope — of which there are many kinds — is in the shape of head and horns, and length and thickness of the neck. Most antelope, and particularly the gazelles, have rather long necks. Gnus, on the other hand, possess necks that resemble those of cattle. Their attitudes in standing are also cattle-like.

The hartebeests have long, homely heads, somewhat like those of gnus, but lacking the thick growth of hair on the front of the face.

Also, the horns are set on a high pedicle.

Kudus are deer-like in form, with the broad ears of deer, and with similar tails. Their corkscrew-twisted horns will deserve your careful study from different viewpoints.

Eland are built somewhat like Jersey cattle, with heavy bodies and rather short legs. They also have long dewlaps on their necks. Their ears resemble gazelles' ears more than those of cattle. Drawings of both deer and cattle will help with the drawing of eland. The horns are of course different from those of cattle in that they grow straight back from the head, and show a twist.

Waterbucks look and carry themselves much like our American elk. The long, heavily-ringed, gracefully sweeping horns deserve particular attention, as they add much to the appearance.

Oryx are heavy antelope, also somewhat cattle-like in appearance and carriage, but with slimmer legs. Their tails are lengthy and rather horse-like. Their horns are long

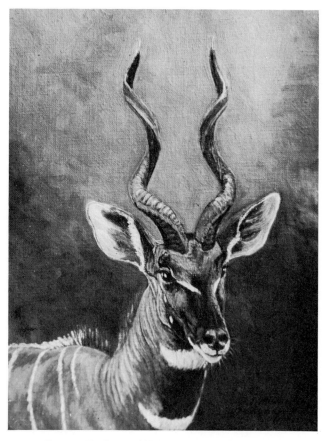

Lesser Kudu — Oil study, Ruvu River

48

and slender, being sometimes curved and sometimes straight.

Speaking of antelopes' horns, it will be seen from the above that there are several types; twisted, straight, and curved and re-curved. Some horns are lyre-shaped, others short and goat-like. Occasionally the tips curve backward; again they are bent forward. Antelopes' tails are horse-like, deer-like, rabbit-like, or tufted.

In this antelope classification are included various horned animals for which the zoologists find no place among the cattle, sheep and goats. There are even in-between kinds that closely resemble goats, among which the goat-like chamois is a conspicuous member. So antelope, being neither cattle, sheep nor goats, are just animals and you will have your hands full if this large group intrigues your interest.

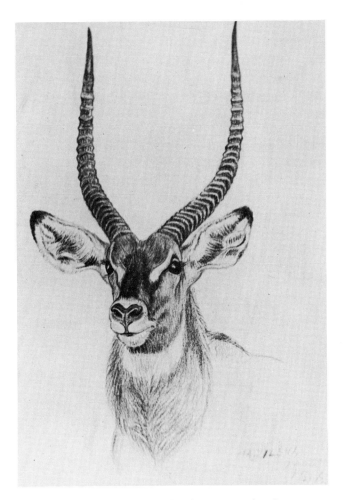

Male Waterbuck — Study from animal

SHEEP AND GOATS

Sheep and goats do not vary greatly in construction from antelope and deer, so if you cannot find the latter, the former will serve quite well as models for general construction. Much of the construction of sheep is hidden by the covering of wool, but that of goats can be plainly seen. In drawing these animals, watch for the shoulder construction — it is clearly visible — and also for the construction of the heavy muscles of the hindquarters. These are the main things for which to look; if drawn correctly as you see them, they will appear anatomically right.

PACHYDERMS: THE ELEPHANT

Now we turn to the elephant, hippopotamus and rhinoceros. Although all are pachyderms, they are not related but form three distinct groups. One thing they have in common, besides their thick skins — the knee of the foreleg is set rather low. Also, they are multiple-toed rather than split-hoofed, the toes, although hoof-like in construction, being set on the feet like heavy, broad nails. The skin displays little or no hair.

Elephants are not difficult to draw, as they stand rather quietly. One must watch for the difference between the Asiatic and African forms, especially in the shape of the head and the size of the ears. The African elephant's head is more rounded or convex in profile than the Asiatic, its ears are much larger, and the outline of the back is less regular. Although the African type seems to stand a bit higher at the forelegs than at the hindlegs, as compared to the Asiatic, this is an illusion mainly due to the fact that the Asiatic elephant has a heavier body that does not slope upward toward the forelegs.

PACHYDERMS: THE RHINOCEROS

As with the elephants, there are numbers of rhinoceros types, but the general construction is the same in all. The Indian rhinoceros has but one horn, while both of the African types are two-horned. Also the folds of the body are more conspicuous and armor-like in appearance in the Indian spe-

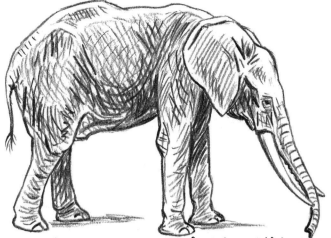

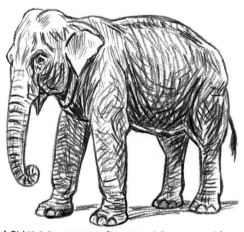

AFRICAN ELEPHANT - Sketched from Life, East Africa

ASIATIC ELEPHANT - Sketched at Sells-Floto Circus

cies than in the African. The so-called white variety of the African rhinoceros has the nose squared off in front. The common variety, called black rhinoceros, has a distinctly pointed and overhanging upper lip. These animals are easy to draw in captivity, as they usually move slowly or stand quietly.

PACHYDERMS: THE HIPPOPOTAMUS

The hippopotamus is related to the pig and is more or less pig-like in shape. Its four toes or hoofs are, however, arranged at one level; it has no side hoofs like those of the pig. The head is not pig-like, but broad at the nose. The ears are very small and rounded. The eyes are set on top of the head like two little knobs. The tail is flat instead of rounded. When sketching this animal, pay especial attention to the construction of the head. The fat body and short legs are easy enough to draw. Add the heavy folds of skin about neck and shoulders and you have him.

THE PIG

If you must draw pigs, then devote the same painstaking care to head construction that you did for the hippopotamus. This will add much to the head's character. The body of the pig is easy enough to draw, and the feet are much like those of deer or cattle. The ears are rather pointed and flop forward to almost hide the eyes.

SMALLER ANIMALS

If your interest is in the smaller animals such as squirrels, rabbits, etc., keep some as pets. White mice, rabbits, squirrels, and guinea pigs can be kept with little trouble, and will prove helpful as models in drawing all rodents. (After you have made studies of them in many positions, perhaps you can return them to the pet shop and get credit toward other species.) White rats make good models, useful in drawing rodents of several species. The squirrel is not unlike a rat with a bushy tail. Mice are but rats in miniature; there is no difference in construction between the two. As a rule, the heads of rodents are very similar; put long ears on a squirrel and it would look much like a rabbit. Most of our rodents are four-toed in front and five-toed behind, though

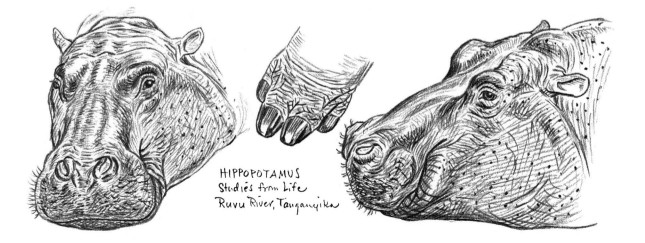

HIPPOPOTAMUS
Studies from Life
Ruvu River, Tanganyika

South American rodents vary greatly in this respect. There is little in the way of muscular construction to notice. Shoulders appear somewhat rounded; the body is rounded and so are the hindquarters when the animal is seated.

You will note in drawing squirrels that their ears are fastened fore and aft to the side of the head. Because of this, they cannot freely move the ears forward and backward, as rabbits can. Also, you will never see a squirrel with its ears down. This is true not only of tree squirrels, but of ground squirrels, chipmunks and spermophiles. Some spermophiles, one form of which is often called striped gopher, have shorter ears than the tree squirrels and chipmunks.

The small carnivorous animals — those belonging to the weasel, civet and allied families — usually have long bodies, short legs, and rather triangular-shaped heads. Ears are somewhat rounded; eyes and nose are small. As a rule, all feet are five-toed. Variations may be found in the badger, that is broad and flat of body, and in some Old World civets, that have longer legs and are more or less foxlike in build. The skunk is made more compactly; the wolverine is constructed like an oversized skunk. Weasel, mink, and marten are similar in construction. Draw one and it will help you to draw the others. Note especially how these creatures, when moving about, hump up the back in a sort of undulating manner. Try to capture this distinctive attitude in your work, as it adds much to the character of these little beasts.

APES AND MONKEYS

The members of the ape and monkey families are more complicated in construction, yet if you study and draw the construction of one it will help you in drawing all. Pay particular attention to the drawing of arms, legs, hands and feet. Study carefully the construction of the eyes, ears, nose and mouth. Most of these have the eyes close-set, the nose flattened and the mouth broad. The forehead slants or rounds backward from the ridge over the eyes. The ears are more or less like human ears; this is rather noticeable on such apes as the chimpanzee.

In drawing the big apes, you will see that they have no tails at all, not even stumps of tails. This is true of all the gorillas, chimpanzees, orang-utans and gibbons. In this they are like humans. Also notice that the baboons have tails that are bent, and held in a sort of half-mast manner when they are walking. This bend in the tail of the baboon is permanent. He must hold his tail that way because it grows that way. Monkeys curl the tail at will, but, remember this: the Asiatic and African monkeys neither take hold of nor hang from limbs of trees by their

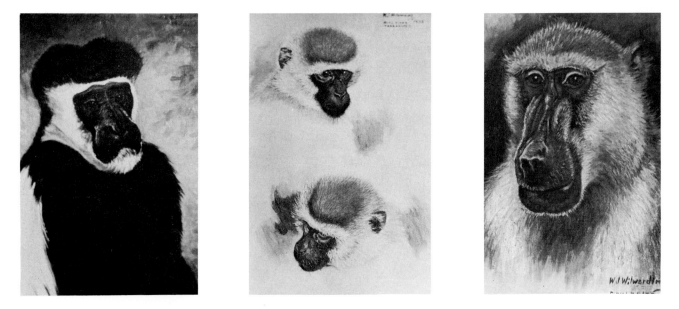

Oil studies from life, Tanganyika. Left: Colobus Monkey, Rau Forest. Center: Green Guinon Monkey, Ruvu River. Right: Olive Baboon

tails. Only South American monkeys have prehensile or grasping tails. It is necessary to keep this in mind or you may show monkeys in your pictures doing things that are impossible. I frequently see chimpanzees and orang-utans drawn with tails, which is of course incorrect, but may be done for humorous effect. If you want to turn humorist and show caricatures of animals, you can obviously do as you please with them — you can even tie the neck of a giraffe into a knot — but the foregoing is a warning to those who wish to show animals as they are.

BIRDS

What has been said about a too earnest study of animal anatomy can be applied to an even greater degree in the case of birds. A young artist much interested in drawing birds and animals once told me that he was going to make a specialty of drawing the anatomy of all kinds of birds. I advised him to forget it and study feather arrangement instead. My reason was obvious. On a bird you see nothing of what lies underneath the feathers. Pluck an owl and it would not resemble an owl at all, but a scrawny, long-legged bird with a lengthy neck and a rather rounded head.

In other words, if you study the feather arrangement of birds you will learn more about drawing and painting birds than from any study you might make of bones and muscles. Here again you will find that birds fall into certain groups, and that in studying one of a group, you will have a basis for the drawing of others. As has been pointed out in a previous chapter, studies made of a chicken will help you with the scratching birds, such as pheasants, grouse, quail, etc. Draw a hawk until you know it well and you can easily portray the eagle and the vulture. Eagles are really large hawks of the buzzard type, and if you can draw the red-tailed, red-shouldered or any of the buzzards, you can draw an eagle without trouble. The so-called turkey-buzzard is not a buzzard at all, but a vulture. Its naked head will deserve study if birds of this type interest you.

In like manner, make careful studies of

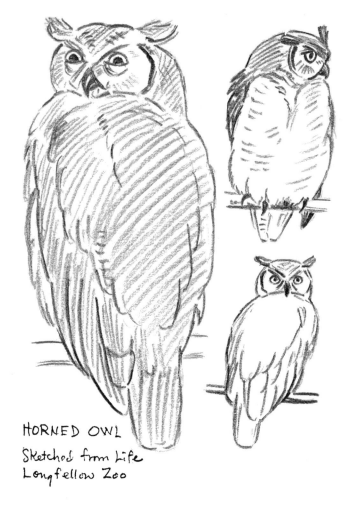

HORNED OWL
Sketched from Life
Longfellow Zoo

the barnyard duck and goose and it will help you in drawing the many wild kinds. Also, drawing your canary will assist you in drawing other perching birds.

If interested in bird drawing and painting, you should keep some cage birds as models — many varieties can be purchased in pet stores. This will enable you to study their attitudes, that all-important thing. One often sees, in paintings, birds that look well so far as colors and construction are concerned, but suffer much from improper or stiff attitudes. A bird well posed makes a better picture than one on which every feather marking is plainly indicated, but which is poorly posed.

Draw wings, feet and bills of birds over and over, until you know their construction. Study the feather arrangement of wings and tails, observing how the feathers of shoulders and back fall over wings and tails. Also

note how birds, when at rest, fold the breast feathers over the wing and partly hide it.

Returning to owls, remember when you draw or paint these strange appearing birds that, though they have flat faces, with large eyes set to look forward, owls cannot shift their eyes from side to side the way humans can, so don't show them doing this. Owls always stare in the direction in which the head is turned. To shift their gaze, they must shift the head, too. (That's why the neck is so constructed that the owl can turn its head around, even to look straight backward. The feathers hide this rather long, flexible neck, giving the impression that the bird has no neck to speak of.)

Owls are not the only birds that cannot shift their eyes sideways. You will notice in drawing many kinds of birds from life that they cock their heads to look this way and that.

If you are interested in drawing and painting decorative pictures of birds, you will want to study the long-tailed ones such as the pheasants, of which there are many interesting forms. The long-necked and long-legged ones — the herons, cranes and flamingoes — are also useful for decorative purposes. Pay special attention to the manner in which these long-necked and long-legged ones hold their necks in graceful curves. Herons especially curve the neck back near the head in an interesting manner. Flamingoes also describe many S-shaped neck curves that you would do well to study.

Once you have the typical construction of the various groups of birds and animals well in mind, you will have gone a long way in your ambition to be an animal artist. Remember that you will accomplish this by keeping everlastingly at your sketching from life. The mind retains that on which you have made it concentrate. If you doubt this, I might call your attention to the fact that this chapter was written without reference to any notes or drawings, but entirely from what I have remembered of animal forms. Any artist can train his memory in similar fashion, by the simple practice of drawing from life at every possible opportunity.

53

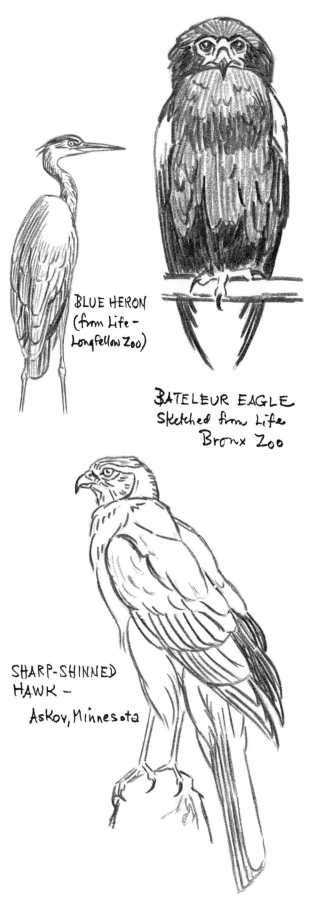

BLUE HERON
(from Life –
Longfellow Zoo)

BATELEUR EAGLE
Sketched from Life
Bronx Zoo

SHARP-SHINNED
HAWK –
Askov, Minnesota

Chapter VI

ANATOMICAL CONSIDERATIONS

WHILE I do not believe that more than a general understanding of "internal" animal anatomy is necessary (as I explained early in the previous chapter), I am aware that many students will want to know something about the framework of various species; also the principal muscles that may be seen on such short-haired animals as horses, cattle, lions, various deer and antelope and some kinds of dogs. Though these muscles may satisfactorily be seen and studied on the living animal, some students wish to feel more secure in their knowledge of what lies beneath the skin. I am therefore showing, in the following pages, pictures of both skeletons and muscles.

These skeletons and muscles are of mammals, which class also includes man. A study of the animal bones — particularly those of the carnivores — will show a similar arrangement to that of the human skeleton. Imagine the human skeleton posed in the position of a quadruped and you will readily see the resemblance.

WHAT IS ESSENTIAL?

Knowing the names of the bones and muscles is of no value to the artist — he is concerned only with form. Suffice to say that the framework of mammals consists of the spine — a sort of ridge-pole — which is supported by the bones of the four legs, and to which are attached the skull and ribs. The tail of an animal is but an elongation of the spine. The spine, for our purposes, may therefore be considered as consisting of the neck bones, those from neck to tail, and the tail bones.

The pelvis — or group of bones of the hips — is firmly attached to the spine, but this is not true of the shoulder blades, which lie on the forward part of the ribs and are fastened to these and the processes of the spine by ligaments and elastic muscles. Here there is no bone against bone, since animals, in jumping, receive the shock of landing with the forefeet; there must be some give to the shoulders, which act as shock absorbers.

In watching animals walk, it may plainly be seen that each shoulder moves up and down, independently, as the weight shifts from one forefoot to the other. Likewise, the hips rise and fall, but not independently, since the framework at that point is so firm that as one side falls the other must rise, in a sort of teeter-totter manner, from the fulcrum at the spinal connection.

SKULLS AND SKELETONS

A study of skulls will help with head construction, since, with the exception of the heavy muscles of the jaws, there is little muscular covering to the skull.

Investigate the general framework of the skeleton as to proportions, with special attention to the positions of the legs. A careful study of the leg bones and their joints will aid in the proper placement of the elbow, wrist, knee and heel joints. These terms I have just used are those associated with man. In animals, the wrist is called "knee," and the knee of the rear leg the "stifle." The heel of animals is designated "hock." The elbow of an animal is close to the body, and connected to what are known as the lower muscles of the shoulder. It will be seen in studying the bones and muscles pictured herewith, that the bone from elbow to shoulder blade — which is the upper bone of the arm in man — is buried in muscles in the case of most animals, exceptions being the primates — the apes, monkeys, etc.

54

Most animals walk on the tips of their toes, those of the forefeet corresponding to the tips of our fingers. On the rear feet, the heel or hock is raised from the ground. Exceptions are the plantigrades, such as bears, which walk with the soles of the four feet flat on the ground. In these, the heel is not raised from the ground except when the foot is in motion. In the horse, this heel or hock joint forms the principal joint about midway of the rear leg. It is similarly placed on cats, dogs, cattle, deer, antelope, etc.

MUSCLES

In studying the muscles of various animals, the differences will not prove as great as may be apparent at first glance. Muscles of goats, deer and antelope are very similar. There is, in fact, little difference between the muscles of the ox and the deer, or beween those of dog and cat animals.

Principal attention should be devoted to the muscles of the shoulders and rear quarters, which can be seen playing beneath the coats of short-haired animals. These cannot be drawn or painted as sharply as they appear on the anatomical figures, however, since membrane, skin and hair cover and soften them.

DANGER SIGNAL — Oil painting by author, Lion, Pare Mountain District, Tanganyika. Reproduced from the magazine "Fauna," published by the Zoological Society of Philadelphia.

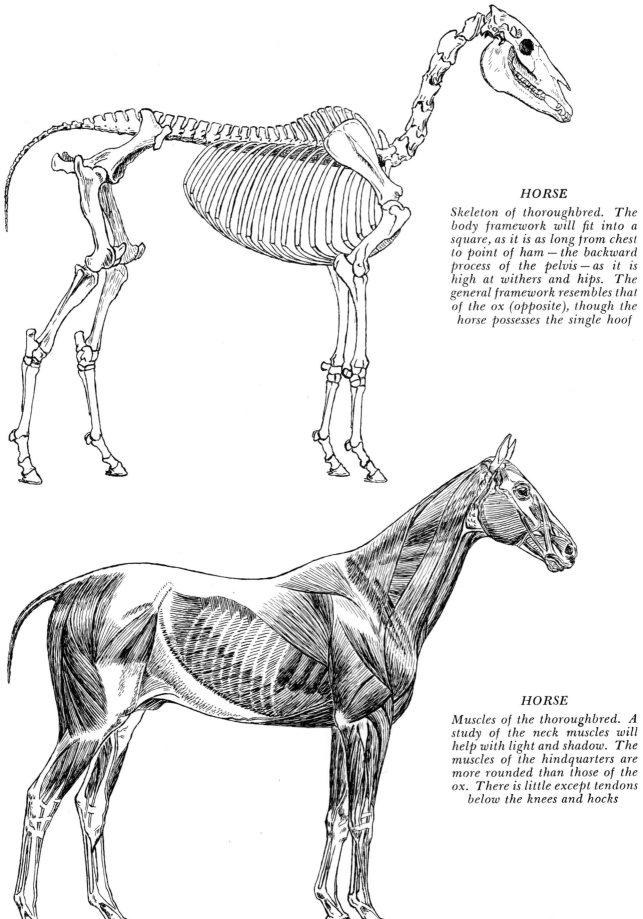

HORSE

Skeleton of thoroughbred. The body framework will fit into a square, as it is as long from chest to point of ham — the backward process of the pelvis — as it is high at withers and hips. The general framework resembles that of the ox (opposite), though the horse possesses the single hoof

HORSE

Muscles of the thoroughbred. A study of the neck muscles will help with light and shadow. The muscles of the hindquarters are more rounded than those of the ox. There is little except tendons below the knees and hocks

56

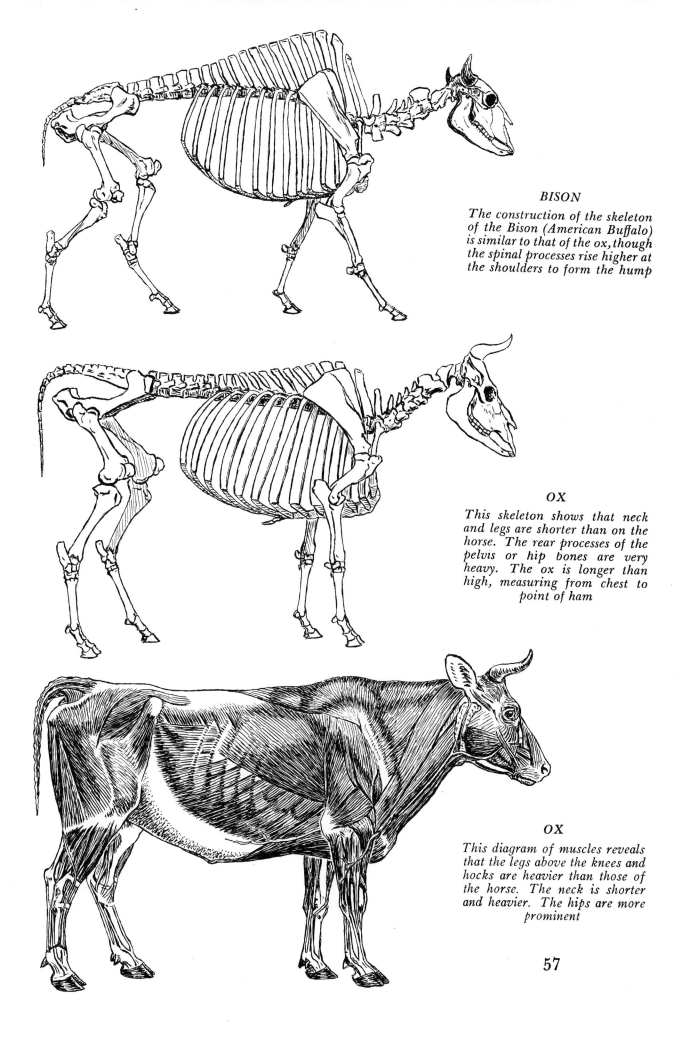

BISON

The construction of the skeleton of the Bison (American Buffalo) is similar to that of the ox, though the spinal processes rise higher at the shoulders to form the hump

OX

This skeleton shows that neck and legs are shorter than on the horse. The rear processes of the pelvis or hip bones are very heavy. The ox is longer than high, measuring from chest to point of ham

OX

This diagram of muscles reveals that the legs above the knees and hocks are heavier than those of the horse. The neck is shorter and heavier. The hips are more prominent

57

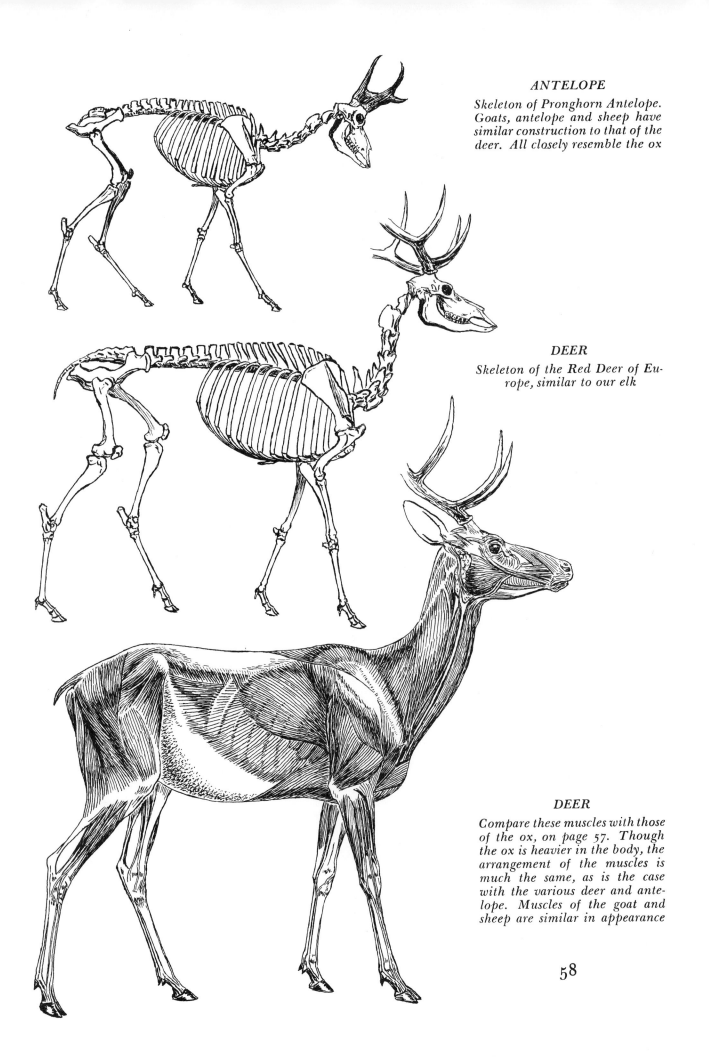

ANTELOPE

Skeleton of Pronghorn Antelope. Goats, antelope and sheep have similar construction to that of the deer. All closely resemble the ox

DEER

Skeleton of the Red Deer of Europe, similar to our elk

DEER

Compare these muscles with those of the ox, on page 57. Though the ox is heavier in the body, the arrangement of the muscles is much the same, as is the case with the various deer and antelope. Muscles of the goat and sheep are similar in appearance

58

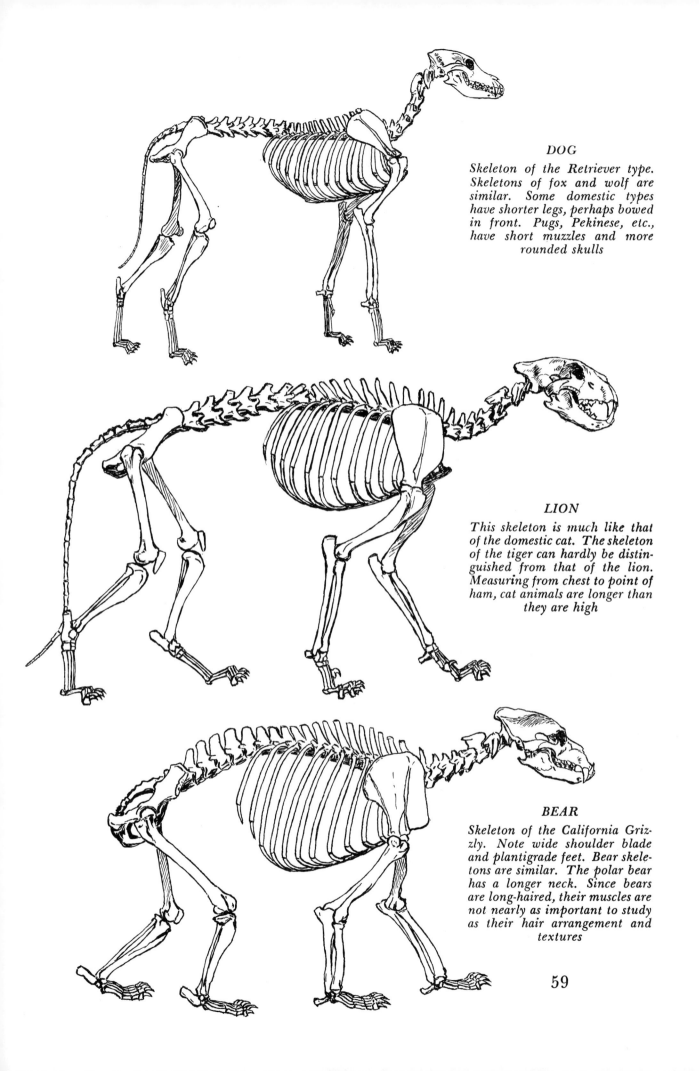

DOG

Skeleton of the Retriever type. Skeletons of fox and wolf are similar. Some domestic types have shorter legs, perhaps bowed in front. Pugs, Pekinese, etc., have short muzzles and more rounded skulls

LION

This skeleton is much like that of the domestic cat. The skeleton of the tiger can hardly be distinguished from that of the lion. Measuring from chest to point of ham, cat animals are longer than they are high

BEAR

Skeleton of the California Grizzly. Note wide shoulder blade and plantigrade feet. Bear skeletons are similar. The polar bear has a longer neck. Since bears are long-haired, their muscles are not nearly as important to study as their hair arrangement and textures

59

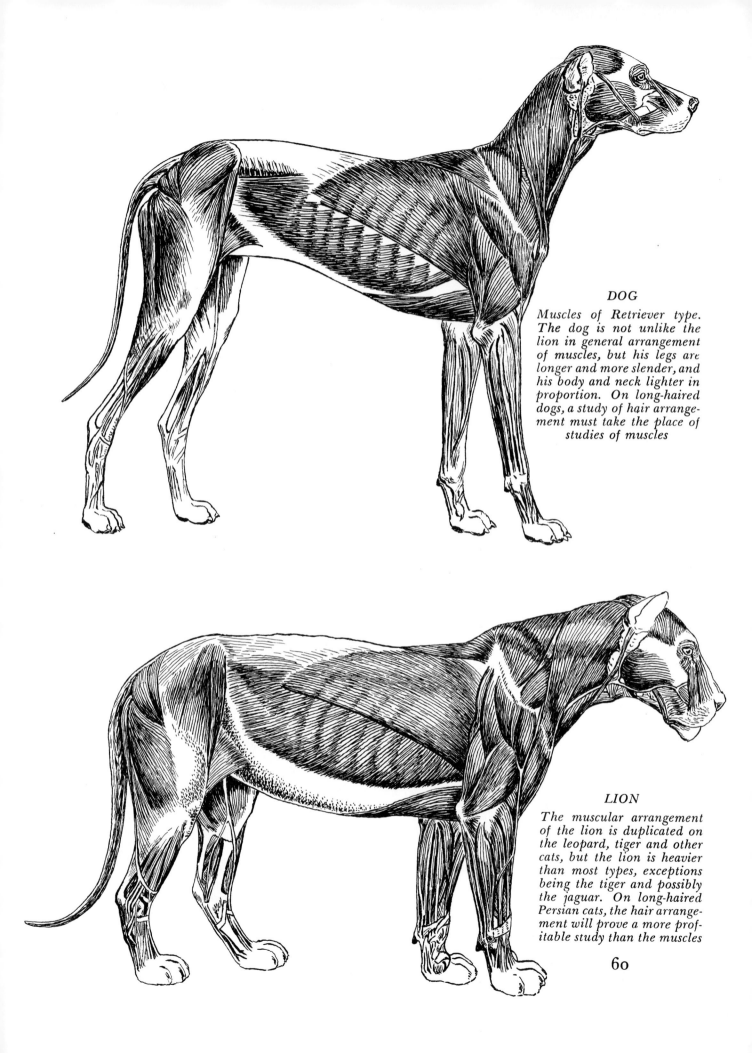

DOG

Muscles of Retriever type. The dog is not unlike the lion in general arrangement of muscles, but his legs are longer and more slender, and his body and neck lighter in proportion. On long-haired dogs, a study of hair arrangement must take the place of studies of muscles

LION

The muscular arrangement of the lion is duplicated on the leopard, tiger and other cats, but the lion is heavier than most types, exceptions being the tiger and possibly the jaguar. On long-haired Persian cats, the hair arrangement will prove a more profitable study than the muscles

60

Chapter VII

ANIMAL ACTION

WHEN THE ARTIST uses the word "action" in connection with animal drawing, he may have either of two things in mind.

First, he may think of the *pose* of the animal -- the position it happens to hold when he is drawing it. We could refer to this type of action as "dormant" or "local," as the animal's potential power for movement is not at the moment being exercised. By way of example, a sleeping animal is depicted in proper action if its pose, as it lies asleep, is faithfully recorded.

Second, there is the type of action that conveys the idea of *motion*. Whatever the degree of this motion — whether it is slight, as when an animal is slowly walking about or switching its tail, or whether it is violent, as in the case of a jumping or galloping animal — it can rightly be called action.

MOTION IS CONSTANT

You will find in drawing animals that, even when at rest, they move more than is obvious at first glance. A horse may be standing, relaxing in the corner of a pasture or the shade of a tree in the heat of the day, but he does not necessarily stand there like a statue. Insects are among the causes which prevent that. He stamps one foot, then another; or he slowly swings his hips to shift the weight from one hind foot to the other. He switches his tail at flies. He swings his head from side to side, and moves his ears forward and backward. Watch any animal at rest and you will rarely see it motionless for long periods of time.

THE ILLUSION OF MOTION

We have spoken before of how necessary it is for the animal delineator to grasp the local action or pose of an animal quickly, and record it on his paper. Now we focus our attention on the art of suggesting motion — an important matter, for it is no easy thing for the artist to express on paper or canvas an illusion of active movement.

Pictures are of course static, and the animals in one's picture cannot actually move across the paper or canvas. A galloping horse stays in a fixed spot in the picture, frozen into a single place and attitude. You may portray a deer soaring over a log, but it remains forever suspended in your picture. You can draw or paint only the idea or illusion of motion. You can best learn to do this by studying the attitudes of animals in motion, then showing each in the action that seems to carry it forward in the picture.

DECEPTIVE ATTITUDES

Motion pictures and instantaneous photography have both demonstrated that in every leap of the gallop an animal goes through a whole series of motions, for a galloping animal is actually leaping across the ground. (It does this, though, in exactly the opposite manner from that employed when it leaps over an object. A galloping animal has all four feet bunched under it when it is suspended momentarily in the air, while a leaping beast, in one phase of its jump, has its legs outstretched almost to the limit.) Yet, there are many attitudes, even when an animal is in such violent motion, that, being held for only a split second, do not individually convey the idea of motion at all, and if you draw the animal in some of these attitudes your picture will look static, or the animal will appear awkward in motion.

Speaking of the gallop again, here the animal doubles its legs under it and leaps forward. In this leaping action it is propelled

by the great muscles of the rear quarters. The animal strikes the ground with its outstretched forefeet and the motion carries the body forward, so that the forefeet, which a moment ago were in front of the body, are now underneath it. At the same time, the hind feet, that were stretched backward as the animal left the ground in the forward leap, are carried forward. Just before the hind feet strike the ground under the animal, for the next jump, the forefeet are lifted free of the ground and the animal is suspended in the air. Again the forefeet are outstretched before the animal, to take the weight at the end of the leap, and the action is repeated as before. It is easy to see that the legs go through all sorts of positions in leaving the ground, bunching for the next leap and stretching forth at the end of the leap. So I repeat that many of these attitudes, as instantaneous photographs show, do not convey the idea of motion at all. In pictorial representation, you must catch the animal when outstretched at the end of the leap or with legs bunched for the leap. These attitudes alone possess the violent motion necessary to create in your picture an illusion of swift action.

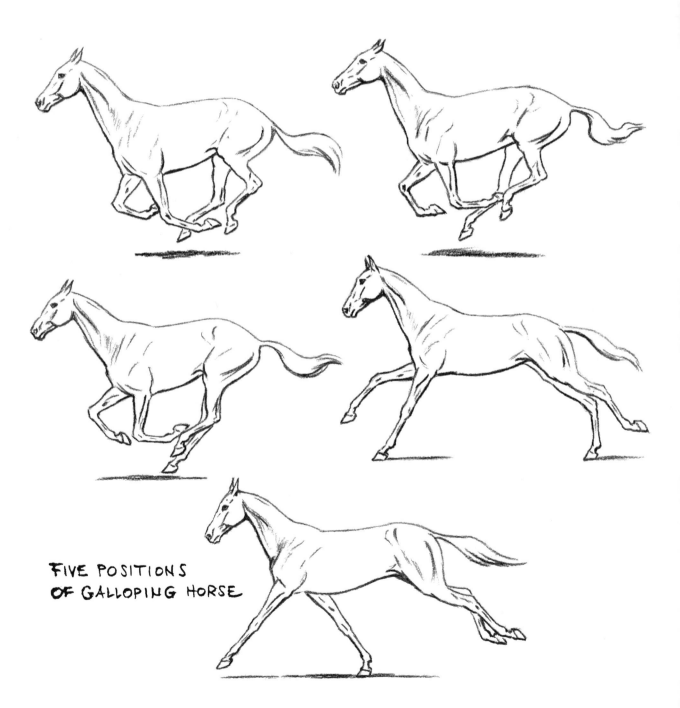

FIVE POSITIONS OF GALLOPING HORSE

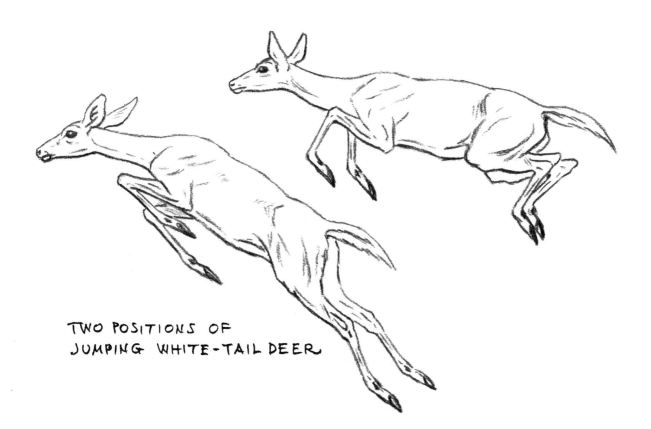

TWO POSITIONS OF
JUMPING WHITE-TAIL DEER

AIDING THE ILLUSION

If you are drawing or painting a galloping horse, you can of course help the action by showing a streaming mane or tail, and a cloud of dust. As a matter of fact, though the streaming tail helps your illusion of motion, horses actually give the tail a violent flirt or twisting motion at each jump of the gallop.

In the same way, a jumping animal — one that is going over some obstacle — can best be illustrated either by showing it at the beginning of the jump as it rises in air, or at the end of the jump as it descends. Few pictures of animals that portray them in the very middle of a jump, in horizontal position, give any indication of action. The animals usually look suspended in the air above the obstacle that has been the cause of the leap.

In other words, you must be extremely discriminating as to the exact instant to depict animal action, or you may have animals in your pictures that are correct in action, in the best instantaneous photogra-

phy style, but that are still static. Sometimes the artist even needs to take minor liberties with truth. If your jumping animal does not convey the idea of action with its legs placed in actual natural positions, then stretch them out a bit or double them up into more violent action than they may naturally assume. Do the same, if necessary, with running and trotting animals. I have seen beautifully drawn horses, supposedly running, that seemed to be standing on the forefeet with hind feet in the air. There was no forward action. They appeared to be doing some balancing trick. The artist could have avoided this by cheating a little in the arrangement of legs, thus actually conveying the idea that the animals were moving. In such cases, well-managed dishonesty creates more of a feeling of honesty than does honesty istelf!

By way of further exemplification, not long ago, I saw a beautifully painted picture of an animal that was obviously supposed to be moving rapidly. One foreleg was straight down on the ground while the rest

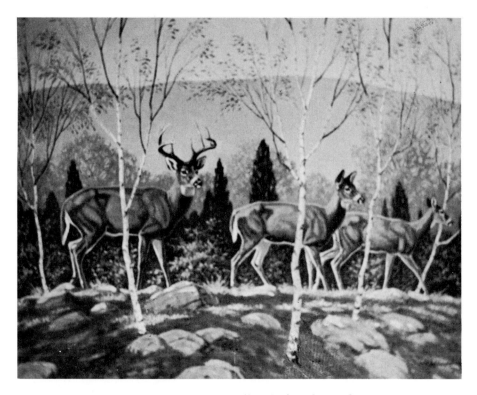

THROUGH THE BIRCHES — Oil painting, by author, of White-tail Deer, Connecticut, showing walking attitudes

of the legs were in running action. That vertical foreleg seemed to root the animal to the ground. Had it been slanted forward, the animal would have been moving at a great pace. The action as pictured was quite correct as to fact, for animals when running do swing forward with the forelegs carrying the weight, one at a time, but, if you want to create in your work a real feeling of action, your animal's legs must, as I have said, be so arranged as to convey to the observer a convincing illusion of speed, even if to do this you must throw photographic accuracy to the winds. Stated differently, the human eyes do not catch, in rapidly moving subjects, certain in-between actions which the camera can easily record, so you must show the beast as your own eyes see it. Maybe your eyes lie to you, but the eyes also tell the same lies to the one who looks at your picture.

WALKING ANIMALS

If you wish to picture an animal walking, don't just show two feet forward and two feet back, but have a knee bent and a forefoot lifted or ready to be set on the ground.

Also show a hock bent, and a hind foot bent back or reaching forward to be set on the ground. All this conveys action to the eye, and the animal seems to be moving forward in the picture. Imagination will prove your ally; if you give some indication of motion, the observer's imagination will do the rest.

ANIMALS AT REST

If you are picturing animals just standing about at rest — maybe deer in a forest, or antelope on veldt or plain — suggest that they are alive by showing tails in motion. Wild animals, like domestic species, seldom stand quietly without switching their tails, since insects usually swarm where animals abide. A stamping leg or a swinging head will also convey the idea that your beasts are alive and not stuffed animals in a glass case. If you portray them grazing, then show the feet in motion, as animals move slowly forward as they graze. Usually one forefoot holds the weight while the other is bent and moving forward for the next step that will take the animal to more grass.

An impression of life and motion can

64

also be created through ear action. Animals swing their ears forward and back. If their attention is drawn by something in front of them, the ears go forward. A sound or scent from behind, and one or both ears will be thrown back. Deer will sometimes stand with one ear forward and another back to catch sounds coming from both ways.

Avoid awkward poses, and try to utilize those that reveal animals at their best. Deer, antelope and other related animals look well with head up and on the alert. An animal posed dramatically need not show more than dormant or latent action. One ear thrown back and the tail switching will indicate that it is alive. Perhaps one foot might be lifted, as if it were about to swing into violent action, possibly to escape some threatening danger.

There is one thing that you will have to watch with care when drawing horned and antlered animals that turn the head this way and that. You will see that each turn of the head gives you an entirely different view of antlers and horns, and this can lead to difficulties if you do not draw the horns and antlers carefully. I recall how I once made a sketch of a kudu bull that was browsing on the lower branches of a tree. Its head was stretched upward and, as the animal was facing away from me, the horns swept downward over the shoulders and I was looking at them in foreshortened view from behind. The bull was browsing rather quietly, and the horns would not have been too difficult to draw, despite their corkscrew twists, had the left horn not been broken off below the tip. I had to draw it as I saw it. Later, I wanted to paint the kudu in the same position in which I had drawn it, but the broken horn gave me trouble. I did not know just how the horn would look in that position if the tip were on it. Fortunately, I had a pair of kudu horns and I posed them in the exact attitude shown on my sketch. It was then easy enough to master my problem.

THE SMALLER ANIMALS

When portraying the action of the smaller animals, such as squirrels, rabbits, etc., you will find that you can picture them out-

65

GULL

MALLARD DUCKS

PHEASANT (walking)

stretched to the limit in running, since these smaller creatures are not affected to the same extent by gravity as are larger and heavier animals. A large beast cannot run with all legs outstretched to the very limit, since it needs one foot under it at a time to support its weight as it moves along. For this reason, elephants do not gallop, for elephants cannot move forward in a series of jumps; they just rapidly amble along.

Rabbits and other small creatures travel in a series of jumps. They may do this slowly, so you can see the successive jumps, or they may scurry along and give the appearance of a gray streak moving through the woods. They bunch the legs at each jump, with the forefeet between the hind ones so that the hind feet are actually ahead of the forefeet as they leap forward. In that act of leaping, the whole animal is outstretched to the limit. Squirrels, mice, rats — all the rodents — run in like manner. They often employ this same motion, although in a more leisurely manner, when just hopping about hunting for food, although rats and mice also have a rapid and slow walking motion.

Squirrels will also walk about with alternate movement of fore and hind feet; they especially do this when suspicious of something, and when they want to approach slowly and carefully. You will see this motion when you offer a nut to a squirrel which has not yet become accustomed to being fed from the hand. It is a sort of creeping motion, entirely different from its usual mode of hopping.

Dogs and cats also stretch their legs to a greater extent when running than do horses and other large animals, and you can show this extension of fore and rear legs when drawing the action of these animals.

BIRDS IN ACTION

In drawing birds in action, you do not have to bother with galloping and jumping views, but, in the case of walking birds such as pheasants and other scratchers, you will see that the foot rests on the toe-tips as the bird moves forward and just before the foot is raised from the ground. As the foot is lifted clear, it slants forward and the toes are folded down a bit. If you show this last position, the bird will look as if it is just standing there balanced on one leg. If you want to show the bird walking, you must catch the foot as the toe-tips touch the ground.

In flight, as has been pointed out before, the wings of birds go through many positions as they flap up and down. Don't show birds with wings only half open in flight, as birds do not fly that way. When a bird

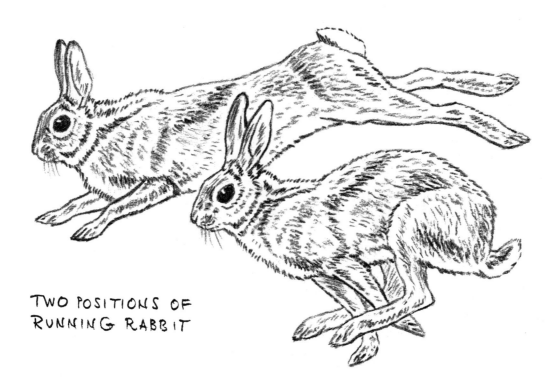

TWO POSITIONS OF
RUNNING RABBIT

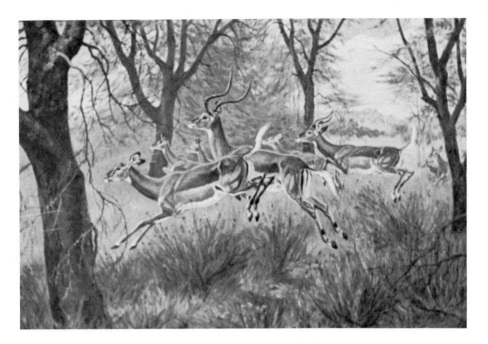

Jumping Impalla, painted from life and nature at Lake Bassotu

flies it has the wings fully extended. Wings pictured either at the end of the flap, upward or downward, will display the best motion. Wings extended at each side make the bird appear in soaring position rather than in rapid wing motion. Here, too, you will find that, as the bird is seen from various positions, the wings will appear differently. You will view the wings of a bird flying away from you from the back edge and they will appear narrow, as will wings seen in direct front view. More of the wing is visible in a three-quarter view and, of course, you can see it in true proportions in direct side view. In this position, the wing closest to you will appear different from that on the other side, since you must deal with perspective; if the bird is tilted slightly in flight, you may see very little of the opposite wing.

If you want to show a bird rising, tilt the body at an angle and keep the head up and the bill slanted a bit upward. Usually, the act of rising is best interpreted with raised wings. A dropping bird is best represented with wings held down, since it uses these as a parachute to break the fall. This is, of course, true only of birds that are about to make a landing. Hawks, in dropping on prey, will at times fold the wings rather close to the body. This allows them to descend with greater speed, and also aids them in striking power, since many hit the prey with the bent knuckles of the foot.

Remember, too, that birds not only spread their wings to fullest extent when in flight, but they also spread the tail feathers, since the tail is used as a rudder. You will notice that most birds, when alighting, will bend the tail downward just before they land to help put on the brakes.

Life and action in standing birds may best be suggested by tilting the head this way or that, as birds are everlastingly tilting their heads to look down or up. Thus one can avoid the stuffed appearance of birds which may result if they are shown standing rigidly with both feet planted on the ground and head held straight.

RAPID SKETCHES: MEMORY WORK

Try many rapid sketches of animals and birds in action and you will learn various ways of making your subjects look alive. After such practice you should be able to catch some action quickly and then draw it rapidly from memory. Once in East Africa,

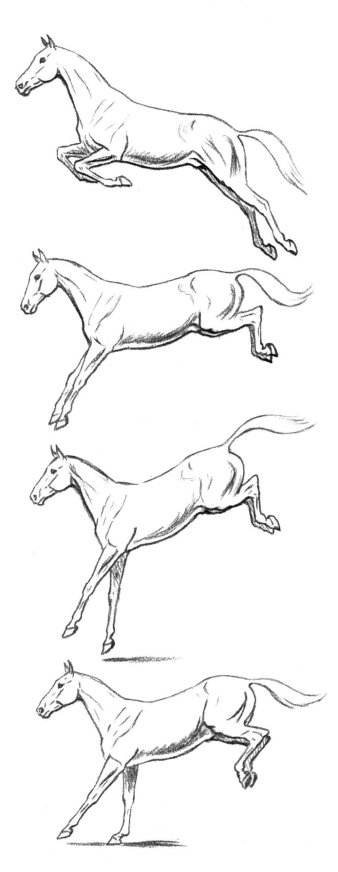

VARIOUS POSITIONS OF JUMPING HORSE

I set out to do some painting and came upon a herd of impalla. They went soaring away over the bushtops in high jumps. I had studied those impalla before and knew their construction rather well. Therefore, with my easel hurriedly set up, I was able to paint them on the jump, in the exact place where I had found them. They obligingly stopped to browse some little distance away and this made the painting easier, for I could look at them for correct colors and markings. The jumping attitudes had to be done from memory. Later, a man who did some drawing and painting happened along on safari. He saw my painted impalla and could not understand how I could paint their actions from memory. It would of course have been impossible had it not been for my previous study.

A good way to obtain action sketches of animals is to train your eye to see the animal as a whole, forgetting color, markings and other detail. Don't concentrate on any one part of the animal as you look at it, but let your gaze take in the whole form. Now, with sketchbook in hand, make rapid notes of the action as the animal moves about. These can be small, just indicating the general form and position of neck, head and legs.

If you are fortunate enough to be in a place where you can see animals running or jumping, select one, look quickly at it, and record your instant impression, simply and directly. If you look too long, your eyes will take in more than you can put down for that one moment of action. Remember that any position of the legs that you can get on paper is the position those legs were in for a fleeting fraction of a second. You can only record what you see in that momentary glimpse and no more. Look again, and, if the eyes take in another position, put that down.

After some practice, you will be able to observe an animal as it jumps across a given area and then execute a series of sketches showing the various positions it assumed while in the act of jumping. I found, for instance, that, after considerable practice, I gained the skill to watch horses galloping

68

about and bucking at a rodeo and to memorize their actions. It was subsequently easy enough to fill a whole sheet of a sketch-pad with little figures of the galloping and bucking horses. There was of course no detail, but this could be acquired at leisure by drawing studies of a horse tied in a stable-yard.

In making drawings of horse action, where the horse is jumping over an obstacle, as at a horse show, you must watch for three positions. Keep your eyes on the horse as it approaches the obstacle. You will note that it is usually galloped toward the jump, but that it hesitates momentarily as it is about to go over. Watch the action at the instant its forefeet leave the ground. Forget the rest and try to record this action on your sketch-pad. Now, when the horse again approaches the jump, wait for that moment when it is in the air and note how the feet are drawn up. Again, forget the rest and attempt to imprison this one action on your paper. Once more, watch as the horse has cleared the jump and is about to set its forefeet on the ground. Be alert for that one thing, keeping your eyes on that side of the jump. Jot it down. If you follow this method for a time at a horse show, you will have those jumping horses where you can refer to them later. The practice will also help you in drawing other jumping animals, such as deer and antelope, for they all jump much the same.

Some artists, from memory alone, as developed through years of studying animal action, can draw animals of many kinds in almost any pose. Perhaps, in time, through the grace of God and practice, you may be able to do likewise.

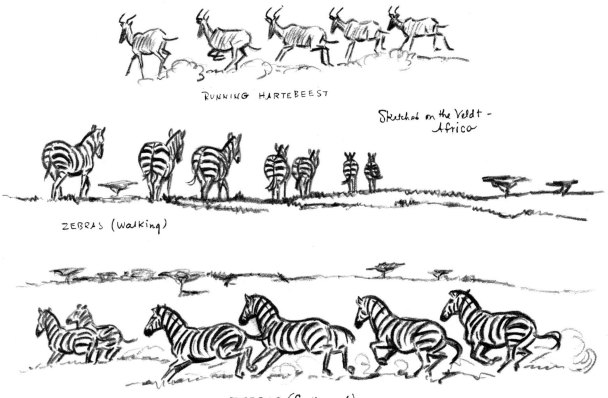

RUNNING HARTEBEEST

Sketches on the Veldt –
Africa

ZEBRAS (Walking)

ZEBRAS (Galloping)

Chapter VIII

TEXTURES AND HAIR DIRECTION

REGARDLESS of whether or not you wish to go deeply into the study of animal anatomy —see Chapters V and VI—there is one thing that you cannot neglect if you would become a good animal artist. This is the vital matter of textures and hair direction. I believe this to be even more important than anatomy. One may know the bones and muscles, the proportions of the animal, and every detail of its construction, but if he has neglected the study of textures and hair direction, he will be lost when trying to paint.

How, for instance, would you be able to make a well-groomed horse, with its satiny skin, look convincing if you had made no study of its coat? The highlights on that glossy coat are controlled in places by hair direction and texture. These in turn depend somewhat on the form of the horse. For example, highlights are noticeable on the shoulder, where it slopes away from the neck. They also appear on the hindquarters, due to the shape of those hindquarters and the

heavy muscles that lie underneath the skin. Then there are highlights on the flanks that are caused by hair direction; the hairs of the body meet the hairs of the hindquarters, growing in a different direction, and a whorl or cowlick is the result. The light catches the whorl and gives you those curved highlights that appear in front of the hips.

The hair areas of neck and head also differ in direction, resulting in other similar highlights. Look at the horse closely and you will see that the hair does not all grow straight down the face. It seems to have its source of growth in the center of the forehead, between the eyes. Here the hair grows away from a sort of focal point in all directions, up to the poll, down the face, toward the eyes and down the sides of the head.

Also, you will note that, even in certain areas on the animal that are in full light, the hair may appear darker than in other adjacent areas, due to the fact that the hair grows in a contrary direction and so catches

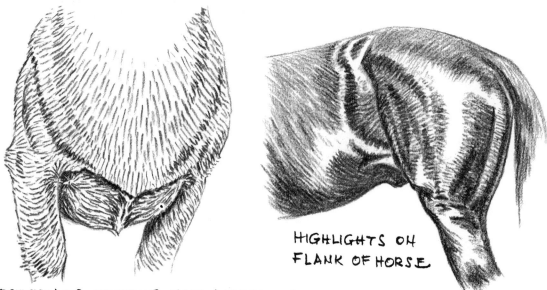

CHEST OF DOG, SHOWING HAIR DIRECTION

HIGHLIGHTS ON FLANK OF HORSE

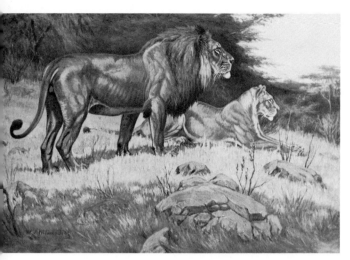

Lions, showing lights and shadows controlled by both hair direction and anatomy. Oil painting by author, Lake Bassotu, East Africa

On the lion — another short-haired animal, so far as its body and legs are concerned — you will observe a cowlick or hair focal point on the upper shoulders, from which the hair radiates in a whorled manner. In the middle of the lion's back the hair grows outward to meet hair coming from other directions, and again there is a difference of value, although viewed in the same light. You don't have to paint the hairs on the body of your lion, or on other short-haired animals, but, if you know the hair direction, you will understand how to arrange lights and shadows on the coat of the animal as they actually appear in nature; you can do this with light and shadow alone.

On longer-haired animals, you must contend with both hair direction and textures, and these are likely to be more noticeable than on the shorter-haired ones.

Notice on the collie dog how the long hairs of the neck, growing outward at the sides of the head and downward below the lower jaw, form a sort of ruff around the head. Note, too, that these long hairs grow forward from the shoulders. This can be indicated successfully with either pencil or brush strokes. On the sides of the hindquarters the hair seems to stand thickly on end, while the long hairs that fringe the back of the hindquarters grow backward and droop downward.

INDICATION

It is quite possible, without drawing or painting all the hairs on the collie, to indicate the texture and hair direction merely by following the hair direction with strokes of pencil or brush, letting the light and shadow do the rest. A few dark broken spots on the hindquarters, to indicate hair-depth, will give the impression that the hair stands outward at that place. Lost edges and blended shadows will create the effect of softness required on the collie and some other types.

the light differently. Rightly painted or drawn, such areas will give the animal the appearance of proper texture, as on the live animal.

On short-haired dogs, such as pointers, smooth fox terriers, etc., hair direction has much to do with the appearance of the dog's chest, as viewed from in front. The hair grows down over the shoulder, toward the chest, and meets hair that grows upward and toward it from the lower body. This causes shadows and highlights that, if properly interpreted, will make the dog look **right.**

It is often quite possible to express soft textures without drawing a single hair, simply by indicating the light and shadow properly and by keeping the edges soft everywhere, not only the outside edges or con-

Mountain Sheep, Wyoming. Oil Painting

tours of your animal, but also those within the outer contours. For example, once when I experimented with the drawing of fur animals in charcoal and pastel, I found that an animal — the muskrat, for instance — could be made to appear soft and furry merely by keeping the shadows soft and the outline of the animal delicately blended into its background. This treatment is successful with foxes and other soft-furred animals. Some artists prefer to let the stroke of the brush indicate the hair-edge lightly against the background, and the brush, being made of hair, naturally gives a hair texture to the stroke.

With wash or water color it is possible to make fur animals appear soft by working wet — that is, by painting in the general halftone, and, while this is still wet, by floating in the shadows, letting them blend by themselves, which they will do in a fuzzed-edge effect that will be quite sufficient to indicate texture. It is necessary in a case of this kind to have all values mixed in advance, and to work with a large brush, and rapidly.

If you wish to show soft textures with a pencil, employ a soft lead such as a 3B or a 4B, sandpapered to a chisel point. Work with broad strokes, as you would with a brush, putting less pressure on each stroke as you approach the edge of a shadow or outline; this will give a blended effect.

With charcoal or pastel it is easy to express soft effects. The drawback with the latter medium is that there is a tendency to keep everything too soft. Here and there, even on soft-haired animals, there are sharp accents and these should be recorded. A few dark strokes to indicate hair depth, where the fur breaks, and some sharpness about the head, at the nose, eyes and perhaps the ears, may be necessary, though the hair may be soft on body, legs and tail.

In painting an animal with a thick dense coat, such as a mountain sheep in winter pelage, it is possible to show the texture in oil paint by using plenty of paint, rather thick, modeling the form by following, with the strokes of the brush, both the contour

72

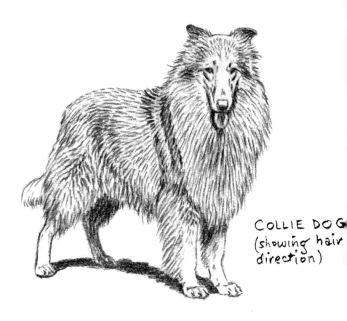

COLLIE DOG
(showing hair direction)

of the body and the hair direction. If your paint is of properly thick consistency, you will not have to paint a single hair to make the coat appear like hair, for the brush strokes will take care of that.

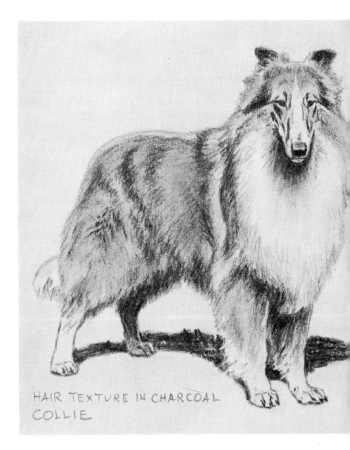

HAIR TEXTURE IN CHARCOAL
COLLIE

Here is the same Dog depicted above, showing that with a minimum of well-handled detail an adequate effect is possible

I recall how I once painted some lions with paint that was rather thick, carefully following the form and hair direction with broad strokes of a large brush. Later, when this picture was on exhibition, two men came to look at it. One of them, after sticking his nose almost upon the canvas, remarked to his companion, "You can actually see the hair on those lions." What he saw was the texture of the brush in the paint, for a bristle brush leaves the marks of its hairs in the stroke. The second man bought the picture. I imagine he is convinced that I painted each separate hair, which would, of course, have made the picture look finicky and overworked.

In the case of many warm-colored animals, such as Irish setter dogs, and bay, chestnut and sorrel horses, one can represent textures by delicately applying cool highlights. These red-brown animals actually have cool, lavender highlights playing about on their coats and, if these are indicated in the proper light value and not overdone, they will do much toward adding the proper texture.

It will also be noticed that as you look at such warm-colored animals as leopards and tigers against the light, a cool, lavender sheen is visible on the back where the light strikes it. This can best be indicated by first painting the animal in its true colors and values, and, later, when the paint is dry, glazing the cool light over the other hues.

Long-haired animals, such as bears and fur animals, may be drawn or painted by the simple process of indicating properly the light and shadow as it plays on the hair. The depth of fur can be expressed by dark strokes suggestive of the breaks in the fur. With proper light and shadow — avoiding sharp edges to shadows — and just a few breaks in the fur, you can make an animal look soft and furry without drawing or painting a single hair.

Some artists think it advisable to paint in an indication of hair in just a few places, perhaps in a soft edge against a bit of background, or on some portion of the animal that would be the focal point of the picture, letting the imagination of the observer pro-

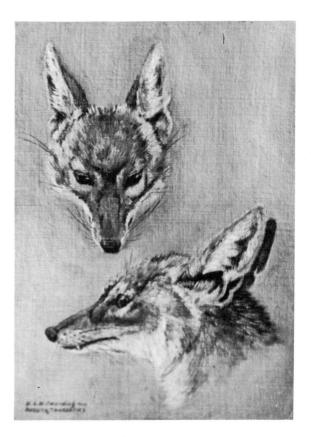

Black-backed Jackal, Lake Bassotu, Tanganyika. Oil study from life, showing hair texture in detail

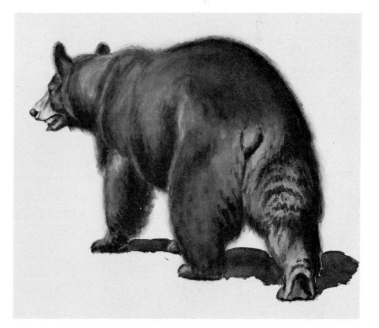

Textures of fur in wash. Observe the simplicity of the indication. The tone edges are important

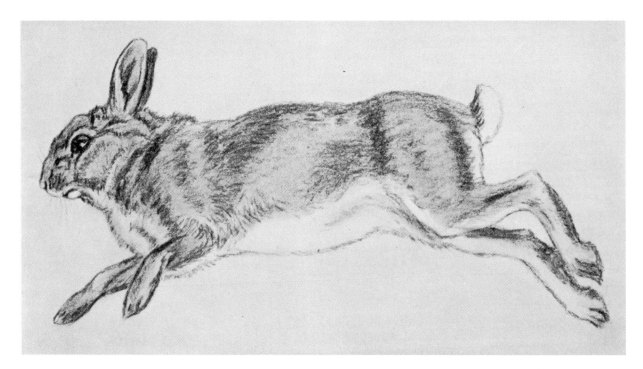

Rabbit, drawn in charcoal from the animal

vide the rest. This is done much in the manner in which one delineates a few bricks or stones on a wall, instead of painting each separate brick and stone; or a few stones on the bank of a river to indicate that all is stony.

MORE ABOUT HIGHLIGHTS

Bear in mind that animals with short, glossy coats have highlights that are very light in contrast with the general body tone, while furry animals do not. Strong contrasts would destroy the soft effect of fur on the latter. This is just a matter of considering textures. Smooth silk has sharp highlights which would destroy the texture of velvet. The same basic fact is true of animals. In much so-called modern painting, textures are avoided or neglected, and the hardness which is so noticeable in much of this work is due to this. If you wish your animals to appear hard as stone, then you also can disregard textures, but you will lose much of their true character.

BIRDS: FEATHERS

In drawing or painting birds, you will observe that some exhibit feathers that are smooth and rather hard in texture, while others have soft feathers. Many birds possess both kinds. The smaller song birds often have soft body feathers, while the wing and tail feathers are quite firm. The feathers of birds like the common pheasant are smooth and rather firm on the breast, upper back, wings and tail, while those on the lower back are softer.

Some birds, like grackles, have feathers with a decided sheen, which reflect various lights. In black and white work, this sheen must be shown with highlights. In color work, these reflections are indicated in the true hues exactly as they appear on the bird; this can only be done by carefully observing the bird itself and matching every hue.

A truer rendering of flight feathers on the wings of birds can be obtained, with either pencil or brush, if the strokes follow the direction of the webbing, just as a truer rendering of body feathers can be gained by letting the strokes follow the direction in which the feathers lie.

HORNS AND ANTLERS

Turning to animals, the hard textures of horns and antlers can best be shown by keeping edges hard and highlights sharp,

since the tines of antlers and the smooth surfaces of horns catch and reflect sharp highlights. The hard appearance of the antlers and horns on these animals will make their coats appear soft or silken by contrast, providing the lights and shadows on their bodies have been handled properly.

SOME LOGICAL AIDS

A dead rabbit, that you might purchase at the meat market, will afford excellent practice in the study of textures and hair direction, as will a fur neckpiece. The late Charles Livingston Bull, who for many years was one of the most popular illustrators of animal life, kept skins of wolves and other animals in his studio and threw these on the floor where he could study them when making his illustrations. When one does this he must use care not to be intrigued into drawing or painting separate hairs. If he allows his brush or pencil strokes to suggest the hair direction, the lights, and the shadows and their edges, he will have won a major battle in the true handling of textures.

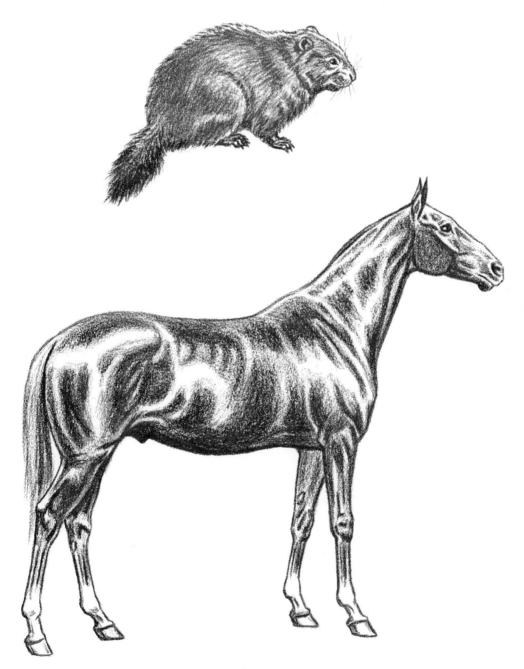

Comparison of glossy and long-coated textures of animals' coats

Chapter IX

ANIMAL COLORS

FOUR-FOOTED ANIMALS vary in color far more than may be manifest at first glance. Even animals of one kind differ greatly. I recall how a friend of mine, who was quite a hunter, once returned from East Africa with a half-dozen skins of lions, two of them so badly damaged by bullets that he asked a taxidermist to use one skin to patch the other, in order to make a good rug from the pair. The taxidermist had considerable trouble with this, since, though both skins were tawny, they were not of the same shade. As to the other skins, when they were placed side by side it was found that no two of them were an exact match.

I once had a similar experience with a client — a furrier — who ordered from me, for his store, a painting of a red fox. I first submitted a small color sketch. It did not please him. The fox, he said, had too much white on the belly and too much black running up the legs. "But red foxes are like that," was my protest. He replied that good red fox skins were not marked that way. To demonstrate his point he led me to his store where we opened a bale of red fox skins. When these were arranged side by side, it was plain that while some exhibited wide bands of white on the belly, others had narrow bands, and there were all sorts of variations. The black markings on the front of the legs showed similar diversification—some ran only a bit above the feet; others reached far up the legs.

"Take your choice," I said, "and I'll paint the one you want." He looked at the skins and decided that none was perfect. The ones with little black on the legs had broad white bellies, and those with narrow white belly markings had much black on the legs.

At last, he decided that he would send to New York for the finest red fox skin obtainable: this should be my model. When in due time it arrived, it was a beautiful, large, long-haired and thickly-haired skin, but there was more white on the belly than on any of the skins he had shown me, and the legs were black in almost their entire length. I painted it and he was satisfied.

HORSES, TOO

Horses vary still more in color, as do most domestic animals. The colors of horses are called bay, chestnut, sorrel, roan, gray, black, white, etc., but ask a horseman what color a certain horse is and often he will be in a quandary, for there are all sorts of in-between colors. This is especially true of bays, chestnuts and sorrels; put them side by side and you will find divergencies in hue between those that are called dark sorrels, light sorrels, chestnuts or bays. Many so-called black horses have considerable brown in their coats. White ones are often grizzled with gray. One would, of course, expect this among horses, since chestnuts are bred to sorrels and bays, and the offspring may have a color that is a combination of these.

WILD ANIMALS

While among wild animals one does not expect this same degree of variation (since, because of natural breeding, they follow more regular colors and patterns), even wild animals differ considerably, as we have just seen in the case of the lions and foxes. Colors are seasonal, too; deer, which are a warm-gray in winter, tend toward red in summer. Regardless of season, individual specimens vary; look closely at deer in a group and this will be evident. Some will be warmer in hue than others; some will be dark, others light.

Observe a group of black bears, as in the bear pit at a zoo, and you will find surprising differences. One will be glossy blue-black; another, brown-black; still another, almost brown; from there they will range all the way to cinnamon. Even the cinnamon bears vary from dark to light.

This divergence of color among wild animals helps the artist considerably, especially since he must show animals under different lighting conditions which will obviously further affect color appearances. There are many arm-chair naturalists in this world who think they know exactly what color every animal should be, and they are often loud and free with their criticisms of animal paintings. Since animals vary so in color, you need not worry about these opinionated gentlemen, for, if you approximate the typical color of the kind of animal you are painting, you may be sure that some individuals of that kind will possess the identical color you use.

AN IDENTIFYING COLOR

Despite these variations, there is such a thing as a common or identifying color by which you may know a certain species. In some animals this color runs so constant that furriers can select dark, medium and light skins in sufficient numbers to make perfectly matched fur coats — otherwise, fur coats would have to be a conglomeration of multicolored skins. This emphasizes the fact that the common or basic color of a given kind of animal is the thing with which you have to deal in painting pictures of animals in color.

MODIFIED APPEARANCES

This common color is often referred to as the local color. However, local color is supposed to be the innate or normal color of the animal as it appears in a neutral light, that is, neither strong sunlight, nor deep shadow. Whether or not there is such a thing as observing an animal in a true neutral light is questionable. Many factors affect color appearances. Colors are changed, for example, by reflections of other things nearby. You might think, for instance, that you are observing a red fox in true neutral light as it stands in the woods in neither deep shade nor strong sunlight, but reflections from green foliage, a blue sky, or brightly sunlit white clouds, could easily influence the color of that red fox. The reaction of your own eyes to the colors surrounding that fox would also influence its apparent color. Look at it long enough against a green background of foliage in strong sunlight and that vivid green would make the fox appear much more red-orange than it would against a gray rock. Turn your eyes from the fox and let them rest for a time on a gray rock; then look at fox and green background again, and everything will appear more vividly colored than before. (I am taking for granted that your eyes are at least typically susceptible to color influences. This varies in individuals.)

What I have been trying to emphasize is that such a thing as a true local color really does not exist. You view a thing in a certain light and you see its color in that light, and as influenced by its surroundings.

FURTHER ILLUSTRATIONS

I have the head of a hartebeest, or kongoni, hanging on the wall of a room adjoining my studio. There are times when this head seems to be a neutral tan color; yet, when the late sunlight comes through a window, that head appears a vivid orange-brown, almost red. In the bright African sun, these animals look as red as light sorrel horses. In the shade of a tree, they seem tan and even grayish-brown in places. In deep shade, against a sunlit veldt of yellow grass, they appear dark brown and, sometimes, almost black.

When I was a young lad collecting specimens of small animals for my work, I shot a red squirrel that looked a rich orange-red in sunlight. Studying it in the shade of a tree, I wondered why I had thought it so brilliant in hue. Haven't you seen a bird that appeared particularly brilliant, as it flashed by in the sunlight, only to see it alight on a limb in the shade and apparently lose its brilliance? That is what light and shade will do to color.

Stated differently, an animal or bird is the

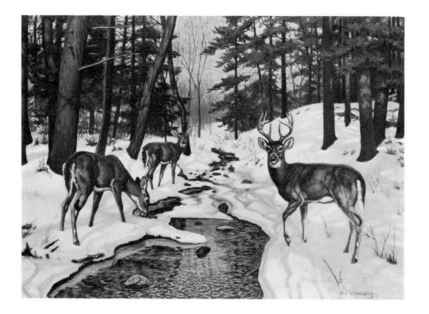

color it appears in the light, and in the surroundings, in which you are viewing it. Look at two white horses, one under a tree in the shade and the other in the bright sun. If you paint them both white, the whole picture will be wrong, for the one in shadow appears darker. It may have some green in its color if there is much green grass about. There may be blue in its color, if it appears against a yellow field. The horse in the sun will have yellow in its color, and even blue reflections from the sky on its back. Underneath, it will reflect the warm colors of grass and earth that are warmed by the sunlight. These same warm, underneath reflections will not be so noticeable on the horse standing in the shade.

The layman or novice, knowing that a certain species of animal has a common or identifying color, may wonder why, if there is such a thing as a common color, the artist can't paint this animal in that color, ignoring all other considerations. But the layman doesn't know, as the artist does, this basic fact we are discussing — that though an animal may be referred to as white, there is no such thing in nature as fixed, unchanging white, or, for that matter, any other hue.

Even artists can be fooled! I recall how once an artist friend criticized a painting of mine showing two white dogs standing in the snow. The light was back of the animals and I had a brilliant light in a sort of halo effect on the coats of the dogs as they stood against the bright light. He argued that snow was the most brilliant thing in nature and that the dogs must appear darker. It happened that the snow in the distance, which formed a background for the dogs, was in shadow from a forest, so those white dogs must obviously look brilliantly lighted against it. Often a white dog will look darker than snow, and even a bit more yellow, but in the case of the light back of a white dog, the hairs often catch the light and surround it with a brilliant outline.

A white cat sitting on a window ledge and viewed from indoors will look dark against the light outdoors, but, should the sun strike that white cat, it will appear much lighter than the outdoor colors that you view through the glass. The same cat, with the setting sun on it, will appear orange, and you must paint it orange if you want it to be correct as it looks in that light.

We have already seen that animals that are brown or reddish-colored will usually appear many shades warmer — almost red — in bright sunlight. The lower the sun, the warmer-colored they will look; bathed in a red sunset color, some of these animals will seem red-orange. Tan ones appear a golden

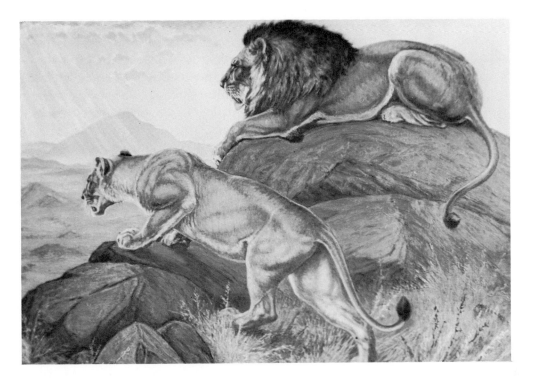

LIONS — Oil painting by the author, Lalgarjin, Tanganyika. Shows male darker in color than female, the male being a tawney olive and the female light taffy.
Property of George L. White, Cos Cob, Connecticut

bronze in this light, and white ones light orange, even pink at times. Black animals take on very warm hues in the light of the setting sun — sometimes a warm purple color.

Gulls flying against the sun will look dark, but, when the sun is on them, the same birds will stand out in the most brilliant white against gray clouds or a blue sky. A touch of yellow in the white, when you paint them, will make them seem even more vivid.

Sunlight in space is said to be pure white light, but as it comes through the atmosphere it takes on a yellowish quality which causes it to turn things warm in color. In painting, you must therefore resort to yellow to interpret a sunlight effect.

HIGHLIGHTS

In the chapter on textures, I have referred to the cool highlights on warm-colored animals, such as red setter dogs and dark sorrel horses. These highlights actually appear lavender, and the usual explanation, that

this hue is the cool reflection from the sky, is so much unadulterated nonsense. I have observed these cool highlights on reddish-colored animals when there was no possibility of getting reflections from a blue sky. Mix that reddish-brown color on your palette and then blend white with it to make it light and you will note that the color cools as it becomes lighter. When you see the cool reflections on the animal, you are observing places where a strong light has diluted the color of the animal until it looks very light; in other words, the light has highlighted those places. In doing this, the light has turned the colors cool; they appear still cooler or more lavender to your eyes, since your eyes view them in contrast with the surrounding warm color.

COLOR VISION

The reaction of the color nerves in your eyes is another factor which has as much to do with the colors you see on an animal as has the action of light. Sit before a brilliantly sunlit landscape for a time and sketch

it in colors and you will find this out for yourself. As you look from the vivid colors before you to the pure colors on your palette, your eyes, somewhat exhausted, soon begin seeing things that they would not see under other, more normal, conditions. Your paints themselves may seem to turn dull gradually; your painting may do the same thing, even though quite bright. Sometimes a sketch which has appeared drab to my tired eyes has exhibited satisfying color when viewed later, after my eyes were rested.

You can easily test this for yourself. Place a piece of bright red paper in bright light and hide part of it with a piece of black paper. As you stare at the red, it will gradually seem to grow more and more dull, because certain nerves are becoming temporarily fatigued. After a minute, remove the black paper, and, in a second or two, the part of the red paper which has been hidden by the black will appear far more brilliant than the rest. (If interested in such "after images" and other visual phenomena as they affect the painter, let me refer you to *Color in Sketching and Rendering*, by Guptill [Reinhold].)

ARTIFICIAL HUES

The brilliant blues, purples and other bright colors that artists often put in their shadows are sometimes the result of looking too hard at sunlit colors and the pure paints on the palette. These men may argue that they saw these colors that way; perhaps they did, but if so their eyes were temporarily lying to them. The nerves registering one color have become very tired of that color because it is too bright with light. Then the nerves registering that color's complement come to the fore and make one see things he would not see under normal conditions. If colors begin playing tricks with your eyes, rest them from time to time by looking at neutral colors or shadows. Maybe you won't have this trouble, as eyes vary in individuals, but many eyes are super-sensitive to colors. You will soon find out about your own when you begin painting from nature. Since artists work with many colors on the palette, their eyes are particu-

larly sensitive to colors, or soon become so through the unusual exercise of the color nerves.

In my youth I studied with a landscape painter who was forever painting violet and purple shadows on grass. The grass appeared a cool green to me, as compared to its warm and lighter green color where the sun shone on it. The painter looked at the brilliant light on the sunlit grass and his eyes saw purple and violet where there was shadow. He would have been insulted had someone told him that he was color blind, for he would have argued that he could see brilliant colors where others could not. I firmly believe that a person who sees purple where others see blue-green is color blind at the time, even though he may have normal color vision otherwise. I mention this matter of eye exhaustion not as an abnormality of an individual, but as something with which most artists must contend, and that must therefore be recognized if they would do good work.

It is, of course, perfectly all right — and advisable at times — for one to put some of a color's complement in its shadows, but for him to paint the entire shadow in that complementary color is not only an insult to nature, if he is trying to be realistic, but an insult to the people who view his picture. Orange animals with purple shadows, and white ones with pure blue shadows, may appear colorful, but one had better neutralize those shadows if he would make them appear as they do to eyes that have not been looking from one pure color to another on the palette. Most people do not have to look at bright and varied colors all day, as artists do, so colors appear more neutral to them. One's pictures will be more acceptable if they are a bit too neutral rather than a bit too bright.

BACKGROUNDS

To change the subject a bit, you will discover in studying animals, as you find them in their natural surroundings, that most of them fit readily into their backgrounds. With very few exceptions, animals are rather neutral in color, running the

whole gamut of warm and cool grays, and warm and cool browns. Because of this, they blend so easily in color with their surroundings that often, unless they move, it is difficult to see them. In short, nature has provided them with the perfect camouflage. I have at different times run suddenly upon a deer in the woods that I did not see until it became alarmed and moved off. A gray mountain sheep lying among the rocks is hard to detect. Even such animals as some of the striped antelope of Africa — bushbucks and kudus — are not easy to see at first glance when they stand quietly in the bush. Large beasts, like the elephant and the rhinoceros, blend readily into the shadows of their native bush country and, even in sunlight, their gray colors look like those of tree stems and thornbushes.

Since nature fits animals so naturally into their surroundings, the artist is often wise to follow the same plan in his paintings. Some of the best animal paintings I have seen are those in which the artist repeated in the background the colors of the animal.

Remember, in painting black animals, that black is only black under certain conditions. In warm light, as has already been pointed out, black turns warm in color. Under strong light, black is not black at all. A black animal standing out in the sun appears, where the light strikes it, very many degrees lighter than black. It may be black in the shadows, but, if some light is reflected from warm-colored grass, earth or rocks on the ground, the lower part of its body will reflect that warm color. Often, an animal that looks as if its local color is black will be found to be distinctly brown — with perhaps a purple touch — where the light falls upon it. Sometimes there are cool lights, even blue reflections, on black animals.

COLOR NOTES

I have found it an excellent practice, and very helpful in my work, to make notes of the colors of animals under certain lighting conditions, standing before each animal and carefully jotting down all the colors in light and shadow. In doing this, one must, of course, have some basis from which to work. There are no standard names for many neutral colors, so mostly they go by such names as cool-gray, warm-gray, brownish-gray, yellowish-gray, etc., which, if one looks at

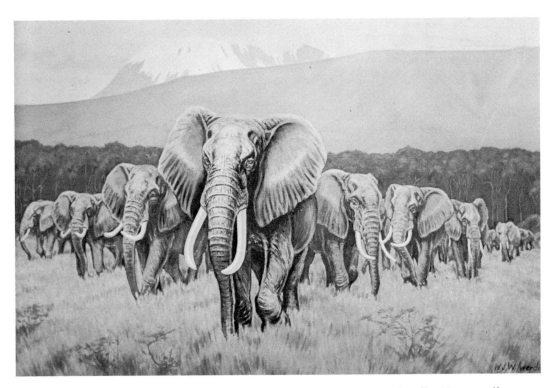

MARCH OF THE GIANTS — Oil painting by the author, Lalgarjin, Tanganyika

his notes later, may mean nothing at all. In my notes, I compare the color of the animal before me with that of some other animal that I know very well. I might, for instance, make a note that a certain animal is slightly warmer in color — more yellow or red — than the warm-gray of the deer in winter. Or I might note that an animal is just a trifle more yellow than a light sorrel horse, or that another is colored like burnt umber mixed with white and a touch of yellow ochre. Those notes mean something to me. I might get a little off the color when painting, but, as I have pointed out, animals of a kind vary, so my painting will still be close enough to the general color of that species of animal.

MY PALETTE FOR ANIMALS

Such colors as Venetian red, yellow ochre, ultramarine blue, raw and burnt umber, ivory black, and white I find most useful in depicting the colors of animals. With that rather limited range you can paint almost all animals that roam this earth. Of course. if you wish to paint the brilliant colors of an old Mandrill baboon — the way he appears fore and aft — you will have to add vermilion and cobalt blue to your palette, but I don't know why you should want to paint one! Still, you never can tell what artists will choose to paint—or what the public will buy! I once painted a group of baboons around a water hole in an East African forest, for the sole reason that I wanted to. Yet many people who viewed the picture liked it. One man saw it on exhibition and bought it. I really believe that I could have sold that subject six times.

Antlers of animals are warm-hued and can usually be painted with such colors as yellow ochre, raw and burnt umber and white. Horned animals — especially those that have ringed horns, such as waterbucks — generally have black or dark brown horns, sometimes with touches of ochre.

Usually, where animals appear small in a landscape, the artist does not worry much about the color of eyes. Where they are painted larger, one must, of course, indicate this color. Eyes vary greatly from a very dark brown (almost black) to yellow and whitish-yellow. Some animals, like the hartebeest, have golden-brown eyes. The eyes of mountain sheep are light, while deer possess dark eyes. Most antelope have dark brown eyes. The eyes of cat animals are light colored as a rule, many being light ochre.

COLORS FOR BIRDS

In painting birds, one normally indicates the correct colors of the eyes, since birds are usually painted life-size or close to it. (Obviously, in painting birds at small size in flocks, it is not necessary to pay any attention to eye color.) Eyes of birds vary considerably in hue; many birds have red, yellow, orange or even white eyes. When it comes to their legs, feet and bills, there is also hardly a color that is not sooner or later found. Since their plumage likewise runs the gamut of every known hue, in painting birds you will need a far greater color range on your palette than when painting animals.

Though birds are of course animals, bird painting, in my opinion, is a separate thing from animal painting. If your interest is in painting birds, you will have a far greater range of colors to study and make notes on than in painting animals. It is a lifetime job in itself. However, many painters of animals do very well with birds and many bird painters do equally well with animals, though this is not always so; specialists in either line often produce disappointing results when they attempt the other.

FILING FIELD NOTES

Whichever you choose as your first love, make color notes everlastingly and preserve them systematically so that you will know where to find them. I keep my field notes properly classified, available for instant reference. Notes are of little value if made in haphazard fashion, and of no use if you cannot find them when needed. Artists as a class apparently do not like to be methodical, but I have found the methodical ones the most successful in their work; and this applies especially to animal and bird painters, who must make their notes and sketches afield or in the zoo.

Chapter X

MARKINGS

IT HAS always been my custom in drawing and painting animals — whether mammals, birds or fish — to draw the form first, very carefully, and then to fill in the light and shadow — in color, of course, in the case of color work — after which I add the markings of stripes, spots or rosettes. Working in this manner, once the modeling of the basic forms is completed — whether in color, or in light and shade only—it is so much easier to see whether the markings should be light, medium or dark; also how they can be made to follow the form and help express it. When adding stripes, one must watch with particular care this matter of following the form, or the animals may be made to appear flat as the side of a room. A zebra, for example, has a well-rounded body; let the stripes suggest this roundness unless you want your zebra to look flat.

In this connection, don't forget that the markings of an animal, like its basic forms, are subject to the laws of perspective. Any one of these markings will appear in true form only when we look directly at it; *i.e.,* only when the line of sight from eye to surface is at right angles to that surface. When an animal is in profile view, therefore, its markings will be seen in true shape and size only on its sides. As they round over the back, belly or rump, they will appear in foreshortened form and must be so drawn. To illustrate this point, we know that a round plate appears as a true circle only if we look straight at it. Seen somewhat from the side, it appears as an ellipse. That is the way rosettes and round spots on animals look. Another point to remember is that stripes which look wide when seen in direct view become narrower, through foreshort-

ening, when viewed in perspective. If one can keep all these things in mind — if he can get his markings right in light and shadow and in perspective — they will not only appear to follow the form, but they will actually aid in expressing the form.

LIGHTING

The values of the markings obviously vary according to the direction and strength of the light which illuminates the animal. With a strong light from above falling on an animal's back, the way it usually does out-of-doors, even dark markings on the back look very light. On the sides, such markings seem darker, and, underneath, darker still. Be careful therefore not to draw or paint your animal with a strong light on its back and then show black markings in that area. Also in the case of white markings, do not picture them the same in value in the shadows as in the light. While the white markings in shadow areas will of course be lighter than the body color, they will be considerably darker than in light areas. In very dark shadows, white markings may be lost entirely. In short, the values of markings must be consistent with those of the immediate surroundings.

RESTRAINT

Avoid making markings more obvious in your drawing or painting than they appear in the living animal. It is often the tendency of beginners to overstress them. If you lean either way, it is far better to restrain markings a bit than to accentuate them. It is also well to soften the edges of markings slightly, so that they will not appear too harsh, but will seem to be a part of the animal. In plain words: try to avoid the effect that someone has painted the spots

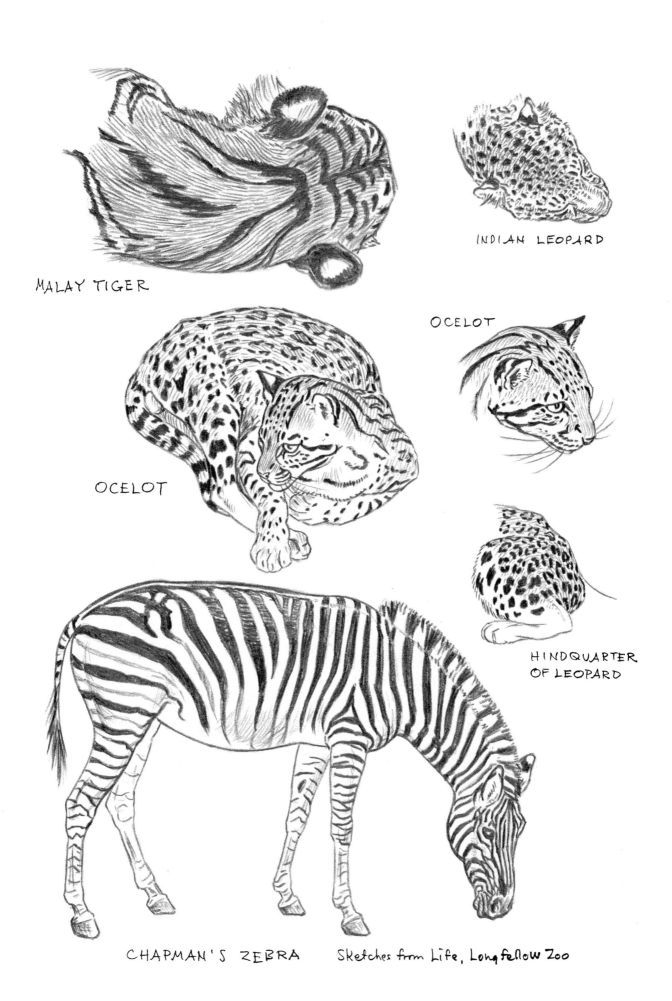

MALAY TIGER

INDIAN LEOPARD

OCELOT

OCELOT

HINDQUARTER
OF LEOPARD

CHAPMAN'S ZEBRA Sketches from Life, Longfellow Zoo

or stripes on the animal. A good painting looks like the thing it is supposed to represent and the paint is not obvious.

THE TIGER

A tiger is a yellow-brown beast, close to orange in some lights. It has white below, inside the legs, and a good amount on the head. In painting the tiger, these colors must have primary consideration and you will do well to follow my scheme and first draw, paint, and finish the modeling of your subject, as though it had no stripes. After that, black stripes can be added; they will of course follow the contours that you have already shown. It goes without saying that, unless you know the general pattern or arrangement of those stripes, you will run into difficulties. The stripes have a distinct arrangement on the head; also on the neck, where they begin at the base of the head and run backward and downward. Above the forelegs, they extend forward and backward. On the sides they run from the back downward, with occasional breaks. On the hindquarters, certain stripes run forward and

WHITE-TAIL
DEER
From Specimen -
Minnesota

others backward. This general arrangement holds for all tigers, but the stripes vary on every individual and no tiger is striped the same even on its own two sides.

ZEBRAS

As to zebras with their conspicuous stripes, the general body color is a sort of creamy white or light buckskin. The lower side is whiter, as are the legs. The stripes are dark chocolate brown, looking black in some lights. The highlights of these dark stripes are cool. The manner in which the stripes are arranged varies with different species, each species having its own individual pattern of stripes. No two zebras are ever striped exactly alike and, again, no zebra is ever striped the same on both sides. To make zebras look right you must study the striping arrangement. This is sometimes difficult to do from life. I did it in Africa by shooting them for my studies. You can perhaps best study the arrangement from photographs. Naturally, if you want to pic-

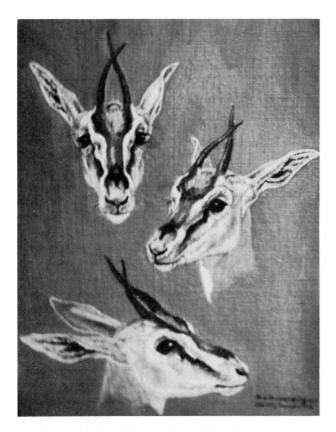

Thomson's Gazelle, female. Oil study from animal, Lake Bassotu, Tanganyika. The horns are deformed; usually they do not cross

85

ture zebras in various positions in a group, you will have to refer to photographs showing how the striping looks in those positions.

LEOPARDS, JAGUARS, OCELOTS

In sketching and painting such animals as leopards, jaguars, ocelots, etc., you must contend with similar problems. Each species has its own pattern of markings — a pattern which the stripes, spots and rosettes of all animals of that kind follow. As with tigers and zebras, no two specimens ever exhibit *exactly* the same markings, however, and no two sides of any animal are ever exactly alike.

In the case of both the leopard and jaguar, the rosettes on the shoulders and forequarters are broken up into spots. In other words, the rosettes, though present, are not noticeable, because they are thus made up of small spots. On the sides, these rosettes are also broken, and the spots enclosing them are fewer. On the legs, the spots tend to be round and to fuse in places. The jaguar has larger rosettes than the leopard, and there are spots inside the rosettes which the leopard lacks.

A well-meaning artist friend once advised me to paint only a few spots on a leopard and leave the rest of the animal without spots. His claim was that I could not see all the spots at one time any more than I could see all the leaves on a tree. I doubt very much that you or any other artist could foist an incompletely spotted leopard upon the public. After all, when you paint a leopard you are picturing it as it is supposed to look. If you inspect a leopard in a cage, you can let your eye rove over that whole leopard and study the spotting. Why should the observer be robbed of this pleasure when looking at your picture? I think this focal point business — this trick of concentrating attention on one limited area — has been overdone. If the artist carefully painted only the focal point in a picture and left the observer to imagine the rest, then why not paint a person's portrait by showing the face nicely painted and letting the hands appear as so much flesh-colored mush? For the satisfaction of most art or animal lovers, if you are going to draw or paint tigers or leopards, give them all of their stripes and spots. They are so marked, and that is how they should be made to appear.

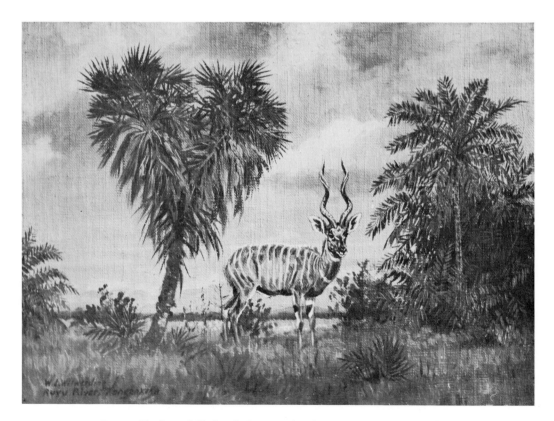

Lesser Kudu — Oil sketch from animal and nature, Ruvu River

Not that you need to be too pernickety. Whatever your animal, if you follow the general pattern arrangement of stripes, spots or rosettes, you can vary their shapes and usually even their number. In other words, while the general arrangement and effect must be there, you need not copy every last spot and rosette in minute detail any more than you need draw or paint all the hairs on the animal.

ANTELOPE

In drawing the various members of the antelope family, you will note that many have distinctive markings, such as black bands on faces and legs. In some species — notably the oryx and certain gazelles — there are likewise black bands on each side of the body between fore and hind legs. Many of the antelope group have dark bands running down the face that appear as if they passed right through the eyes. Some, like the gemsbok, have the face marked to look as if they wore a halter. These markings are characteristic and should be noted carefully in your studies.

Animals like the impalla antelope and some species of gazelle are three-toned on the body; that is, the back is darker than the sides in a distinct band, and the belly is marked off sharply in white. The white of belly on these and other animals often runs downward inside the legs and shows as a white line back of the forelegs and in front of the rear leg, from stifle to hock joint.

Many horned and some antlered animals have the lower part of the head white, and this white often runs downward on the neck or throat. This is especially noticeable on our deer. A great many deer, for some reason that nature knows best, are also light-colored around the eyes.

Many African antelope, including the bushbucks, bongos, nyala, kudus and elands, have white stripes on the body. Usually these start at a light stripe along the middle of the back and run downward on the body in a vertical manner. On bushbucks they are more broken. They vary in number on the different species. On the lesser variety of kudus, for instance, there are more stripes

87

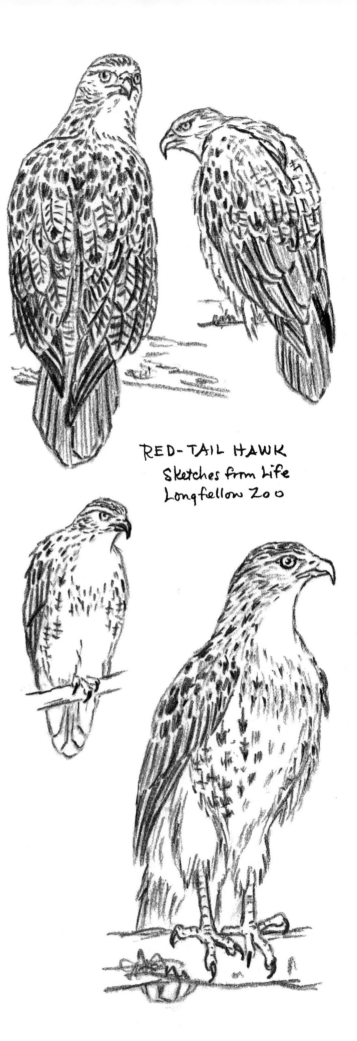

RED-TAIL HAWK
Sketches from Life
Longfellow Zoo

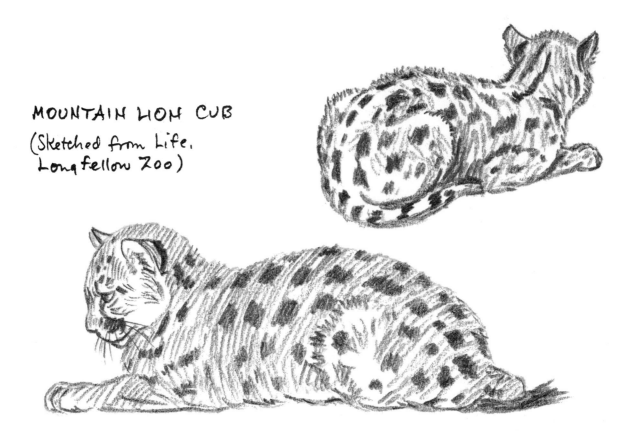

MOUNTAIN LION CUB
(Sketched from Life.
Longfellow Zoo)

than on the greater kudu. Also, you will note on the lower neck of the former a sort of half-moon area of white. A similarly located white area is also very pronounced on our American pronghorn antelope, where the markings extend backward along the sides of the neck. On this last-named animal, the white color of the belly extends far up the sides.

As an incidental detail, there are often little white spots, or black and white markings, just above the hoofs on many horned animals, particularly antelope of Africa and India. These are characteristic markings, and, unless the feet are hidden in vegetation, they should be shown.

THE GIRAFFE

In the case of the giraffe, there are three rather distinct types. The northern type is spotted with irregular rhomboids. The second or reticulated type is marked just as its name implies, in a sort of network of lines; that is, rhomboid spots are present as on the northern variety, but they are so close together that the light lines between form

a regular network all over the animal. It is really as if the animal were not spotted, but brown or tan in color with a light network over all. The third or southern type, which extends up into Tanganyika and southern Kenya, exhibits spots so broken around the edges as to look like leaves instead of rhomboids.

THE LIONS

Many animals that in maturity are rather plain in coloring have spots when young. This is true of the lion. Although its spots are noticeable to some extent on the mature animal, the casual observer gains only the general effect of a tawny, unspotted animal. Our own mountain lion, by the way, is spotted in early cubhood.

IN AMERICA

Our large American animals are, happily, not so patterned with stripes and spots as are those of the tropics. With the exception of the aforementioned pronghorn antelope, which is rather strikingly marked, our mature deer, elk, moose and caribou are neither striped nor spotted. Fawns of deer and elk

88

Northern Pike, sketched from fish, Minnesota

exhibit spots, a thing of interest if you wish to picture the young animals. The young of moose, caribou and pronghorn are not spotted, however, nor are the young of mountain sheep and goats.

As a final word on animals, it is self-evident that instead of trying to give you the markings of all species, I have merely called your attention to the kind of things to look for, whatever subjects you may choose.

BIRDS

In drawing and painting birds, you will run into a multitude of markings that vary considerably on different species. In the case of birds which are barred, streaked and spotted, like the hen pheasant, or the hens of mallard or pintail ducks, it sometimes helps to study individual feathers on different parts of the bird; for instance, on back, shoulders and breast. You will find the individual feather rather easy to draw or paint. You should try this — it will make the markings of the whole bird more understandable and therefore easier to represent. Don't feel you have to paint every feather, though. Since, on the complete bird, the feathers so overlap that each individual feather does not show, you need only mark a few feathers and indicate the rest by suggesting light edges, bars or spots. With a bit of practice you will find that this indication is not difficult, but it is well to study the general pattern of the spots first, as suggested in drawing animals. Underneath the markings,

incidentally, there will be a basic color, as in animals, to which the markings will be added. Be sure to get this color right.

THE COCK PHEASANT

My method of painting the markings of a cock pheasant is to paint the bird first in all its varied body coloring, carefully modeling the form in light and shadow as this is done, and blending one color into another in places where they blend on the bird. When this underpainting is dry, I add the markings, being careful to give the appearance of overlapping feathers, since the edge of one feather overlaps the one beneath it in a sort of shingled effect, and, in so doing, hides part of the markings of the other feather. Since in certain lights many of these markings have green and violet reflections, I use dark blue mixed with a bit of black, to make the markings appear black, and then add the light touches of green and violet. If the picture is done in oil paint, I do this while the paint is still wet. Painting into pure black oil paint when wet would sully the color of the reflections, which is not the case to any great extent when dark blue and black are mixed for the dark markings. With water color and tempera, you have no such worries, but here, too, I would advise blue mixed with black, instead of pure black, since this mixture has more life. Burnt sienna mixed with Prussian blue, or umber mixed with either Prussian or ultramarine blue, will also serve as a substitute for black.

89

GENERAL

Many birds like grouse, hen pheasants and hen ducks have a light buff or grayish-buff body color, with darker brown and black markings. It is best to paint and model them in this general body color and then to add the markings, as just suggested for the cock pheasant.

As already hinted, you will find in studying the markings of birds that, while these are usually arranged in more or less regular rows, there is considerable variation. Avoid too great a regularity, therefore, as it can easily make drawings and paintings of birds appear stiff and monotonous. In looking at birds drawn by many bird artists for books on bird identity, you will note that the markings are often far more regular than on the live birds. Much of this work is done in painstaking detail, and there is no question that the artists know their birds, but a stiffness and an artificial character creeps into such work because of the too distinct regularity in pattern of markings. A few breaks in a line of markings, or a wavy line of dots or dashes instead of a straight line would come much closer to the living bird.

Sometimes you will find these markings V-shaped, sometimes like arrowheads, and, again, there will be V-shapes or arrowheads with small irregular dots either above or on the outside border of these markings. Study the shapes and arrangements of all such markings, and their drawing will not be difficult.

FISH

The markings of any one kind of fish are also much alike in arrangement, yet, as in birds and animals, there are the usual variations in individuals. On brook trout, there are vermicular markings along the back which may at first look difficult, but they will prove relatively easy to indicate. The markings are noticeable because they are light in contrast with dark, or vice versa. If the body color of a fish is dark, paint this first; then, when this is dry, add the vermicular markings in the lighter color, keeping in mind that it is not necessary to copy each mark precisely as you see it on the trout. Note the general wormy trend of the markings and follow this in your indication. If you get these markings approximately right, they will look right. After all, we know that such

A SPOTTED ROGUE — Oil painting by author, African Leopard, Ruvu River

markings differ on every trout in the stream.

In the same manner, in the case of a pike, you first paint the dark body color and white belly and then add the small light-colored markings on the sides. These should not be too large or too small. If you make them too large, the pike will appear to lack spots; if too small, it will be over-spotted.

It is bad practice to put in the markings first and then try to paint the body color around them. This will result in messy work, whatever your medium. In the case of oil or tempera, light detail can easily be added over darker underpainting beneath. If you are working with water color, however, to have it show light on dark you will need to turn to opaque paint. Naturally, if the fish is light-colored and you wish to add dark markings, as present on some kinds, you paint the fish in its light color and then add the darker markings, in which case you do not have to resort to opaque paint for water color. The same will of course apply to wash drawings of fish.

AT A JUNGLE POOL — Oil painting by author,
Leopard in Rau Forest, Tanganyika. Courtesy of
the Zoological Society of Philadelphia

Chapter XI

BACKGROUND MATERIAL

ONCE YOU HAVE progressed in the drawing and painting of animals until you know how to construct them correctly, place them in proper action, and handle them in light, shade, color and textures, you will have gone a long way in acquiring the art of depicting animals realistically, but your task will not be fully complete until you have also learned how to paint the natural settings in which they are found.

In the preliminary stage of my studies to become an animal painter, I spent many years in drawing and painting animals in zoological gardens and circus menageries. Looking for recognition, I sent my life drawings to exhibitions, and the judges invariably accepted my work and it was hung. This encouraged me to produce paintings, which I also sent to exhibitions, and which without exception came back rejected. I was fortunate in that some of the artists on these juries were kind enough to offer a few words of advice. They told me that my animals were all right, but that they did not fit into their surroundings. In plain words, my backgrounds were insufficient. I had spent so much time in drawing and painting animals that I had entirely neglected the study of landscape painting.

I am fully aware that, if you are interested only in doing black and white drawings, you need little in the way of backgrounds. Dog artists who make etchings or crayon sketches, rarely show much in the way of background. Some simply present the dog with a cast shadow beside it. Others picture a puppy with a shoe, or some other accessory, and let it go at that. Sometimes the artists who paint horse portraits depict them with nothing but a vague background of various tones, in the way portraits of people are so often handled; or, where the whole horse is shown, they include a bit of fence, a few trees, some sky and clouds, and the thing is complete. Even for such a treatment as this last, you need to know how to express distance and how to paint trees, skies and clouds. Also, when you step into the realm of wild animal painting and you wish to picture animals in their natural surroundings, you not only have to know what these surroundings are like, but you must be prepared to draw and paint them as well as you do your animals, else they will suffer in comparison.

I well recall how, years ago, I read a review of an exhibition of animal paintings. The exhibitor was a new man in the field and he had been given his chance at a one-man show. The critic wrote, "The animals are well done, but the backgrounds are entirely inadequate." This would have been a fitting criticism of my own paintings as they looked when I first sent them to exhibitions. Fortunately, I early learned of this crying need in my own work, and immediately sought a well-known painter of landscape under whom I studied for two years.

I hadn't worked long with him before I found what was wrong with the landscapes that I had smeared about my animals. They lacked authenticity; I had been making them up, with a total disregard of colors and values as seen in nature. My instructor wasted no time with me in the studio. We bundled up our canvases and paints and went outdoors to paint directly from nature. I was at it but a few months before a jury of selection — one that had rejected my work before — accepted one of my paintings for exhibition. They dropped me a line saying,

"This is the best thing we have ever seen from your brush. Your animal fits naturally into its background."

DIVERSIFIED PRACTICE

Obviously, one's outdoor practice should be diversified. In my own case, since wild woods intrigued me and I wanted these for my wild animal backgrounds, I spent so much time, at first, painting bits of woods that I neglected skies. Then I found that, when I needed an expanse of sky and clouds in a picture, I was lost. I corrected this by doing nothing but skies from nature over an extended period. At the start it was difficult; the clouds would not stand still. I learned that a quick outline of some interesting cloud form was necessary; then the colors should be painted in from the same cloud, even though it constantly moved and changed its form.

I also discovered that a careful study of water was essential, since moving water and calm water with its reflections, as well as cast shadows on water, were things that one could not remember through observation alone. Here, as in the case of animals, one must sit before his subject and paint it thoughtfully if it is to be impressed upon his memory.

In short, if one makes a concentrated effort, as he sketches from nature again and again, to remember how trees, ground, rocks, water and sky look, he will find later, when he sits in the studio before his bare canvas, that his memory, supplemented by his sketches, will enable him to paint most backgrounds effectively.

Don't neglect the painting of rocks if you intend showing such animals as mountain sheep, elk and other species that live in rocky country. These can add a decorative touch to your foreground, if painted well. If painted badly, they can all too easily look like distorted masses of clay. If you have trouble with rocks, then paint rocks for a time and nothing else. Always remember that the remedy for lack of knowledge of any natural forms is to draw and paint them

WEANING THE CALVES — Oil painting by Rosa Bonheur. Courtesy of The Metropolitan Museum of Art, New York

from nature until you know them. There is no excuse for painting some things well and others badly. The things you paint badly point the accusing finger of neglect at you.

For special backgrounds, travel may prove necessary. Rosa Bonheur obtained the backgrounds she needed for her deer and other wild animal subjects in the Forest of Fontainebleau. In the surrounding countryside, she painted the bits of landscape required for her cattle and horse backgrounds.

Kuhnert, the German painter of animals, journeyed to Africa and Asia for his backgrounds of African and Asiatic species. He tells how his instructor, Meyerheim, laughed at him when he insistently talked of going to Africa. "Do as I do," said Meyerheim, "take a board, cover it with sand, scatter a few stones about in the sand and the desert will be complete." But Kuhnert was not satisfied with a board covered with sand and a few stones; he wanted to see how the African wilderness looked and he was sure that it was not just a bit of sand with some stones scattered about. Kuhnert became famous, he has been called the Frans Hals of animal painters. Everyone has seen his pictures of lions and elephants standing in the yellow grass of East Africa, even though they have not noticed his signature. Few in our country have ever heard of Meyerheim.

Francis Lee Jaques paints birds as few have ever painted them. But birds alone would not make his pictures the masterpieces of wild fowl painting that they are. He journeyed to the Arctic, the Tropics, to far away South Sea Islands, from North to South in our own land, just to learn how birds live and where they live, and what their natural habitat of sky and land and water really looks like. Possessing such knowledge, his birds and backgrounds, one complementing the other, make complete pictures.

Carl Rungius, who, to me, is the dean of all animal painters, has reached the pinnacle of his profession by going to nature for everything that he puts into his paintings. His masterpieces of animal painting in the Administration Building of The New York Zoological Society in the Bronx Zoo, are records not only of animals as they are, but also of the country in which they live — Alaska, British Columbia and our wilds of the West.

The wild fowl and animal paintings by Lynn Bogue Hunt exhibit a similar stamp of authenticity, clearly indicating that the artist saw and painted the settings in which his birds and animals are shown.

So it should be with all painters of animals who aspire to reach the pinnacle of success. If their settings are to ring true — if they are to look as if the birds and animals pictured really are at home in their native environment — then these artists must acquire as sound a knowledge of such settings as of their living subject matter, regardless of how far afield they are forced to go.

Since in my own case I wanted to paint the big game of our own land and Africa, I found it necessary to seek the wild places here and in that country. Perhaps my method of gathering background material may serve as a help in your search for similar material.

First of all, you must be sure of what you want. If you desire a background for a picture of a wild rabbit, you will not need miles of woodland. A vacant lot full of weeds will give you the few square yards required. Some weeds and leaves on the ground will be enough for the rabbit picture. The same holds true if you want background material for the painting of a pheasant. A few leaves from some shrubby growth of oak, sumac or briar; some interesting weeds, maybe with feathery, decorative tops; a bit of ground with grass and leaves scattered about; and your background is complete. Sit before these things and sketch them in the arrangement you want; pluck a branch of leaves, some weeds and bits of grass and take them to the studio and you will have enough material for your painting.

Even for a painting of a deer, you will not have to go far for your background material. Deer inhabit country in which many kinds of trees grow, such as aspen, birch, maple, willow, cedar, fir, spruce and pine. In the environs of almost any town, unless on the plains, you can find wild spots that

94

*WOOD'S EDGE — Oil painting by **author***

will do. I once produced a successful background for a deer picture by going to the outskirts of Minneapolis and painting a low spot with a bit of water, shrubbery, and a few trees. You need not necessarily go to a place where deer are found. Let it suffice that deer would normally live in such a place. Perhaps, in the past, deer were found in that very place, for they were widespread before this country was populated. By the same token, for a picture in which you want to show a moose, you can paint a background of water, with lily pads and evergreens. Maybe there has not been a moose among the lily pads in that lake for a hundred years, but it is the sort of place in which moose live and, if you do a good job of painting the scene before you, the moose will look quite right in those surroundings.

For a painting of a deer, don't try to include the whole countryside. Try to visualize the deer as standing in the landscape before you and let your mind's eye enclose deer and background within the confines of the picture you intend to paint. You will discover that a few stems of birch, some scrubby willow shoots, and a bit of grass, bush and ground, will be quite sufficient. You need not include evergreens, but if you think they should be there and they are not in the scene before you, go to some place where there are evergreens; sketch them and utilize them in your composition when you arrange your painting in the studio.

THUMB-NAIL SKETCHES

For gathering background material, I have two sketch boxes. One is what is known as a "thumb-nail" sketch box. It holds canvas panels about 5 by 8 inches in size. Rather small, indeed, but I have painted in oils many backgrounds with that little box. I glue canvas, with a smooth tooth or weave, to pieces of cardboard and use these for my panels. The brushes are sables — the kind employed for oil painting. They come with

95

Oil sketch of acacia trees and veldt, Tanganyika. (Part of this sketch was utilized in Kudu painting reproduced at the left)

GREATER KUDU — Oil painting by author, from collection of Winston Guest, New York. (Note how part of the accompanying landscape was used for background)

long handles and I have to cut them short to fit into the box. The bits of landscape that I want for backgrounds can be painted on panels of that size, in from twenty minutes to a half hour each. The light does not change in that time and it is easy to record light and shadow. I go into all the detail that the small canvas will allow, since the pointed sable brushes permit this. Then, when I enlarge these sketches, I do not add further detail, but put each picture on canvas much as originally painted from nature, except that I may move branches or stems of trees to make a proper composition with my animal.

In doing these sketches, I usually record the exact values and colors of things as I see them in the landscape before me. Remember that in such work one is not sketching from nature merely to learn what the forms of trees and bushes are like — he can find that out from photographs. The artist goes to

nature for color and values. He looks especially for those interesting variations of color that will give him a pleasing color pattern in his painting. In your own work along these lines, you will see, in the subject matter before you, cool grays, warm grays, pinks, tans, straw colors and many warm and cool variations of green. Make an interesting pattern of these colors. Don't waste too much time in painting every twig on a bush or tree. Paint leaves in masses of light and shade. Suggest, with your brush, whether the leaves grow in dense masses or are loosely scattered on the tree or shrub. Grass can also be painted in masses, with just a few strokes to indicate an individual stem here and there. Watch values closely, so your sketch will have proper depth.

SELECTION

When you bring your sketch to the studio you may find that there is more in it than you want for your animal painting. Use what you want and omit the rest. I once painted a landscape in Africa that included some yellow acacias, some thorn-bushes and a stretch of yellow veldt. The colors in part of that landscape were just what I later wanted for a painting of a kudu, but I knew that I could not use all that landscape without having a very small kudu in the picture. After all, one must consider the relation in size between his animal and his landscape. I wanted the kudu to be the main thing in my picture, so from that sketch I utilized

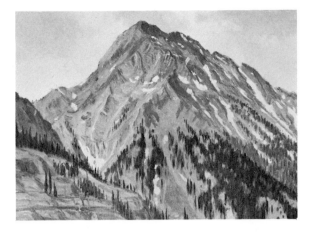

Oil sketch of mountain, Brown Rock Canyon, Wyoming. (Used for background of painting reproduced at the right)

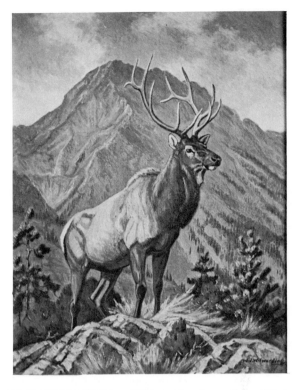

ELK, WYOMING — Oil painting by author. (Note how snow on peak, shown on sketch at left, was omitted from painting to avoid conflict with the animal's antlers)

for my background only acacia trees — I even left off the tops of these — and the bushes, omitting those miles of yellow veldt.

RELATIVE SIZE

This reference to the relative size of animal and background material reminds me of how a taxidermist once asked me to view a painting attempt of his, which he fondly imagined to be a sort of museum habitat job. He had mounted a red squirrel on a piece of birch stump, carefully sawed off flush on top to support the animal. All this was enclosed in a glazed box, the inside back surface of which was covered with a painting supposed to represent the true habitat of the squirrel. It showed evergreen trees about eight inches high, standing right back of that squirrel on his birch stump. In relation to those trees, that squirrel was larger than an elephant!

When you are making a sketch, walk up to some tree stem that will be in the foreground of the sketch and maybe right back of a deer that you will place in the picture. Measure off about how high a deer would be if it stood by that tree stem — a big buck might be about four feet high at the shoulder. Note this height mentally or, if you think it necessary, make a small mark on your sketch to indicate how high the deer would reach on that tree. Then when you make your finished painting it should be easy to keep deer and tree in proper relation-

ship. If you find that there will be too much tree above the deer, cut the tree off at the upper frame line.

DIRECTION OF LIGHT

Watch very carefully for another thing: In any painting based on a sketch of a deer (or any other animal) and another sketch of a landscape setting — or on any two sketches, for that matter — be sure that your light comes from a single direction. Don't for example, use a study of a deer in which you have the light from the right in combination with a landscape in which the light falls from the left. Many years ago I saw such a painting in an art exhibition — a huge painting showing a herd of buffaloes apparently floating in a cloud of dust above two clumps of sage-brush. Back of the buffaloes came an Indian on horseback. The light was strong on the right side of that Indian. It was strong on the left sides of the buffaloes. Also, they cast shadows in opposite directions! Even the jury had missed that one.

97

OMISSION: SUBORDINATION

Sometimes you will find, after making a careful study of a landscape, that there is not only too much landscape for your picture, but that there are things in it that conflict with your animal. Omit them from the final painting. I once painted a mountain peak in Wyoming that I wanted as a background for an elk picture. It had been cold and there were many traces of snow on the peak, running in streaks down the rock crevices. I made the mistake of trying to paint the mountain with those streaks of snow showing. They fought with the elk and had to be removed. Snow on mountain peaks, with the sun on it, has a bad way of wanting to come forward and steal the show. It is best to paint it in cool shadow colors, if it must be included at all. Clouds passing over mountains throw shadows on them, so it is perfectly correct to picture a mountain in shadow with your animal in full sunlight before it.

LARGER SKETCHES

I have mentioned two sketch boxes that I use in my work, and have described the first. The other is larger, taking a canvas panel about 10 by 14 inches. In this one I can carry a greater supply of paints and brushes. I use an easel with it, the box serving only for carrying canvas panels and other painting things. For these larger panels I prefer bristle brushes for broad effects, employing the pointed sables only for drawing tree branches and other detail. On extended trips into the wilds of our own country and Africa, I utilized this larger sketch box most frequently, as it permitted me to make better studies of the landscapes I wanted for larger canvases. After all, there is a limit to which a thumb-nail sketch can be enlarged — it is seldom easy to increase it to the size of a 30 by 40 canvas· I have found, however, that the 10 by 14 size is quite sufficient for such enlarging. Also, I can often employ bits from the same landscape study for several paintings, if these paintings are not too big.

Again it is possible to combine something from one sketch with something from an-other. This is permissible, since you are composing a work of art and can do what you want with it. Rocks, or any other sort of foreground, might be borrowed from one sketch, and a background of forest or mountain peak from another. Or a foreground might be selected from one sketch, a forest from a second, a mountain peak from a third, and a good sky from a fourth. If you compose these consistently and pleasingly you will owe apologies to no one.

THREE TYPES OF STUDIES

There are really three kinds of outdoor subjects needed for backgrounds. First, there are those small bits of leaves and vegetation required for pictures in which smaller animals and birds are to be shown. As has been pointed out previously, a decorative branch with leaves, or a few decorative weeds, may suffice for such pictures. Some artists like wild flowers and include these or some typical plant with which the animal is associated. Second, there are the bits of landscape, including a few tree stems, bushes, a little water, or something like this, against which you will pose a deer or other wild creature. In either of these, your setting will not be a complete composition in itself, but will need the animal to complete it. Third, there is the large expanse of landscape — perhaps some scene in mountain country, jungle or badlands — into which you will fit a herd of animals. Here, too, the animals will provide part of the composition; but, in this case, your landscape must also compose well and should be painted to appear as if the animals could run out of the picture and still leave a composition that would be pleasing in itself.

In doing a study for the last of these three methods of presenting animals, your job is that of the landscape painter, for you are really picturing a landscape with animals, not an animal with a bit of landscape. A rapid sketch of the whole scene will be necessary to grasp the main effects of light and shadow, since they change quickly — often much too quickly. Then, if there are trees that are a main part of the composition, it may be necessary to make separate, more

careful studies of these. If there is a mountain peak in the picture, it may even prove desirable to make a separate study of that. If a sky with clouds is to be an interesting part of the composition, that may also call for a separate study.

None of these studies need be too detailed. Work for broad effects. This is, after all, an animal picture, and if there is too much niggling detail it can easily detract from the animals. Let colors, values and forms look authentic and this will be quite enough. The observer will give his attention to the animals, which will have the main accent, and the landscape will complement it sufficiently. Remember that, if you look at a group of animals in nature, your mind is primarily on the animals, and the landscape about them impresses you as just a hazy blur in which you see no detail at all. You cannot paint it in that blurred manner, perhaps, since it would not look right to the observer, but you can represent it broadly and simply, letting his imagination supply the detail.

For instance, in painting timber growing up a mountainside, it can be indicated in little smears of the brush — you need not delineate each separate tree. Where timber is massed, you can paint it in broad sweeps of the brush. Near the animals — since they are the focal point of your picture — you may want to keep things a bit more detailed, but will doubtless work more broadly as the landscape recedes from them.

As a rule, I avoid colors that are too vivid, and, even in autumn landscapes, subdue the bright colors, since one can live better with pictures that are not overbrilliant. Sunsets are beautiful, but nature gives them to us in small doses; painted sunsets get tiresome when one has to look at them all day. If you *must* paint sunsets, pick those that are not too gaudy with red. I have sketched many sunsets, but rarely use them in a picture.

Personally, I believe that a sunset is quite sufficient as a picture subject by itself and that one should not mix several subjects in one painting.

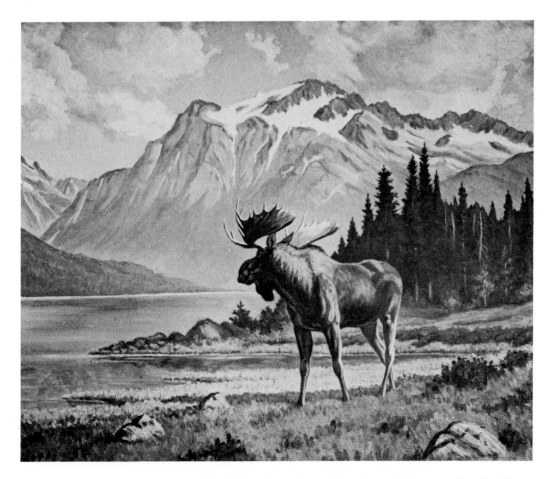

WILDERNESS KING — Oil painting by author. A composed picture, using sketch of moose combined with foreground from one place and background from another

Chapter XII

ANIMAL CARTOONS AND COMICS

CARTOONING OFFERS a highly remunerative field for the artist who likes to draw animals. Walt Disney, the famous animator; Ed Dobbs, of *Mark Trail* fame; Walt Kelly, the creator of *Pogo,* are notable examples of artists who rose to fame and fortune through animal cartooning.

CARTOONING AND CARICATURE

Cartooning and caricature are two different things. We call caricatures cartoons, but a cartoon is not necessarily a caricature, nor need it be comical. Ed Dobbs' *Mark Trail* cartoon is neither caricature nor an attempt to be comical. He draws his animals as realistically true to nature as any serious illustrator of natural history books. This is factual cartooning.

On the other hand, most of the animals in the Disney cartoons are drawn to look comical — cute and funny in an appealing way. This, too, is true of Walt Kelly's *Pogo* creatures. These are cartoon comics.

To be a Walt Disney or a Walt Kelly you have to be a naturally funny man. Lacking this, one had better try some other form of animal art rather than that of animal comics. To carry on a cartoon, like that of Ed Dobbs, you must not only be a good animal draftsman, but must have the knowledge and ideas to carry a natural history cartoon along through the years.

Edwina Dumm, who signs her famous *Cap Stubbs and Tippie* cartoon "Edwina," has a combination cartoon of people and animals, in which "Tippie," the dog, is a leading character. While she appears to put human expressions on her dogs, these are really exaggerated dog expressions of surprise, joy, etc. Her animals look like the real animals and are not caricatured. Here, again, you have

to be a naturally funny person to create a cartoon of this kind.

DO WHAT YOU CAN DO BEST

No one wants advice, but here, anyway, is something to think about. If you are thinking of entering the animal cartooning field, then stick to the kind of thing you can do best. If you like to draw animals as they are and have accumulated a fund of knowledge about their habits, then do serious animal cartoons. On the other hand, don't try to be funny, if you are not funny. You will only appear ridiculous and will have the competition of all the funny people in the cartooning field.

If you do think of animals in terms of funny things that happen, then the whole world is your playground. Walt Kelly found his idea among southern swampland creatures. Edwina found her model sleeping on the hearth. You may find yours in kangaroo-land, among the jungle monkeys, or among the lions and other animals on the African veldt.

ANY ANIMAL CAN BE DRAWN FUNNY

Any animal can be made to look funny. Kangaroos look funny as they come fresh out of the pouch. Take a good front-view look at the face of an ostrich some time. You don't have to exaggerate some animals' forms or expressions much to make them look comical. All you do then is to think up a funny situation to go with the funny looking animal with the funny expression.

Bear in mind that every animal has certain characteristics that set it aside from others. We have gone into this matter in other chapters of this book. Exaggerate an animal's main characteristics and you have caricatured the animal. You can do this with a stork by giving it a heavier beak and longer

legs. You can do it with a pelican by giving him a more rounded body and a larger pouch to his bill. Make the panther longer of body and more slinky than he is and put a leer on his face and you have a panther cartoon. The moose gets an exaggerated muzzle, lankier legs, and a few changes to his antlers. The beaver gets larger teeth and a larger paddle tail. You can make animals look awkward by the way you draw their legs and feet.

KEEP ANIMALS LOOKING COMICAL

Remember one thing if you want to draw animal funnies — keep them looking comical! A caricature is not necessarily comical; it may be grotesque and something grotesque is not always funny. So, keep your animals looking comical. Almost anyone likes comical animals. You keep them comical by studying the animals so you know what they look like and then you change them a bit in form or expression to make them look funny.

You need not know animals the way the naturalist does, or the way the animal illustrator does. All you need know is the main characteristics, that is, what makes one kind of animal look different from another kind. From there on, you begin inventing, adding and subtracting. Of course, your cartooned animal must still look like a tiger, gorilla, or what have you, otherwise it would not look like a cartoon of that certain animal.

Look what we did with this giraffe. We made him a bit knock-kneed, set his horns at a rakish angle and gave him a long-faced amazed expression. He never looked down before and did not realize that he was so far from the ground.

ANIMAL CARICATURE

To make a caricature of an animal is not difficult. It is done the way we make caricatures of people. In making a caricature of a person with a big nose, you give him a larger nose. If a person has bushy eyebrows, you emphasize these by making them still more bushy. One with prominent teeth is given very prominent teeth. A fat person is caricatured by making him exceedingly rotund and, if thin, he will be drawn exceedingly thin.

The hippopotamus is almost a caricature the way nature made him. You don't have to do much to him to make him look funny. Here, we have drawn one to look much as he does naturally, and, below, we have a caricature of him. We made him rounder of body, gave him enlarged feet and exaggerated the bumps over his eyes. His mouth was turned up in a grin. You could make a broader caricature of him by making his mouth enormous. Many funny cartoons of the hippopotamus are drawn that way. Try it.

Try making caricatures of many kinds of animals in this manner. Play up their outstanding characteristics. You will be surprised to see how you can make animals look funny by a few changes around the eyes and mouth. Exaggerate these things and you will have an animal caricature that is funny. Always try to make them look funny, not just grotesque. A great many aspiring cartoonists fail in trying to make people look funny, because they make their characters look grotesque rather than comical.

Remember that the whole world is with you if you can make people laugh. They won't put up a statue in the public square to commemorate you, but they will pay money for the privilege of laughing with you.

THE KANGAROO AND ZEBRA

Note how we made the kangaroo look funny by exaggerating his long hind legs and by giving him larger ears and a queer expression. We also took a few liberties with his forefeet.

We did the same thing with the zebra. One illustration shows him as you might find him at the zoo; the other one demonstrates how we rounded his body, gave him short, sturdy legs, big ears and a heavier black muzzle. The odd expression on his face was not at all difficult. Taking advantage of his striped face, we made two heavy curved stripes over his eyes. With the heavy oval dots for the eyes themselves we gave him a humorous expression.

COMIC EXPRESSIONS

Most humorous expressions on the faces of animals are arrived at by the way you handle the eyes and mouth. Look at people. How do their expressions change? Isn't it the way the eyes and mouth appear? That, too, is the way your dog looks happy or downcast. You would do well to study a dog's change in expression. In cartooning, we exaggerate these changes in expression and take liberties with them.

Note the expressions on the animals below. The rabbit has a shrewd smile. He just thought of something funny. This was accomplished by curves around the mouth and eye. The way the eye looks back and down has added to this expression.

The goat was handled the way many old-time cartoonists put expressions on their animals. His ears, horns, and nose are drawn the way a goat looks, but there are dots for the eyes and the eyes are in front and not on the sides of the head. Curved lines around the eyes and mouth make him "grin like a goat."

The thrush under the rabbit was made to smile in a similar manner. Note how the bird at the right looks angry. The lines over its eyes are angular.

Note, too, how one buffalo head has a smile on it, while the other looks as if he can think of nothing that is good. Curved lines got us our first effect and angular ones gave us the scowl on the other one. Keep these things in mind — curved lines for smiles and angular lines for sullen, angry expressions.

Our fox was given a wondering look because we gave him large, rounded eyes. The moose has a worried look because of the way we gave his mouth a droop and because of the dot we used for his eye.

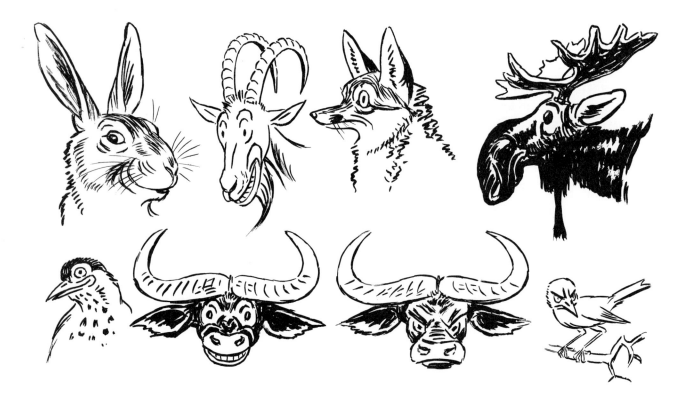

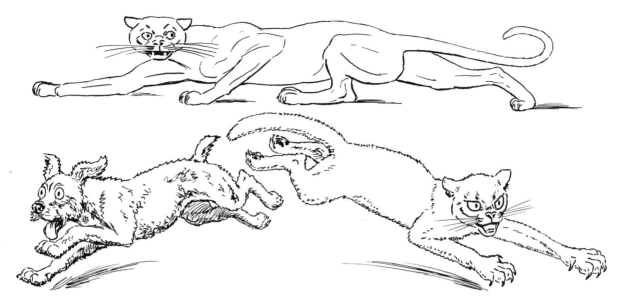

CARTOON ACTION

At the top of these two pages we show you animals in action. We have taken the natural action of the horse and exaggerated it. To the left the horse is shown as he trots and in the upper cartooned horse there is exaggerated trotting action. The other running horse is in exaggerated galloping action. Horses do not gallop that way, but we can show this in a cartoon.

Also note how we stretched out our panther to make him look sneaky. The running dog actually follows the action of a running dog, but we gave him that "escape from peril" look by the way we handled his eyes. The cat, too, has greatly enlarged eyes, as well as enlarged forelegs and paws.

You can learn a great deal about animal outlines by taking a brush and ink and drawing silhouettes of animals. You can do this by copying photographs. Make them comic in the way we handled these farm animals. Cartoonists who draw people are forever drawing and studying people. Animal cartoonists can spend many profitable hours at the zoo or on the farm. It pays well for those who excel.

Chapter XIII

HOW A PICTURE IS MADE

WE WILL SUPPOSE that you have sketched animals from life until you know the animals and have hundreds of sketches and studies, and that you have sketched nature outdoors until you know what nature looks like. Still, you are confronted with the task of combining this material to produce worthwhile works of art. Just what a worthwhile work of art is depends on what it is produced for. Most animal drawings and paintings are produced for the following reasons: as illustrations for story books or books on natural history; as covers for magazines; as illustrations for magazines; as paintings to hang on the wall, or as mural paintings. Many pictures of animals are, of course, drawn and painted to be used as illustrative material in advertisements.

BE HONEST WITH YOURSELF

Be honest with yourself and draw and paint the thing you like, as you like it. We will take it for granted that you like to draw animals, or you would not choose them as models for your work. Draw and paint the animals that you like best. Arrange them in picture compositions that will be pleasing to you. If you thus succeed in pleasing yourself, you will also please others, though you may be sure that you will not satisfy everybody. Some artists try so hard to please certain people or certain groups, who might view or buy their work, that they fail to please themselves. In so doing, they also fail to please others who have similar tastes. So, do your work honestly and sincerely and you may be sure that honesty and sincerity will show in your work.

SUBORDINATION OF THE SETTING

Your typical picture will be an arrangement of an animal and the setting in which you plan to show it. It may be a domestic animal in a setting such as might be found around a house, yard, barn or pasture, or it may be a so-called wild animal in its wilderness or jungle home. In either case, bear in mind that the animal comes first. Everything else must give place to it. Nothing else should have accents as strong as those on your animal. Don't become so enamoured of a landscape sketch that you are using for your setting that you work it up in too strong accents, stealing the show from your animal.

It took me a long time to learn this. My instructor in landscape painting had talked so much about proper accents in a landscape that I temporarily forgot I was using my landscapes as backgrounds for animals. I wondered what was wrong and why my pictures were spotty with accents. Then I studied paintings by famous animal painters and found that, when viewing them, the spectator saw the animals first, the settings later. The landscape was quite sufficient, the colors pleasing, but values and colors were handled so they would not assert themselves.

The painter Kuhnert was a master of this restrained manner of painting. He put just enough of the animal's natural habitat into a picture to place it properly. The background material was sufficient, but never overdone. Without the animal, one of these paintings would be entirely inadequate as a picture. In other words, his backgrounds were used to enhance his animals, never to detract from them — they never steal the show.

The landscapes in themselves are poor to a point of poverty, yet the colors comple-

ment the animals and the whole thing is a complete and pleasing performance.

Look at any painting by the artist. Carl Rungius, and you will find a similar situation. A few lichen-covered rocks on which mountain sheep are standing, a bit of mountainside or a distant peak, some sky, and the picture is complete. Without the mountain sheep, this would not be the case. Rungius is a painter of animals; when you look at his pictures you see the animals· The setting is accurate, because he goes to nature for it, but he picks what he needs and no more.

SIMPLICITY

Most of the really great paintings of the world are not cluttered with things; instead, they are masterpieces of simplicity. A composition that gives you a pleasing pattern of a few large and varied forms will be quite sufficient for a picture that may be breath-taking.

You do not have to go to the animal painters alone to learn this lesson of simplicity; look at the works of Rembrandt, Frans Hals, and — to come closer to home — Winslow Homer. In these works you will discover this same feeling of broadness and simplicity; it is one of the things which make them the masterpieces they are. One thing is certain; we do not tire of simple pictures as we do of those that are so complicated that eye and mind are soon overcome with fatigue from looking at them.

POINT OF VIEW

In a previous chapter on gathering background material, I spoke of the bits of material that would be quite sufficient for a picture of a wild rabbit or a pheasant, and I warned against using a broad sweep of landscape with such relatively small creatures. This is important, for it has to do with your point of view, a first consideration in composing a picture, without which you will surely lose your way.

I have seen a great deal of good drawing and painting go to waste on paper or canvas, because the artist had entirely neglected or lost his point of view. I recall seeing, in a painting, two birds which were supposed to be about the size of sparrows, picking away in the center of a road. The whole road was there, as well as the sides of the road and a little house at the bend, and those two little birds were painted to fill the whole foreground, their bodies almost spanning

THE FOX HUNT by Winslow Homer. Courtesy of The Pennsylvania Academy of the Fine Arts

the road from side to side! An ostrich sitting on eggs in the middle of that road would not have taken up the room that those two birds appeared to occupy in the picture. The artist wanted to show those birds in the road, so he painted the whole road. What he would have seen, had he looked at two little birds in the road, would have been just a bit of ground around them. If he considered it desirable to paint the whole road, then his birds should have been the size of pin points. If it was his ambition to paint the birds life-size, then he shouldn't have tried to crowd in the whole road. So take this as a warning — do not lose *your* point of view!

How much of the surroundings do you think you could clearly see, if you looked at a rabbit on the ground? A good guess would be a few leaves and a bit of grass. So if you intend to paint a rabbit at natural size, then you would wish to include as background only the things immediately about it. If, on the other hand, you should desire to include the whole woods, then your rabbit would of necessity have to be painted at very small size. To exemplify my point still further, I recall a picture in which a robin took up the whole foreground. Back of the robin was a tree, painted to appear like a high tree, with a nest in it and the robin's mate sitting in the nest. The effect was absurd. If the artist was determined to paint a robin, full-sized, in a picture, and a high tree back of it, showing its mate in a nest, then he required a canvas as high as a house. With the bird alone, painted life-size, he needed for surroundings only the bit of ground and vegetation in its immediate neighborhood, assuming that he painted on paper or canvas suited in size to his representation of the bird.

Give your point of view practice by observing birds or small animals as you see them outdoors. Notice, as you look at a squirrel seated on the ground with a nut in its paws, how much of its immediate surroundings you could put into a painting of it if you painted the squirrel life-size. Try to frame squirrel and surroundings with your mind's

eye, enclosing enough of what you see within the proportions of a paper or canvas you might choose for the little animal's portrait. What have you? The squirrel, a bit of ground and maybe a few leaves. You do not see the large oak tree back of the squirrel, within that imaginary frame, or the big woods beyond. So don't paint the big woods and the oak tree, but the squirrel and the things that are just about it. Remember the taxidermist and his red squirrel, mentioned in the previous chapter.

If you choose small song birds for your subject, then you need for your picture only a branch or two, with a few leaves as accessories. Arrange them in a pleasing composition; you will want nothing more.

THE PRELIMINARIES

Naturally, if you wish to paint pictures, you must have the pictures in your head before you can put them on paper or canvas. By observing animals, they will give you ideas for good picture compositions. You may see an animal or bird in an interesting pose, or in some attractive lighting arrange-

Diagram showing background that would be included in picture of squirrel, omitting the woods

ment or background that will give you an idea for a picture. Make notes and even small memory sketches. Then, with the aid of sketches and studies of the animal, and sketches of the background, you are ready to proceed. Besides your small composition and idea sketches, it might also be well to make a rough color sketch. This will do away with too much experimentation on the final painting. Don't make the mistake, however, of overdoing this business of preparatory sketching — in other words, don't carry the sketches for your composition and color too far, for, if you do, you may work yourself out on these and have no enthusiasm left for the final painting. If you possess good studies of the animal and setting, you will have enough for your work without detailed composition sketches. I recall how I once worked some sketches of galloping zebras over and over and made several color sketches for a picture I had in mind. I put so much effort into those sketches and studies that I had nothing left for the final painting and it was a failure.

MAKING A TRANSFER

Draw your animal carefully; see that it is just the proper size for the picture space, and then transfer it to paper or canvas. Don't make this drawing directly on the canvas or paper on which you intend finishing your work, since, if it does not prove the right size, or in exactly the correct location in the picture, you will have trouble in removing it and much time will be wasted. Instead, in the case of an oil painting, transfer the drawing to your canvas by coating the back with charcoal and then relining each line. Next, outline the transferred lines carefully with some warm paint that will be in sympathy with the final color you intend to use for the animal; let it dry, and wipe any surplus charcoal away so it will not sully your paint. If you prefer, you can fix the charcoal lines with fixatif. For a painting in water color or wash, you can make your transfer by blackening the back of your sketch with a soft pencil, using that for transferring the picture to the paper. With the outline of your animal thus transferred, lay in the principal lines of your background and set the thing aside for a fresh look the next day. If it seems right, you can begin your work.

There are so many good books on how a painting should be composed and painted, and so many good painters who give instructions, that I shall not go into detail of methods. Here are a few popular volumes for those who wish to investigate this field. *The Technique of Oil Painting,* by L. Richmond (Pitman); *The Art of Landscape Painting,* by L. Richmond (Pitman); *The Art of Painting in Pastel,* by L. Richmond and J. Littlejohns (Pitman); *The Practice of Oil Painting and Drawing,* by S. J. Solomon (Lippincott); *Landscape Painting,* by Adrian Stokes (Lippincott); and *Perspective as Applied to Pictures,* by Rex Vicat Cole (Lippincott).

MY PAINTING METHOD

My own method, when I work in oil, is to paint the colors in thinly at first without using white, employing some good drying medium such as turpentine, or a mixture of this and varnish. The colors are brushed on in a very liquid form, much as in painting with water color, and the various areas are covered to make an interesting pattern. This is done without too much contrast and usually in a slightly warmer tone than is planned for the final work.

After this underpainting is dry, which is usually the next day, I finish the painting in a heavy or "impasto" method. I fully complete one thing, while it is wet, as I may not have time to do the whole subject in a day. For instance, if I am working on an animal's head, or perhaps the sky, I finish that before I leave it. In this way I can model and blend more readily, and my completed work preserves its freshly-painted appearance. It is especially desirable to finish painting water while the paint is wet if one wishes to preserve its liquid appearance; water, worked on after the paint is dry, is quite apt to develop an edgy and hard effect entirely out of keeping with the true appearance of water.

Don't forget that an artist is concerned

only with appearances. He tries to make things appear on paper or canvas approximately as they do in nature. A sky must be painted to look like a sky; clouds must give the impression of floating mist; everything, in short, must be so painted as to create the proper illusion. Detail has nothing to do with this. A picture may be painted broadly and yet give a very good impression of the appearance of things, while another, done with infinite detail, but badly painted, may fail in this.

To make an animal appear natural in a picture requires an exact knowledge of its form and some understanding of its habits— its manner of standing or moving. It must not only fit naturally into its background, but it should give the impression of standing in front of things that are behind it. A far-away mountain must look distant, though, of necessity, one must paint its colors right down to the outline of his animal. The animal must appear solid, not flat. Earth and water must seem to lie flat, rather than to stand on end. Sky and clouds, though painted right against the outline of a mountain, must look as if they are beyond it.

A PAINTING IS AN ILLUSION

In other words, a painting is an illusion, created with colors of varied values and textures. If true to nature, it must not appear flat as the canvas on which it is painted, but must give a third dimensional impression of form, solidity, space. These qualities have nothing to do with composition. A well-composed picture may be lacking in every one of these, while a poorly-composed one may have them all in abundance. If you have been a close student of nature and have repeatedly painted her colors and values as you have seen them, your creation of this illusion should not be difficult.

Most paintings wear better if the composition is not too evenly balanced. For instance, a low horizon with considerable sky, or a high horizon with but little sky, usually works out best. One should avoid monotony of spacing, of areas and of colors.

Animals all standing in the same position

would look monotonous, as would walking animals all with similar attitude of legs. This also holds true for jumping or running animals, or for flying birds. To give a true presentation of a flock of rising birds, there should be variety in wing movement. When birds in a flock rise, some have the wings lifted while others have them down or held almost horizontally, and, in the process of flapping, there will be any number of in-between positions. In short, birds do not beat their wings in accord as soldiers move their feet in marching.

Any painting that purports to present nature as it truly is can have no monotony of forms, whether they be those of clouds, trees, mountains, rocks or animals. Man alone plants trees in monotonous, evenly-spaced rows; nature scatters them about. There is a school of painters that has thrown old rules of composition to the winds and insists upon repetition of form. This is nothing new, certainly not modern. The ancients repeated forms in art. Primitive people have always done this in decorating such craft objects as pottery and woven mats. Theirs was seldom an attempt to represent

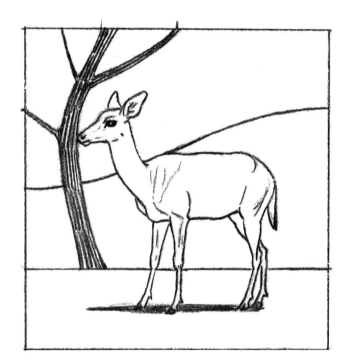

Diagram showing bad composition. Nose and tree are tangent. Shoulder of animal coincides with hill. Space divisions too nearly equal

nature as it appears to the eye, however, their repetition of forms having been used only as decoration. In decoration, repetition of form still has its place, but it has no place in true nature painting. Nature does not duplicate — no two rocks, no two trees are ever the same; in fact, no two leaves on any tree are repeated exactly. Therefore, to paint nature truly, the artist must show variety.

VARIETY

In your own work, then, strive for variety in your groups of animals, as well as in groups of trees or anything else that goes into your picture. Avoid similar spacing between trees and animals, and between these two and the frame lines of your picture. Also avoid effects of continuity or connection between unrelated lines, such as would exist if the line of a tree, mountain or something else in the background appeared to run right into and to follow the outline of an animal. Tangents often come within this displeasing class, so do not allow the nose or some other part of your animal to exactly touch the outline of a tree or other object in the picture. Let the animal definitely cut across objects or avoid them.

In placing one animal behind a second, avoid such confusing effects as are sometimes seen when two legs run right next to one another in a sort of double-leg effect. In pictures that are higher than wide, keep the heads of your animals up. An animal with its head down, or with its neck horizontal with its body, seldom looks well in a vertical picture.

Watch your relative scale and your perspective, so that your animal will not be out of size with its surroundings, or that animals in the background or middle distance will not appear out of proportion with those in the foreground. Proper perspective is just a matter of establishing a horizon line at your eye level and drawing vanishing lines from the shoulder and forefoot of an animal in the foreground to a vanishing point located anywhere on the horizon line. Vertical lines drawn between those vanishing lines will give you the heights of similar animals standing in the distance.

Remember that, if an animal in three-quarter front view is standing on ground that slopes upward toward the horizon, its rear feet will be higher than its forefeet. Only an animal standing on the edge of a hill, with the farther slope hidden from you, would have its rear feet hidden and lower, if shown as coming uphill toward you.

Avoid showing an animal doing impossible things. If it is browsing from a tree, be sure that it is not plucking leaves from a tree so distant that it could not possibly stretch its neck that far. I recall how a student showed me a picture of a plowman and horses. The plowman was walking along in the foreground. In the middle distance were drawn the horses and plow and yet the plowman had hold of the plow handles!

Above all, do not begin your painting if you are uncertain about the appearance of something you intend putting into it. Get rid of that uncertainty first by finding out exactly what that particular thing looks like, whether it be animal, tree, rock, mountain or cloud. Uncertainty as to the form, value, color or texture of any pictorial element may cause you to fumble about with your paint. Don't expect suddenly to discover the

Diagram showing horizon, vanishing lines from shoulder and foot of cow, and cow in perspective. A horizontal line drawn parallel with horizon line will show all animals along that line of same size

solution popping into your head. If you don't know at the start, you won't know when you have to paint it. It may be something that will make or mar your picture. Remember that a good artist has all his material at hand when he begins his picture. He has learned that careful preparation is nine-tenths of the battle.

MATERIALS

Use good materials. Some cheap ones may give you trouble. For practice work, you can use cheap paints and painting surfaces. For work that must last, use the best available. There are now many manufacturers of good paints and other artist materials.

In oil paint, I like zinc and titanium white mixed, though some artists like flake white, which is lead white. It has a sticky quality that I dislike. I like cadmium yellow, orange and red, also yellow ochre, venetian red, raw and burnt umber, burnt sienna, ultramarine blue, cobalt blue, viridian and ivory black. I use alizarin crimson on some paintings, but never mix it with the earth colors — ochres, umbers, siennas, iron oxides. You might add other colors or may wish to use an entirely different palette.

I never have more than five or six of these colors on the palette at one time and often paint with only four or five colors on the palette. The colors on the palette depend on the picture I am painting.

Get a book or booklet on the chemistry of colors. Most paint manufacturers have booklets that tell the composition of their paints. They don't all use the same chemicals. It is usually considered to be the best chemistry not to mix lead colors with cadmium colors and not to mix lake colors with earth colors. You can get along without alizarin crimson. I suggest that you read *Studio Secrets* and *Oil Painting for the Beginner* by Frederic Taubes, also *Oil Painting Step by Step* by Arthur Guptill, all published by Watson-Guptill Publications, Inc., who published this book that you are reading.

JUST DAWDLING ABOUT — Oil painting by author, Elephants, Singida District, Tanganyika. Reproduced from "Fauna," published by the Zoological Society of Philadelphia

I have found that Harrison red, supposed to be a *safe* substitute for American vermilion, bleeds through other colors in a nasty brownish-yellow hue that cannot be overpainted. It may be quite all right when used in a few pure touches as accents. I avoid lamp black for oil painting because it takes forever to dry.

ILLUSTRATION BOARD

You can paint with oil paints on illustration board. Do your drawing on the board and simply fix it with fixatif. Don't fix it too heavily or it will take on a slick surface that may prove bothersome in painting. Sometimes I spray it with retouch varnish before beginning painting.

CANVAS

Good linen canvas has a pleasant tooth and works very well under the brush. I prefer the single-primed surface as it is a bit more absorbent. Some like it double-primed and smoother. I like canvas that is mounted on a panel instead of on a stretcher, but many artists prefer stretched canvas. Panel-mounted canvas is not as subject to injury, nor will it sag in damp weather as stretched canvases often do. Many of the old masters painted on wood panels.

MEDIUMS, VARNISH, ETC.

Some artists use only turpentine with which to thin oil paint; others prefer raw linseed oil, pale drying oil, stand oil, or a copal painting medium. I have painted pictures by thinning the paint with kerosene and those paintings have not changed in color in twenty-five years. It is not supposed to be good chemistry. They dry with a mat finish when you use kerosene. I use it only in sketching.

A painting that has dried can either be varnished or protected with a wax coating. The wax coating has the advantage of not having a high shine to it. I shave up refined, white, beeswax, which can be bought at the drugstore in thin white cakes. Put the shavings in an old cold cream jar and cover with turpentine. Put on the cover and let it stand for a few days. The wax will dissolve into a white paste. You can spread this thinly over your painting with your fingers, rubbing it

even. Don't apply it until the painting is well dried. You can't varnish over this.

Retouching varnish is sprayed on a painting when the colors have dried to a dull finish, to bring up the colors before you go on with further painting. You can apply it as a protective coat after the painting is done and is just dry to the touch. I apply it with a fixatif sprayer. Don't blow it on until the canvas is wet with it.

Cobalt siccatif is a good dryer to mix with your oil paints if you wish the painting to dry fast. Mix just a little with each color and with the white paint. Don't mix dryer with any painting that you expect to have hanging in the great art galleries of the world. Dryers are only used by artists who do magazine covers and illustrations that must dry very quickly so that they can be delivered.

Some bird artists paint in their setting and let it dry. They then cut silhouettes of their flying birds out of cardboard. These are placed against the dry background painting and each is outlined with a pencil. They then paint the birds. Some do all right with this. Others that I have seen look exactly as if someone had done this — the birds look too sharply outlined against the sky.

COMPLETE EACH FORM

No matter how you arrive at putting your animals on the canvas or paper, always complete each bird or animal, even when one is partly hidden by the other. Just drawing parts of an animal around another one very rarely give a convincing impression. To make heads, legs, and other parts that show back of another animal, take their proper place and properly connect, you must draw the outline of the animal, and, after you have drawn the other animal in front of it, eliminate the parts that should be hidden.

MISCELLANEOUS SHORT CUTS

Don't make difficulties for yourself. Even professional artists of long standing do this. For many years, I squared off my sketches to enlarge them on canvas the way the old masters did. I now put my sketch in an enlarging machine and have the enlarging done in minutes that used to take hours. You can buy projectors that will do this for you.

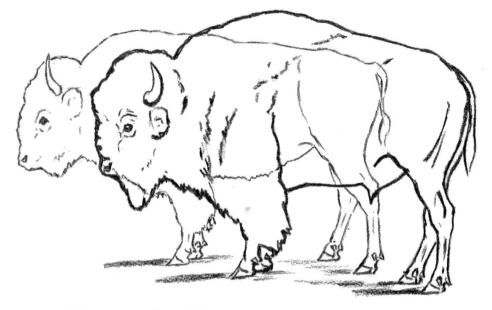

Diagram stressing wisdom of drawing both animals completely when one is placed behind another

RELATIVE SIZE

In drawing flying birds, you do not have to use vanishing lines to a horizon in depicting birds in the distance. Just see to it that the larger ones are in front of the ones that appear smaller in perspective. You also do not paint the distant ones in the same contrast and detail as those closer to you.

REVERSING POSITION

To reverse the position of an animal, of which you have a good sketch, simply draw it on tracing paper and turn the tracing paper over. Remember that you are reversing the lighting on the animal when you do this.

THE MIRROR

A mirror on the studio wall back of you is a very excellent critic. You can turn around and see your picture in reverse. If composition lines slant the wrong way, or if something is unbalanced, you will see it at once. Values that are off will often assert themselves when thus viewed, as will colors that jump at you from some part of the painting. Make use of the mirror as a helper.

ELECTRIC LIGHT TEST

Very often, you can tell whether or not your values are off by looking at your paint-ing under an ordinary yellow electric light — not a daylight bulb. The yellow light tends to gray the colors and bring out the values. Values that are too dark can be detected at once. If they look too dark in that light, it is best to correct them.

STARTING OVER

Don't fight with your painting. If something goes wrong, scrape it out and do it over. If something looks wrong at the end of a day's painting, scrape it out; it might be too dry to correct properly next day. A fresh look and a fresh start, with your mind alert next day, may save the painting.

YOUR FRIENDLY CRITICS

Once you have become established in your way of painting, go your way and don't let others paint your pictures for you. There are many who will try to do that with advice.

Be sure of what you want; be true to your-self and to your work. Go directly after what you want and don't worry about what others want. Remember that many a good painting has been spoiled by two much overpainting, too much correcting. We don't reach perfection on this earth, but keep this in mind ever — strive to excel.

A GALLERY OF PICTURES
BY FAMOUS AMERICAN
ANIMAL ARTISTS

SOUTH AMERICAN HERONS MANCHURIAN CRANES

THREE OIL PAINTINGS BY JESSIE ARMS BOTKE

NEST IN THE SIMSON WEEDS

116

THE NEW WORLD PASTEL BY PAUL BRANSOM
Reproduced by permission of the Saturday Evening Post,
copyright by the Curtis Publishing Company

ZOO SKETCH OF BROWN BEAR BY PAUL BRANSOM

CH. SCOTSHOME SURPRISE DRYPOINT BY MORGAN DENNIS

THE CHALLENGE OIL BY CARL RUNGIUS, N.A.
Original in the Enschende Museum, Holland.

CAIRN TERRIERS OIL BY DIANA THORNE

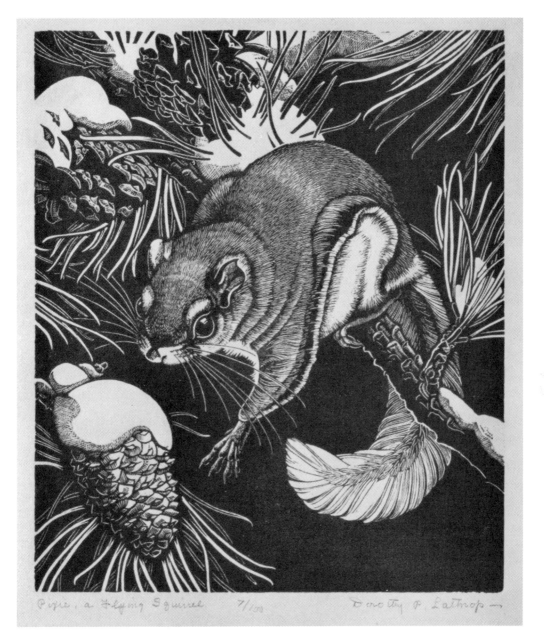

PIXIE, A FLYING SQUIRREL WOOD ENGRAVING BY DOROTHY LATHROP

OUNCE OR SNOW LEOPARD OIL BY CHARLES ROBERT KNIGHT
In the collection of animal paintings in the Administration Building, New York Zoological Park

Above:
BOXTED CONFIDER
OIL BY WESLEY DENNIS
Courtesy of the artist and
Esquire magazine

Right: MARCEAU
SKETCH FROM LIFE
BY WESLEY DENNIS
Courtesy of the artist and
Esquire magazine

BLUE AND SNOW GEESE
OIL BY F. LEE JAQUES

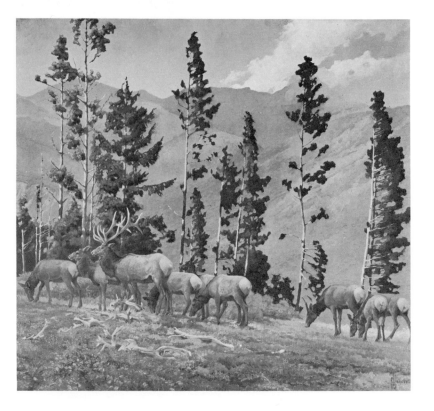

AMERICAN ELK OR WAPITI
OIL BY F. LEE JAQUES

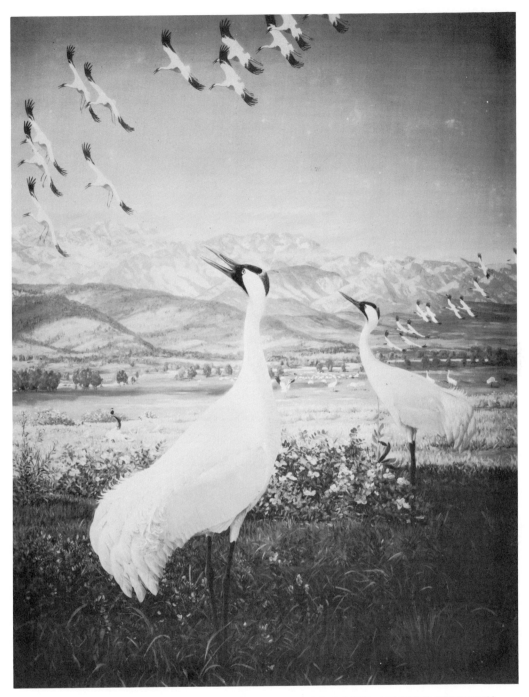

WHOOPING CRANES OIL BY LOUIS AGASSIZ FUERTES
In the collection of animal paintings, Administration Building, New York
Zoological Park. Courtesy of the New York Zoological Society

INDEX

127

INDEX

Dover Books on Art

PRINCIPLES OF ART HISTORY, H. Wölfflin. This remarkably instructive work demonstrates the tremendous change in artistic conception from the 14th to the 18th centuries, by analyzing 164 works by Botticelli, Dürer, Hobbema, Holbein, Hals, Titian, Rembrandt, Vermeer, etc., and pointing out exactly what is meant by "baroque," "classic," "primitive," "picturesque," and other basic terms of art history and criticism. "A remarkable lesson in the art of seeing," SAT. REV. OF LITERATURE. Translated from the 7th German edition. 150 illus. 254pp. 6⅛ x 9¼. 20276-3 Paperbound $4.95

FOUNDATIONS OF MODERN ART, A. Ozenfant. Stimulating discussion of human creativity from paleolithic cave painting to modern painting, architecture, decorative arts. Fully illustrated with works of Gris, Lipchitz, Léger, Picasso, primitive, modern artifacts, architecture, industrial art, much more. 226 illustrations. 368pp. 6⅛ x 9¼. 20215-1 Paperbound $6.95

METALWORK AND ENAMELLING, H. Maryon. Probably the best book ever written on the subject. Tells everything necessary for the home manufacture of jewelry, rings, ear pendants, bowls, etc. Covers materials, tools, soldering, filigree, setting stones, raising patterns, repoussé work, damascening, niello, cloisonné, polishing, assaying, casting, and dozens of other techniques. The best substitute for apprenticeship to a master metalworker. 363 photos and figures. 374pp. 5½ x 8½.

22702-2 Paperbound $5.00

SHAKER FURNITURE, E. D. and F. Andrews. The most illuminating study of Shaker furniture ever written. Covers chronology, craftsmanship, houses, shops, etc. Includes over 200 photographs of chairs, tables, clocks, beds, benches, etc. "Mr. & Mrs. Andrews know all there is to know about Shaker furniture," Mark Van Doren, NATION. 48 full-page plates. 192pp. 7⅞ x 10¾. 20679-3 Paperbound $5.00

LETTERING AND ALPHABETS, J. A. Cavanagh. An unabridged reissue of "Lettering," containing the full discussion, analysis, illustration of 89 basic hand lettering styles based on Caslon, Bodoni, Gothic, many other types. Hundreds of technical hints on construction, strokes, pens, brushes, etc. 89 alphabets, 72 lettered specimens, which may be reproduced permission-free. 121pp. 9¾ x 8. 20053-1 Paperbound $3.50

THE HUMAN FIGURE IN MOTION, Eadweard Muybridge. The largest collection in print of Muybridge's famous high-speed action photos. 4789 photographs in more than 500 action-strip-sequences (at shutter speeds up to 1/6000th of a second) illustrate men, women, children—mostly undraped—performing such actions as walking, running, getting up, lying down, carrying objects, throwing, etc. "An unparalleled dictionary of action for all artists," AMERICAN ARTIST. 390 full-page plates, with 4789 photographs. Heavy glossy stock, reinforced binding with headbands. 7⅞ x 10¾. 20204-6 Clothbound $15.95

Dover Books on Art

ART ANATOMY, Dr. William Rimmer. One of the few books on art anatomy that are themselves works of art, this is a faithful reproduction (rearranged for handy use) of the extremely rare masterpiece of the famous 19th century anatomist, sculptor, and art teacher. Beautiful, clear line drawings show every part of the body—bony structure, muscles, features, etc. Unusual are the sections on falling bodies, foreshortenings, muscles in tension, grotesque personalities, and Rimmer's remarkable interpretation of emotions and personalities as expressed by facial features. It will supplement every other book on art anatomy you are likely to have. Reproduced clearer than the lithographic original (which sells for $500 on up on the rare book market.) Over 1,200 illustrations. xiii + 153pp. 7¾ x 10¾.

20908-3 Paperbound $5.00

THE CRAFTSMAN'S HANDBOOK, Cennino Cennini. The finest English translation of IL LIBRO DELL' ARTE, the 15th century introduction to art technique that is both a mirror of Quatrocento life and a source of many useful but nearly forgotten facets of the painter's art. 4 illustrations. xxvii + 142pp. D. V. Thompson, translator. 5⅜ x 8. 20054-X Paperbound $3.50

THE BROWN DECADES, Lewis Mumford. A picture of the "buried renaissance" of the post-Civil War period, and the founding of modern architecture (Sullivan, Richardson, Root, Roebling), landscape development (Marsh, Olmstead, Eliot), and the graphic arts (Homer, Eakins, Ryder). 2nd revised, enlarged edition. Bibliography. 12 illustrations. xiv + 266 pp. 5⅜ x 8.

20200-3 Paperbound $3.00

THE STYLES OF ORNAMENT, A. Speltz. The largest collection of line ornament in print, with 3750 numbered illustrations arranged chronologically from Egypt, Assyria, Greeks, Romans, Etruscans, through Medieval, Renaissance, 18th century, and Victorian. No permissions, no fees needed to use or reproduce illustrations. 400 plates with 3750 illustrations. Bibliography. Index. 640pp. 6 x 9. 20557-6 Paperbound $7.95

THE ART OF ETCHING, E. S. Lumsden. Every step of the etching process from essential materials to completed proof is carefully and clearly explained, with 24 annotated plates exemplifying every technique and approach discussed. The book also features a rich survey of the art, with 105 annotated plates by masters. Invaluable for beginner to advanced etcher. 374pp. 5⅜ x 8. 20049-3 Paperbound $4.50

OF THE JUST SHAPING OF LETTERS, Albrecht Dürer. This remarkable volume reveals Albrecht Dürer's rules for the geometric construction of Roman capitals and the formation of Gothic lower case and capital letters, complete with construction diagrams and directions. Of considerable practical interest to the contemporary illustrator, artist, and designer. Translated from the Latin text of the edition of 1535 by R. T. Nichol. Numerous letterform designs, construction diagrams, illustrations. iv + 43pp. 7⅞ x 10¾. 21306-4 Paperbound $3.00